PHOTOSHOP® CS5
TRICKERY & FX

STEPHEN M. BURNS

Course Technology PTR

A part of Cengage Learning

COURSE TECHNOLOGY
CENGAGE Learning™

Australia, Brazil, Japan, Korea, Mexico, Singapore, Spain, United Kingdom, United States

COURSE TECHNOLOGY
CENGAGE Learning

Photoshop® CS5 Trickery & FX
Stephen M. Burns

**Publisher and General Manager,
Course Technology PTR:** Stacy L. Hiquet

Associate Director of Marketing: Sarah Panella

Manager of Editorial Services: Heather Talbot

Marketing Manager: Jordan Castellani

Acquisitions Editor: Heather Hurley

Project and Copy Editor: Marta Justak

Technical Reviewer: Lee Kohse

Interior Layout: Shawn Morningstar

Cover Designer: Michael Tanamachi

DVD-ROM Producer: Brandon Penticuff

Indexer: Valerie Haynes Perry

Proofreader: Sue Boshers

For product information and technology assistance, contact us at

**Cengage Learning Customer and Sales Support,
1-800-354-9706**

For permission to use material from this text or product, submit all requests online at
cengage.com/permissions

Further permissions questions can be emailed to
permissionrequest@cengage.com

Library of Congress Control Number: 2010925125
ISBN-13: 978-1-4354-5757-7
ISBN-10: 1-4354-5757-9

Course Technology, a part of Cengage Learning
20 Channel Center Street
Boston, MA 02210
USA

Cengage Learning is a leading provider of customized learning solutions with office locations around the globe, including Singapore, the United Kingdom, Australia, Mexico, Brazil, and Japan. Locate your local office at:
international.cengage.com/region

Cengage Learning products are represented in Canada by Nelson Education, Ltd.

For your lifelong learning solutions, visit **courseptr.com**
Visit our corporate website at **cengage.com**

Printed in the United States of America
1 2 3 4 5 6 7 12 11 10

*This book is dedicated to my mom and dad
for having inspired me to always excel at what I do.*

*It is also dedicated to the artists who strive
to express themselves uniquely.*

FOREWORD

What is an artist anyway?

Is he what he makes and how he makes it or how well he makes it? Is he the lifestyle that he lives or the product that he creates? Is he obligated to pass on what he knows as a teacher and mentor? Is his success or failure based upon his sales or his prestige in the eyes of the critics or his value and reputation amongst other artists? What defines an artist anyway or does he defy description? Are his ideas judged by how well he respects the past and tradition or how defiant he is of the norm and standard of traditional art and his individuality and creative nature of rebellion?

Stephen Burns is all of these things and more—artist, photographer, visionary, teacher, mentor, and author. He creates beautiful artwork of traditional and nontraditional imagery. He is unique and creative in all that he attempts. His value and reputation as a teacher and mentor are well documented by any who have had the privilege of taking one of his classes or seminars, many of which are free to all who can cram into the rooms. His contribution as a leader and organizer are well known and valued by the Adobe User groups that he leads and develops.

However, as an author, he shines in all of these modes and more. Stephen has the unique and talented ability to lead the beginner or seasoned veteran through the varied and adventure-filled pathways of Photoshop. His knowledge of this program and its relevance to other 2D and 3D programs is astonishing.

I am a printmaker, photographer, and artist who has been teaching digital and analog printmaking for years. I have had the good fortune of using and teaching Photoshop on many levels to a variety of students. I approach the use of the Photoshop program as a tool for the creation of something out of nothing. It is far more than the digital darkroom that it appears to be. Use of its tools for anything other than that for which it was originally created is of supreme importance and attraction for me. Anyone who can demonstrate an application of those tools in creative ways, surprises and delights me! Stephen Burns is one of those rare individuals whose facility and understanding of those tools and techniques is beyond comparison. In his hands, Photoshop becomes the

instrument of a virtuoso performer. The methods he has developed and the imagery which results become the symphonies of harmony, color, and form which delight the eye and spirit in much the same way that a great soloist evokes wonderful music from the instrument that he or she has mastered.

Photoshop CS5 Trickery & FX takes us beyond what we think we may have known was possible in Photoshop and transports us to a realm where all is possible.

Stephen's understanding of the 2D and new 3D features is astounding. I was delighted with the many examples of exciting imagery that he created and the complex but understandable steps he takes to arrive at these gems of imagery.

Take the journey with him and become as transfixed and delighted as I was while you travel through the visions of his mind!

Jack Duganne

ACKNOWLEDGMENTS

Without the support of so many others, this book would not have been possible.

I would like to thank Heather Hurley, Marta Justak, Shawn Morningstar, and Brandon Penticuff of the Cengage Learning team for their patience and professionalism in seeing this book to fruition properly.

A huge thanks to my tech editor, Lee Kohse. You're the best, buddy!

Thanks to Wacom for creating the Cintiq tablet, which is a wonderful tool for the digital artist. Particularly, I want to thank Tony Arredondo, Steve Smith, Doug Little, and Pete Dietrich for their support in sharing the Wacom tablet with other digital artists.

Thanks to Aaron Westgate of *Layers Magazine* and Issac Stolzenbach of *Photoshop Users Magazine* for their never-ending support.

Thanks to Jim Plant, Michael Kornet, Donetta Colbath, Jay Roth, and Chilton Web of Newtek (www.newtek.com) for listening to my suggestions and for their generous LightWave support.

In addition, a huge thanks to Adobe for creating such outstanding software, as well as Zorana Gee and Pete Falco of Adobe who patiently put up with all of my persistent questions.

Also, I would like to thank the members of the San Diego Photoshop Users group (www.sdphotoshopusers.com) for their dedication and support in helping me build a strong network of digital artists from which I always draw inspiration.

ABOUT THE AUTHOR

Stephen Burns (www.chromeallusion.com) has discovered the same passion for the digital medium as he has for photography as an art form. His background began as a photographer 28 years ago and, in time, progressed toward the digital medium. His influences include the great Abstractionists and the Surrealists, including Jackson Pollock, Wassily Kandinsky, Pablo Picasso, Franz Kline, Mark Rothko, Mark Tobey, and Lenor Fini, to name a few.

Stephen Burns has been a corporate instructor and lecturer in the application of digital art and design for the past 12 years. He has been exhibiting digital fine art internationally at galleries such as Durban Art Gallery in South Africa, Citizens Gallery in Yokohama, Japan, and CECUT Museum of Mexico to name a few. Part of his exhibit won him first place in the prestigious Seybold International Digital Arts contest.

Digital Involvement

Stephen teaches Digital Manipulation workshops in the San Diego area, as well as nationwide. He is an instructor at Light Photographic workshops (www.lightphotographicworkshops.com), Xtrain (www.xtrain.com), and Photoshop Café (www.photoshopcafe.com/video/products/photoshop_poser.htm). You will often see him involved as a team leader and presenter at Siggraph (www.Siggraph.org) at the "Digital Atelier" located at "The Studio."

Stephen Burns is the author of several books published by Cengage Learning, including *The Art of Poser & Photoshop, Photoshop CS Trickery & FX, Advanced Photoshop CS2 Trickery & FX, Advanced Photoshop CS3 Trickery & FX, Advanced Photoshop CS4 Trickery & FX*, and *Photoshop CS5 Trickery & FX*. Each chapter is a step-by-step instruction on how to create digital effects and artwork. He is also a contributing author in the book *Secrets of Award Winning Digital Artists* (Wiley Press) and *Photoshop CS Savvy* (Sybex). Go to www.chromeallusion.com/books.htm for more information.

He is the president of the San Diego Photoshop Users Group (www.sdphotoshopusers.com), which is the largest Photoshop users group in the nation. There are currently 3,500 members strong and growing.

TABLE OF CONTENTS

INTRODUCTION

In the introduction of my last book, *Advanced Photoshop CS4 Trickery & FX*, I mentioned that the greatest advantage that digital artists have is that their medium—the computer—combines all of the creative art forms, while giving artists the potential to communicate on a whole new level.

However, it can only be considered "potential" when artists are willing to broaden their perspectives and horizons to include other traditions in what they create. With Photoshop CS5 Extended, Adobe has turned this potential into a reality. Photoshop CS5 (www.adobe.com/products/photoshop/compare/) represents the most significant upgrade yet to the Adobe product, bringing together the functionality of 2D, 3D, and video into one interface. In addition, Adobe has added the capability to create custom 3D objects through Repoussé.

This book assumes that you already have a basic working knowledge of Photoshop's interface and understand the functionality of its tools. It also assumes that you are somewhat proficient with putting concepts together using multiple imagery. What this book does not assume is that the Photoshop practitioner is proficient in utilizing 3D texturing or animation. We are going to continue to use compositing and special effects to create artwork, but this time, we will take a deeper journey into discovering the potential of CS5 Extended's 3D tools and functionality.

Each chapter is a complete tutorial that gives you insight into the possibilities for taking your creative skills to the next level, going beyond the still photograph. Throughout this journey, you will be exposed to the traditional or analog approach to creating so that you can start to make a connection about how things were done in the past. Having an insight into the past not only helps you with understanding the terminology being used in Photoshop, but it also serves as insight about what you are doing throughout the creative process. However, as time and technology progress, traditional concepts are slipping farther away from today's students. Their exposure from the beginning is not based on analog technology; instead, it is based on the computer. It will be interesting to see what type of artists this new age will produce.

Bonus Videos

Check out the eight bonus videos included on the DVD under the "video" folder. If you would like to see more, please go to http://layersmagazine.com/author/stephen-m-burns.

System Requirements

In addition, please make sure to check out the system requirements for both Windows and Mac at http://www.adobe.com/products/photoshop/photoshop/systemreqs/.

What's on the DVD-ROM?

All of the images represented in the tutorials of the book are in a folder titled "chapter images" on the DVD. The content files that you need to follow along with the tutorials are listed in a folder titled "tutorials." In addition, the author has given you bonus videos that contain tutorials not included in the chapters of this book. We hope that you will enjoy them.

DVD-ROM Downloads

If you purchased an ebook version of this book, and the book had a companion DVD-ROM, we will mail you a copy of the disc. Please send ptrsupplements @cengage.com the title of the book, the ISBN, your name, address, and phone number. Thank you.

SIMPLIFYING
THE INTERFACE

IN THIS CHAPTER

- CS5 Extended UI
- Tools Palette
- The command palettes
- Cascading menus
- The Paint Brush improvements
- Adobe Bridge
- The ACR (Adobe Camera Raw) interface
- A brief overview of Mini Bridge

Whenever a digital program is updated, the intention is to improve its workflow and functionality to appeal to a broader base of artistic traditions, and Photoshop CS5 Extended does just that. This chapter not only gives you an overview of the interface, but it also describes the new features included in Photoshop CS5 in an effort to give you a deeper insight as to how to improve your creativity with this program. To make sure we are on the same page in terms of navigating the interface, I'll provide you with a brief explanation of Photoshop CS5 Extended's interface, which includes Bridge, creating brushes, 32-bit environment, and ACR (Adobe Camera Raw). The practical and creative uses of the tools will be covered in later tutorials.

OPEN GL IN CS5 EXTENDED

One of Photoshop CS5 Extended's improvements is that it uses the graphics card hardware to function more effectively in an Open GL (Open Graphics Language or Open Graphics Library) environment. Programmers for 3D and video programs have worked diligently to design their software so that the user can produce work more effectively without any slowdown, which usually results from rendering. Rendering is simply the process of producing shading, texturing, reflection, and lighting details to achieve the final photo-realistic look. Typically, rendering takes an inordinate amount of time and decreases your productivity, which is why Adobe has created CS5 Extended to take advantage of the Open GL capabilities of your graphics card.

Open GL also gives 3D animation software users the capability to see the maximum amount of texturing without actually rendering. So what you are getting is a type of proxy using shaders to simulate the texture capabilities that you have specified for your 3D surface details or video effects. Since shaders rely on vector technology, the results are instantaneous. If you plan to make the most out of CS5 Extended, then make sure that you have purchased an upgraded video card that has Open GL capabilities built in. Adobe, according to its specs, has recommended graphic cards with "Shader Model 3.0 and OpenGL 2.0" capabilities.

WACOM TABLET...AN IMPORTANT PERIPHERAL FOR ARTISTS

The one peripheral that is used by most digital artists and can help you revolutionize your workflow is the Wacom Cintiq (www.wacom.com). The Cintiq comes in two sizes: Cintiq 12WX and the Cintiq 21UX (see Figures 1.1 and 1.2).

The 21-inch version will be your main monitor for the desktop workstation. The 12-inch solution is great to place into your laptop case and work on location.

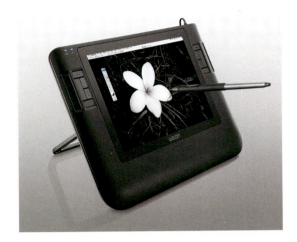

FIGURE 1.1 Cintiq 12WX.

FIGURE 1.2 Cintiq 21UX.

It is especially useful for plein air painting. Using this product, your workflow should be as intuitive as placing paint on canvas and creating with your brush.

The Wacom tablet will replace both your monitor and your mouse because you can draw or paint directly onto the Cintiq monitor. This tool gives you direct eye-to-hand functionality that simulates drawing, painting, and drafting.

Photoshop CS5 Layout

Adobe continues to revolutionize the art of image making. Photoshop CS5 brings 2D and 3D workflow closer together than ever before.

The newest interface has an efficient layout similar to the one that was established in CS3. You can access the Interface options in the Preferences panel (PC)Ctrl+K (MAC)Cmd+K. You have the option to change the interface or its borders to medium gray, black, or any custom color of your choosing.

Note that this is the first version that integrates a 64-bit environment. If your processor and operating system are both 64 bits, then the installer will give you the option to install both a 32- and a 64-bit version. You can choose one over the other, but 64-bit processing is still being perfected and some hardware devices may have some compatibility issues with it. So load both versions to be safe.

Keep in mind that the intention of this chapter is not to provide an intensive listing of all the tools and commands in Photoshop. I'll assume that you already have a basic understanding of Photoshop's interface. However, we will cover some of the new features in CS5 briefly here and extensively later in the tutorials. So let's get started.

You will be able to access all of your tools and commands in Photoshop in three places: toolbar, menus, and palettes (see Figure 1.3).

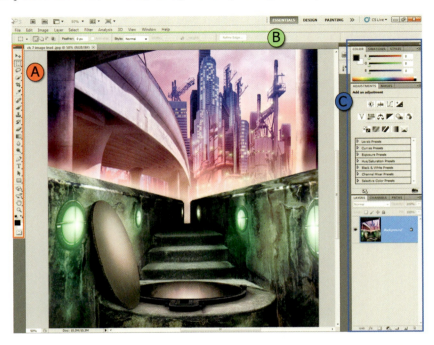

FIGURE 1.3 The Photoshop interface includes A) Tools Palette or Toolbox, B) menus, and C) palettes.

When you load the program, the interface will be in the Standard Screen Mode. The beauty of this interface layout is that it's more customizable to each individual's unique workflow needs, and it maximizes screen real estate. The floating palettes can be attached and detached from the edge of the interface or from one another so you can arrange them the way that works best for you. I will talk about palettes in more detail later in this chapter.

You can access your window viewing modes (View > Screen Mode), which are Standard Screen Mode, Full Screen Mode with Menu Bar, and Full Screen Mode (see Figure 1.4).

You can toggle through each mode by using the F key on your keyboard. In CS5 the background color stays the same default medium gray in the first two modes except for the Full Screen Mode, which is black. While holding down the spacebar, press the F key to toggle your background color to view your gray, black, or any other color that you designate. To get a custom-designated color, select the Fill tool on the toolbar, and while holding down the Shift key, click the colored interface surrounding your image. The color that is designated as your foreground color of the Tools Palette will be the new color applied to your background.

FIGURE 1.4 Access the three different screen modes from the View menu.

Let's take a look at the interface for each mode. Figure 1.5 displays the default screen mode when you first load and open CS5, which is the Standard Screen Mode.

FIGURE 1.5 View of the Standard Screen Mode.

Your Tools Palette is attached to the left side of the interface and the palettes are on the right.

Figure 1.6 shows an example of the Full Screen Mode with Menu Bar. This will fill the screen with the image you are focusing on and hide the Tab view.

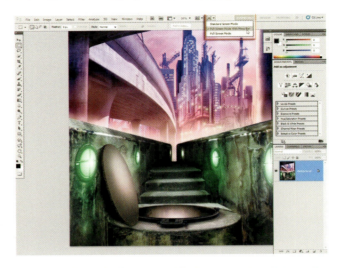

FIGURE 1.6 View of the interface in Full Screen Mode with Menu Bar.

Figure 1.7 shows an example of the Full Screen Mode, which fills the screen with the image you are focusing on and hides everything else.

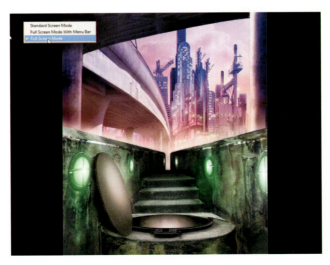

FIGURE 1.7 View of the interface in Full Screen Mode.

Figures 1.8 and 1.9 show the Full Screen Mode with the gray background and the blue background, which, in this case, is a custom color. Remember to toggle through these different colors by holding down the spacebar and pressing the F key.

Let's go to the toolbar next.

FIGURE 1.8 View of the interface in Full Screen Mode with the gray background.

FIGURE 1.9 View of the interface in Full Screen Mode with the blue background.

TOOLS PALETTE

The Tools Palette is the vertical slender bar that houses a visual representation of the variety of brushes and tools that you will use in your creations. Notice that it is displayed in a single column by default (see Figure 1.10).

You can also go back to what you're used to seeing in the previous versions by clicking a toggle switch in the top left-hand corner of the toolbar, as shown in Figure 1.11.

When each icon is clicked, the Options bar changes accordingly. This occurs because, like a painter, you are usually taught not to apply 100 percent of your pigments straight from the tube onto your canvas; instead, you will normally start in lower opacities or washes of those pigments to build form, saturation, and density over time. Also, notice that the bar is divided into sections by a thick line. The first section contains your selection tools. The next section contains your painting tools. Below the painting tools are the vector graphic tools. The last section contains the 3D toolset. As you work through this book, you will be using the painting and selection tools quite regularly.

You also can tear the toolbar away from the interface corners. To do this, click and hold the thin tab at the top of the toolbar and drag it (as shown in Figure 1.12).

You can reattach the toolbar in exactly the same way by dragging it to the edge of the interface. When it comes close to the interface, a blue vertical line will appear on the left-hand edge, as shown in Figure 1.13. When you see this line, release your mouse to reattach the palette to the interface.

Another nice feature is the capability to float documents inside of other document palettes. Figure 1.14 shows several documents within a single window. You can access these documents by clicking their tabs along the top of the window.

Click and hold one of the tabs and pull the document out of the floating palette. Now open several other images and notice that they will all be placed inside of the current activated floating palette (see Figure 1.15).

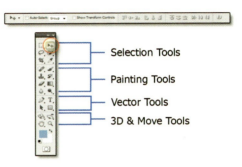

FIGURE 1.11 View of each tool set and the double column Tools Palette mode.

FIGURE 1.10 View of the single column Tools Palette.

FIGURE 1.12 View of toolbar as a floating palette.

FIGURE 1.13 View of toolbar being attached to the interface.

FIGURE 1.14 View of the floating palette.

FIGURE 1.15 View of multiple floating palettes.

PALETTES

You can also access Photoshop's commands in the command palettes. Command palettes are basically visual shortcuts to many of the commands that can be found in the text menus. All palettes have a drop-down menu located on the top-right corner that looks like a small black triangle, as shown in Figure 1.16. This will give you other options for that palette.

The palettes, like the toolbar, also have customizable features. You can minimize them by clicking the toggle button on the corner of the palette, as shown in Figure 1.17.

FIGURE 1.16 CS5 Palettes.

FIGURE 1.17 CS5 Palettes minimized.

When they are minimized, you can place your mouse on the divider between the two palettes and by clicking and dragging, you can resize them to be even smaller (see Figure 1.18).

You can expand any minimized palettes, which in this case are the Layers, by clicking the designated icon (see Figure 1.19). When you are finished using the palette, just click anywhere on the interface, and it will automatically minimize into an iconic mode. Make sure that in your Preferences panel (Edit > Preferences) under the Interface menu you check the Auto Collapse Icon Palettes box to enable this feature.

Auto collapsing your layer palettes can be very handy since the Palette Well is no longer available in CS5.

Just like the Tools Palette, you can tear a particular palette away so that it will float on your desktop (see Figure 1.20).

FIGURE 1.18 CS5 Palettes minimized even more.

FIGURE 1.19 Auto-collapse floating palettes.

These palettes are customizable in that you can attach them not only to the interface but also to one another by clicking and dragging the title bar and placing your mouse on any palette location, as shown in Figure 1.21 (A, B, and C). If the palettes are still in your way, you can access the Preferences dialog box and have Photoshop collapse all palettes automatically when you're done accessing them (see Figure 1.21D). This will allow you to work much like you did with the Palette Well, in which a small icon was always available when you needed to access the palettes.

FIGURE 1.20 CS5 Palettes floating on the desktop.

FIGURE 1.21 Reattach the palettes to a chosen location.

If the palette positions are still too annoying, press the Tab key to make all of the tools disappear. To access them again, just move your mouse to the outer edges of your workspace to the gray bars where your palettes used to be, and they will temporarily pop up to allow you access. When you're finished using them, click anywhere on your interface, and they will completely disappear again.

Another way that you might like to customize your workflow is by placing all of your palettes into one large folder so they are not split up into sections. Figure 1.22 shows a progression from a maximized palette being repositioned within a series of palette stacks. That series is then reorganized into one large palette. Whichever way you prefer for your workflow, CS5 has the most customizable interface ever. Now let's take a look at the menus.

FIGURE 1.22 Organize your palettes in a single folder to assist you with your workflow.

MENUS

You can also access Photoshop's commands in the drop-down menus. The term *menu* refers to cascading text menus along the top left side of the interface, as shown in Figure 1.23. Within each one of these menus are submenus that give you access to deeper commands within the program. Let's take a look at the new commands added. In the File menu, Create New Preview allows you to share your project using the new Adobe CS Review service. You will need to sign in, but afterward you will be able to share your vision through a Web browser to invite feedback and critique from your clients or peers.

The Fill menu (Edit > Fill) has a new feature called *Content-Aware Fill* (see Figure 1.24). This feature will fill in the selected area so that it will be seamless with the entire scene. I will cover this feature in a later chapter.

In the Edit menu, you'll find Puppet Warp (see Figure 1.25). This works like Warp (Edit > Transform > Warp), but you will have a lot more control with warping localized areas with control points. This tool will be utilized in a later tutorial.

In the Preferences submenu (Shift+F5), you will see a new menu titled "3D," as you can see in Figure 1.26. Here you will have the ability to set Ray Trace and Rendering options, set color references to the various 3D elements, and set parameters for your 3D lights.

FIGURE 1.23 Create New Preview.

FIGURE 1.24 The Fill menu with Content-Aware highlighted.

FIGURE 1.25 Puppet Warp.

FIGURE 1.26 3D Preferences.

Under the Image menu is a feature that Photographers have been asking for, ever since the introduction of the Photomatix HDR creation program. Photographers wanted more tone mapping for HDR images natively in Photoshop, and now it's available (listed as HDR Toning), as shown in Figure 1.27. We'll cover that subject in Chapter 3.

The 3D layers have received a significant facelift from their predecessor. If the use of 3D content is part of your workflow, the 3D Layers menu displays a new addition in CS5 Extended (see Figure 1.28). It is called *Repoussé*.

Repoussé will create 3D extruded shapes from text, selections, or vector shapes and import them into a 3D layer. In addition, you can edit their textures, add lights, and then move them around in 3D space. You will be introduced to Repoussé in Chapter 3 "Creating 3D Logos with Repoussé." You might also like to take a look at my latest book *The Art of Poser and Photoshop* (www.chromeallusion.com/books.htm), which will take you deeper into the world of 3D in Photoshop.

You can choose from a variety of layouts that you are most comfortable with. Experiment with these to develop a better workflow that fits your unique situation.

FIGURE 1.27 HDR Toning.

FIGURE 1.28 Repoussé.

THE NEW PAINT BRUSH

The new Paint Brush engine has some additions that bring it closer to the capabilities of Corel's Painter. The added improvements help to improve the brushes' functionality with the Wacom tablet. Let's get to know the basics of altering the Brush properties and saving custom brushes. But first, let's take a look at the new additions to the Brush tools.

One of the biggest complaint from artists was that Photoshop did not have a Mixing Brush tool like that of Painter. In CS5, you can now produce paint effects that replicate the results of mixing paints on canvas. In other words, the subtractive process of applying color is now available by way of a new brush called the Mixer Brush tool. If you lay down several colors on the canvas, you can use this tool to mix and blend the paints, as shown in Figure 1.29.

FIGURE 1.29 Applying the Mixer Brush tool.

In addition, your Options Palette gives you several application styles to simulate traditional paint effects (see Figure 1.30).

FIGURE 1.30 Mixer Brush options.

When you click the Paint Brush icon in your toolbar, you'll see the Options Palette. Click the Tool Preset on the top left. You'll see a drop-down menu of default tools listed. Don't forget to resize this menu by clicking the bottom-right corner of the palette and pulling it to any size to see more options.

You can access the submenu and click New Tool Preset. With each tool, you can save it and its preferences as a preset. In this example, two brushes have been saved, and the colors for the foreground and background were saved with them. Figures 1.31 and 1.32 represent the same brush, except that each one has its own set of colors assigned to it. So, if either one is selected, the colors and its respective properties are displayed and active.

FIGURE 1.31 The Brush tool preset with red and green.

FIGURE 1.32 The Brush tool preset with yellow and blue.

CREATING CUSTOM BRUSH EFFECTS

Now let's see how each dynamic works to create a single animated brush. We are going to start with the traditional brushes that you are used to working with to compare them with the new brush additions.

1. Select the Maple Leaf Brush and clear the Shape Dynamics option of any jitter properties (see Figure 1.33A).
2. Select Brush Tip Shape at the top of the left column. New options will appear in the right column of the Brush Palette. At the bottom of the new options, you will see the Spacing function. Play with this slider to spread out the frequency of the brush strokes. You will see the result of your changes displayed in real time in the preview window (see Figure 1.33B).
3. Additionally, play with the diameter by clicking the dots on the outside of the circle and altering the shape and rotation of the brush (see Figure 1.33C).

4. Click the Shape Dynamics option and make sure that all variables are turned off. The stroke of the brush in the preview window should show one continuous size and spacing (see Figure 1.33D).

5. While still in the Shape Dynamics, adjust your jitter to 92% and notice the stroke update in the preview window, as shown in Figure 1.33E. Jitter is simply the random application of a technique over the length of the stroke. The higher the percentage, the more drastic and varied the result will be.

6. Move the Minimum Diameter slider and watch how the size of the stroke is varied over time (see Figure 1.34F).

7. As you adjust the Angle Jitter slider, notice that the brush applies a percentage of rotation over the length of each stroke. This is great for debris and cloud effects (see Figure 1.34G).

8. As you experiment with the Roundness Jitter slider, notice that this option allows you to apply the full diameter of your mouse shape or squish it for an elliptical effect over the length of the stroke (see Figure 1.34H).

9. Use the Minimum Roundness slider to set the minimum distortion that you want to apply to your image. In conjunction with the other properties, this adds a little more control (see Figure 1.34I).

FIGURE 1.33 Brush properties are set to normal.

FIGURE 1.34 The Brush Palette options give you the ability to adjust the stroke variables and size of your brush.

10. Click the Scattering layer and watch what happens in your preview window, as shown in Figure 1.35J. This is a favorite Brush property—it's great for explosions.
11. Slide the Count slider to the right to add more of the brush effect to the scatter. Both Scattering and Count applied in combination can be visually powerful (see Figure 1.35K).
12. Click the Texture layer to add presets to your brush pattern, as shown in Figure 1.35L.
13. Click the Dual Brush options, as shown in Figure 1.35M, to add custom Brush Presets that will blend your current animated brush.

FIGURE 1.35 Add angle and roundness effect.

14. Change the colors of your foreground and background swatches by clicking the (front or foreground) color swatch near the bottom of the Tools Palette to bring up the color picker. You can choose a color for that swatch and experiment with each of the sliders to understand its effects. There is no preview for this in the stroke window, so you will have to alter each property by drawing on a layer filled with white.

15. Select the Other Dynamics layer. Here you can tell the Brush engine how to apply the effects. Your options are to apply the technique with the Wacom pen's pressure sensitivity, fade over a specified number of pixels, or use the pen tilt, stylus wheel, or pen rotation.

CREATING YOUR OWN CUSTOM BRUSH PALETTE

After you create a few custom brushes, you will want to create a custom Brush Palette. In Figure 1.36, the objective is to save the custom brushes that are highlighted in red into their own palette and discard the rest.

1. With your Brush Presets cascaded, click the submenu icon and click Preset Manager, as shown in Figure 1.37.

FIGURE 1.36 View of custom Brush Palette. **FIGURE 1.37** Activate the Preset Manager option.

2. Highlight all of the brushes that you are not interested in saving with a Shift+click on the first and last brush. Now click Delete to discard them (see Figure 1.38).
3. Your Brush Palette should now look something like Figure 1.39A. Finally, Figure 1.39B displays the stroke view inside your Brush Options Palette.

FIGURE 1.38 Highlight the brushes to delete them.

FIGURE 1.39 Final brushes in the Preset Manager option.

Now let's take a look at the new Brush tools added to CS5 (see Figure 1.40). Open the Brush Palette submenu and notice that you have some brushes that visually represent their traditional counterparts (see Figure 1.41). Select the one that resembles a Round Fan Brush. A 3D preview of the brush is displayed alongside your document. This feature will be helpful for those who work in traditional media because it will show you the tilt and pressure applied to the brush while you work. Once again, the Wacom tablet is invaluable for this feature.

FIGURE 1.40 Brush stroke preview on the Options bar.

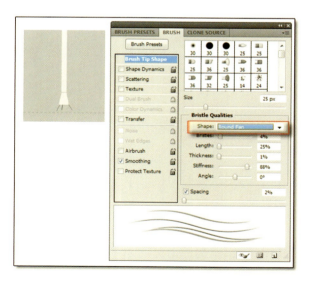

FIGURE 1.41 Round Fan Brush selected.

In this example, only a few bristles were selected, so go to the Bristles slider and pull it to the right to add more bristles (see Figure 1.42).

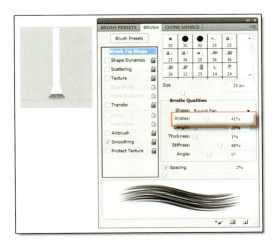

FIGURE 1.42 Increase the Brush Bristles.

Next, go to the Length slider and pull it to the right to extend the length of the bristles (see Figure 1.43). Notice how the 3D preview is automatically updated.

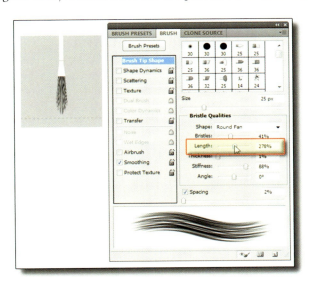

FIGURE 1.43 Extend the Brush Bristles.

Play with the Thickness and Angle options—the preview gives you an update on the result of the brush. Play with these options and discover all types of effects that can be obtained with a single brush style (see Figure 1.44).

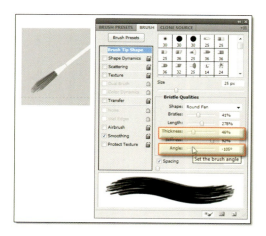

FIGURE 1.44 Set the Thickness and the Angle of the brush.

THE ADOBE BRIDGE INTERFACE

The new Adobe Bridge has gone through some significant changes to allow for more effective organization and categorizing of imagery. Selecting, categorizing, applying metadata, editing metadata, and previewing digital images can be done faster within an interface that is visually appealing and fun to work with.

The interface, as shown in Figure 1.45, looks very much like its predecessor. The interface is divided up into five sections as follows:

Folders (A): Access any location on your hard drive through this folder browser.

Filter (B): Preview the thumbnails that have any or all of the designations that you choose from the Filter menu section. Some of the options used to preview your images are Ratings, Keywords, Date Created, Date Modified, Orientation, and Aspect Ratio.

Content (C): View the results of your filters or any images from a selected location on your hard drive.

Preview (D): Get an enlarged preview of the selected image or images.

Metadata/Keywords (E): Preview and edit your metadata. In addition, in the Keywords tab, you can create and designate keywords to one image or a group of images.

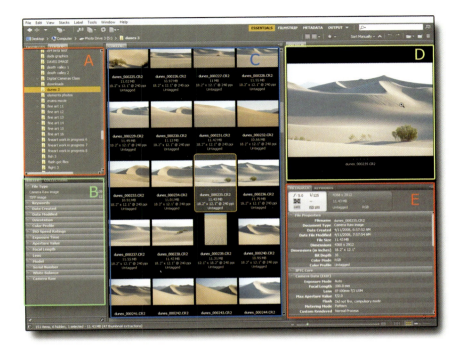

FIGURE 1.45 The Adobe Bridge interface.

When previewing a large group of images, it is also helpful to be able to adjust the size of the image for easier viewing, as shown in Figure 1.45. Use the slider to resize your thumbnails on the lower-right corner of the interface.

BRIDGE VIEWING OPTIONS

Next, you'll see a series of images that will reflect the various workflow styles. On the top right-hand corner of the interface, you can see a series of displayed options. By default, Essentials is selected. Click the Filmstrip, Metadata, and Output to view how the different interfaces are organized to accommodate your individual work style (see Figures 1.46–1.48).

Each interface should look fairly familiar to you with the exception of Output. Bridge now has the capability to output files in a PDF format. It uses a filmstrip view along the bottom to preview your content (see Figure 1.49A). You can create proof sheets of your images or upload them to the Web with a variety of cell column and width configurations as listed under the Output options (see Figure 1.49B).

FIGURE 1. 46 View of Essentials workflow.

FIGURE 1. 47 View of Filmstrip workflow.

FIGURE 1. 48 View of Metadata workflow.

FIGURE 1. 49 A view of the Output workflow.

In the Document section, you also have the flexibility to create in any document size, background color, and output quality. In addition, you can configure your document to be password protected (see Figure 1.49C). Under Layout, you can configure your proof sheets of your images by specifying Column and Rows (see Figure 1.49D). If you want to overlay text on top of your printout, then you will use the Overlays section to accomplish this (see Figure 1.49E).

THE LABELING METHOD

If you have a client who is previewing images that you have created, the labeling method is handy for categorizing and giving rank to each of the files. Right-click the highlighted images and select the Label submenu to assign a color to the images (see Figure 1.50).

FIGURE 1.50 Right-click the selected thumbnails to assign a color and star ratings.

WORKFLOW IN BRIDGE

Bridge is optimized for a more effective workflow in terms of organizing your photos from the digital camera to your storage drive. In Bridge, you can categorize your photos just by adding subfolders to a location on your hard drive. Knowing where all of your photos are located creates an effective organizational system. It is a good idea to have a separate hard drive to store all of your images. There are a number of external storage options on the market, so consider the number of photos that you capture regularly and purchase an external hard drive system for your needs. A lower-cost alternative is to purchase an external hard drive case for under $50. Then you can purchase any size hard drive that you need and place it into the case. Most of these external cases use USB or FireWire connections and come with a built-in fan to cool the storage device.

The external drive will register as a separate drive letter on your computer and may be designated as a Removable Disk drive. Depending on the number of devices on your system, it will be given a drive letter that will range from D to Z. Now, in Bridge, navigate to your external drive.

Make sure that the Folder tab is selected in the top-left window. The window where you would normally see your thumbnails will be blank, so right-click this space and choose New Folder. Give the folder a name that best represents the photos that will be placed into it, for example, "Wedding Photos" or "Night Shots," or you can organize your shots by date. Within these folders, you can add sub-folders, such as "Night Shots in New York," and so on.

After you set up a variety of folders on your hard drive, navigate to any storage card that your camera used to deposit your files. You will usually see a folder called DCIM that will have subfolders with your digital photos stored in them. View your photos in Bridge on the right and make sure that you can see your newly titled subfolders listed on the left. You can drag and drop your images into the proper categories.

CREATING KEYWORDS FOR EACH IMAGE

Now that you have organized all your photos, you need to assign them keywords so that if you need a particular image or a series of images, you can plug in a search word such as "people," and all of the appropriate photos will be listed in the thumbnail view. The following steps explain the procedure:

1. Choose the Keywords tab above the preview window. By default, you are given some predefined categories. At this stage, you will want to create your own categories, so right-click in the empty space of the keyword window and click New Keyword Set, as shown in Figure 1.51.
2. Make sure the title of the Keyword Set reflects the main category of the parent folder that each of the subfolders is located in. In this example, it is titled "Death Valley" (see Figure 1.52A). Right-click the Texture Keyword Set and select New Keyword (see Figure 1.52B). Make as many keywords as you can that will define the images associated with Texture, as shown in Figure 1.52C.
3. If you make a mistake, you always have the option to rename the Keyword Set. Just right-click the Keyword Set and select Rename. Next, type in the new title of the Keyword Set. When you are finished, press Enter; the new set will be viewed and organized alphabetically (see Figure 1.52D).
4. To rename the Keyword Set, just click twice on the title to activate the text-editing mode and then type in the new name (see Figure 1.53). When done, press the Enter key on your keyboard.
5. Now, notice that after renaming the Keyword Set, it was automatically reorganized alphabetically, as shown in Figure 1.54. This is helpful to identify your categories quickly.

FIGURE 1.51 Create a New Keyword Set.

FIGURE 1.52 Create a new name for the Keyword Set.

FIGURE 1.53 Rename your Keyword.

FIGURE 1.54 Renamed Keyword is automatically alphabetized.

6. Next, highlight a series of images by Shift+clicking between the first and the final image or Ctrl+clicking/Cmd+clicking on individual thumbnails (see Figure 1.55). In the Keywords panel, click the check box to associate the proper Keywords with their image or images. Note that if you select the "sand dune" Keyword Set, all of the Keywords in this category will be applied to your chosen thumbnails.

FIGURE 1.55 Apply Keywords to multiple images.

7. Now let's test your search engine. Press Ctrl+F or Cmd+F to bring up the Find panel. In the Source section, navigate to the folder or the subfolders that you want to search (see Figure 1.56).
8. Under the Criteria section, select how you want Find to search for your images. Choose Keywords.

FIGURE 1.56 Choose Keywords Search Parameters dialog box.

9. Define the parameters that the search engine will use to identify the images. In this case, choose Contains. Finally, enter the Keyword that you want to use. "Sand" is used here (see Figure 1.57).

FIGURE 1.57 View of the Search Parameters' results.

That's all there is to it. If you take a look at the thumbnails, you will now see the particular images that were associated with the "sand" search. You can also use the filters to search for images and display the thumbnails. Figure 1.58 shows check marks next to dates in December and January. Any files with these dates included in their metadata will be displayed as thumbnails.

In addition, you can preview images according to their rank or color designation. Figure 1.59 shows examples of all images that have the color designation of red.

Finally, you can organize images as groups or stacks to save space, as well as to apply properties to multiple images as a group. To do this, select two or more images, right-click, and select Stack (see Figure 1.60).

This command has just organized all of the selected images into a stack, as shown in Figures 1.61 and 1.62. The number of images in the stack is prominently displayed on the upper-left corner of each stack, so you can easily see the volume of images that you have organized in your folder.

FIGURE 1.58 Date Created filter is applied.

FIGURE 1.59 Filter applied by color.

FIGURE 1.60 Multiple images selected for a stack.

FIGURE 1.61 Selected images designated as a stack.

FIGURE 1.62 Display of multiple stacks.

THE ADOBE CAMERA RAW (ACR) INTERFACE

Figure 1.63 shows an overview of the Adobe Camera Raw (ACR) interface. It shows the basic preview pane that takes up the bulk of the interface. The tonal, color, and effects controls are on the right, and the workflow and resizing options are on the lower left. Note the histogram in the top-right corner, which displays the tonal information representing the red, green, and blue channels independently. Any information from the center to the left of the graph represents the middle to lower tonalities until it reaches black. Inversely, the center of the graph all the way to the right represents the middle to brighter tonalities toward white.

A higher vertical mound indicates a greater amount of those particular tones and colors in your image. It is important to note that the new ACR will not just open Raw formats.

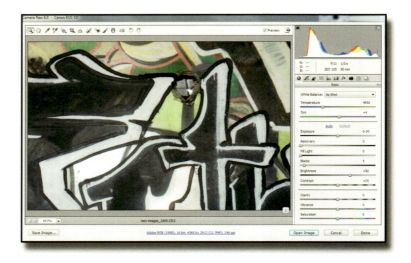

FIGURE 1.63 Raw interface.

You may use your own Raw files, or you can use the one provided online at www.courseptr.com/downloads. Use Bridge to navigate to the file, right-click, and select Open in Camera Raw.

You are now going to gain some familiarity with the power of the new ACR 6 (Adobe Camera Raw) interface. You'll immediately see some improvements to the ACR interface. These changes will not only allow you to gain a better handle on correcting contrast, white balance, or sharpening, but they will also give you the ability to clean up any imperfections having to do with the dust on your sensor, correct red eye, and use new improved tonal and color correction tools. Bridge gives you the most effective way to open your images in ACR. Just right-click the thumbnail and select Open in Camera Raw from the list. You can open TIFF and JPEG images in ACR this way as well.

If you want your Raw, JPEG, and TIFF files to open automatically in ACR, then you can specify this in two places. One is in the Photoshop preferences (Ctrl+K/Cmd+K). Under the File Handling menu, you will see a section titled File Compatibility. Under that heading, click the button called Camera Raw Preferences. On the bottom, you will see a section titled JPEG and TIFF Handling. Make sure that you select Automatically Open All Supported JPEGs for the JPEG option and Automatically Open All Supported TIFFs for the TIFF option.

The second area where you can locate the ACR options is in Bridge. Just go to Edit > ACR Preferences.

Let's explore the new interface.

1. Click each of the drop-down menus in the Workflow Options area to preview your options for color space (A), bit depth (B), sizing and resolution (C), and Sharpen (D), as shown in Figure 1.64.

2. White balance is simply the process of making your whites in your photograph as close to a neutral white as possible. In other words, proper white balance is the process of removing any color cast in the highlight areas. ACR gives you presets that relate directly to the white balance settings in your digital camera (see Figure 1.65), so you can choose one that will give you the best result.

FIGURE 1.65 The White Balance options.

FIGURE 1.64 ACR interface color space, bit depth, sizing and resolution options.

3. Take a look at the color Temperature slider under the White Balance menu. Slide it to the right and then to the left. Notice that as you slide to the right, your image becomes warmer (yellow), and as you drag in the opposite direction, your image becomes cooler (blue). The histogram in the top right gives you an update as to how all of the colors are responding to any and all adjustments in the Raw interface (see Figures 1.66 and 1.67).

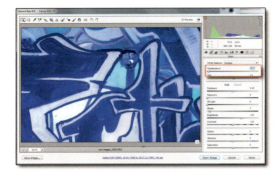

FIGURE 1.66 ACR interface color Temperature cooling options.

FIGURE 1.67 ACR interface color Temperature warming options.

4. Experiment with the Tint slider and see how you can control magenta and green. This is great for situations where textures are photographed near fluorescent lighting. Note how your histogram displays a dominant magenta or yellow, moving higher as you adjust the Tint slider to the right or left (see Figures 1.68 and 1.69).

FIGURE 1.68 ACR interface color tinting toward magenta.

FIGURE 1.69 ACR interface color tinting toward green.

5. The Exposure slider will help you make adjustments to any overexposed or underexposed images. In older versions of Photoshop, you had to click the Preview button for both the Shadows and the Highlights at the top of the interface to observe which areas were losing detail due to underexposure or overexposure. This capability was invaluable to photographers. However,

the way ACR communicates which areas are losing detail due to underexposure or overexposure is through color mapping. Any shadow regions losing detail are designated with a blue tint, and any highlight areas losing detail have a red tint. If you look at the histogram in the top-right corner, you will see two arrows above the black point and the white point. Click these arrows to toggle the blue and red out of gamut preview (see Figure 1.70).

6. In a continuing effort to allow the photographer to have more control of detail in the shadow, midrange, and highlight areas of the image, Adobe has added Recovery. Experiment with the Recovery slider (see Figure 1.71) and notice that the midtone range information is becoming denser. This slider deals with the process of bringing back the midtone information by adding density in those areas.

FIGURE 1.70 Preview of where detail is being lost.

FIGURE 1.71 The Recovery slider.

7. As recovery increases the middle range total detail, the Fill Light slider allows you to brighten the middle range tonal detail (see Figure 1.72). Often in a photographic image, the shuttle and highlight information are acceptable, but the midrange of information is too dark because of the environment's extreme contrast. Adjust this slider to make changes to those areas.

8. Click the HSL/Grayscale tab and select the Convert to Grayscale button located at the top (see Figure 1.73). This is a convenient addition that will likely be very popular because it gives the photographer the ability to create black-and-white photos straight from camera Raw files. You can even control the tonal values by selecting a color and shifting it toward dark or light.

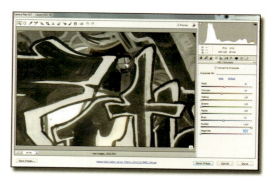

FIGURE 1.72 The Fill Light slider. **FIGURE 1.73** Results of the Convert to Grayscale option.

CUSTOMIZING ACR 6 THROUGH THE OPTIONS PANEL

Let's take a look at how to customize ACR 6 to assist you in preparing your photographic images to be imported into Photoshop. Take a look at the icons in the top-left corner of the interface. If you look from right to left, you'll notice two circular arrows that rotate 90 degrees clockwise to the right and 90 degrees counterclockwise. To the left of those two commands, you will see the Preferences Panel icon for ACR. Figure 1.74 shows some of the options that are available. For example, you can update your JPEG previews to be medium quality or high quality, you can control the cache size, you can make some default changes to your image settings, and you can determine where you want to save the XMP data from the Raw files. After you make adjustments to the settings, they will stay as default settings until you go back and alter the changes.

The next icon to the left of the Preferences icon is the Gradient icon (see Figure 1.75I). This is handy for applying for applying gradients to actually darken or lighten portions of your image. Another convenient addition to ACR is the ability to correct red eye (see Figure 1.75G). CS5 makes it very easy to apply this command. Just select the Red Eye icon and click the red eye in the portrait to remove the red color automatically. You will also have the option to brighten or darken the tonality to make the pupil more prominent.

Figure 1.75F shows the parameters for the Spot Removal Brush that allow you to apply the Stamp tool to your Raw images to remove blemishes or dust problems from the camera's sensor.

Figures 1.75E and 1.75D show the options for the Alignment and the Crop tools. The Alignment tool corrects a rotating or offset photograph. The Crop tool does exactly as the name implies—it crops the image.

Figure 1.75C shows the parameters for the Parametric Curve. This is a wonderful feature that lets you apply color and tonal changes just to the areas that

you select. In other words, by clicking on a local color, you can drag the slider to alter the Hue, Saturation, Luminance, and Grayscale mix of your selection.

Figure 1.75B displays the icon for the Sampler tool option to assist you with white balance or tonal correction by laying down reference points to select localized areas and adjust the white balance. Figure 1.75A is the White Balance tool icon.

FIGURE 1.74 The Preferences panel.

FIGURE 1.75 ACR options.

Take a look at Figure 1.76. It displays an example of how the white balance can be adjusted by clicking various areas of the print. When you click a particular tonal range, the White Balance Eye Dropper will neutralize the highlights in your scene toward more of a neutral white balanced look. In this example, a color sampler was placed on the highlight, shadow, and midtone region to assist in locating where to click when applying white balance. It is designated with circular markers, which are numbered 1 through 3.

Maximum Color Samplers Allowed

Take note that the Color Sampler tool only allows up to a maximum of four targets.

FIGURE 1.76 White Balance applied to local areas of the image.

THE RETOUCH TOOL

Let's focus our attention on Figure 1.77 (A and B), which displays a facial blemish that you can eliminate with the new Retouch tool using these steps:

1. Define the area where you need to utilize the good texture, replace the blemish with good texture, and make sure Heal is selected under the Type menu.
2. Click and drag your mouse to define the circumference of the brush over the area that you consider as the clean texture to cover your blemish (see Figure 1.77A).
3. After the brush size is set, click the Lasso and drag your mouse toward the area that you need to repair. Notice that a second circle has been created, which is designated with a red color and is in connection with the green circle.

FIGURE 1.77 Applying the Retouch tool to eliminate blemishes.

The green circle determines the good texture, and the red circle determines where you're going to place that texture.

4. Drag the red circle on top of the blemish and watch the imperfection disappear, as shown in Figure 1.77B.

The Subtle Differences Between the Healing and Clone Tools

Observe the differences between the Heal and Clone options. Go to the Type menu and switch from Heal to Clone (see Figure 1.78). Healing blends the two textures, whereas Clone just applies 100% of the texture on top of the blemish, thus giving it the darker shading of that selected area in this example.

FIGURE 1.78 Using Clone as an option.

Raw File Function

You are working with a Raw file so you have the ability to make several adjustments that are automatically saved with the file. You can never edit the Raw file directly so you do have the option to remove and reapply any of the Retouch tool settings.

You can also define multiple areas to retouch in the photograph. Figure 1.79A shows the use of several areas being added in one sitting since the figure displays several Spot Removal circular highlights throughout the face. As you probably have already noticed, the blemishes are not the only aspect that needs to be corrected with this portrait. The red eye needs to be taken out as well, which is very common in most snapshots taken with a built-in flash.

Another great convenience included in the new ACR interface is the ability to correct red eye. We are going to use the same photo used for the Retouch tool because it has red eye issues as well. You start by dragging the selection rectangle around the area that is affected with the reddish hue (see Figure 1.79B). Immediately, the red is dramatically reduced. Figure 1.79C shows the options that you have to eliminate the reddish color. Use the Pupil Size to adjust the tool's sensitivity as to the amount of reduction that is required. When red eye occurs, the darker tonalities in the eye are often sacrificed, so use darken to place density back into the pupils.

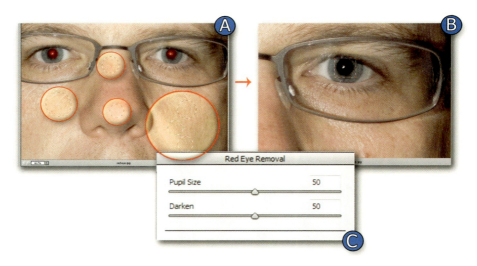

FIGURE 1.79 View of red eye and multiple placements of Retouch/Nodes.

OTHER FEATURES IN ACR 6

Next, let's look at the Curves feature. Click the Tone Curve tab to access the standard Curves command to control the contrast in the scene. You have two options. The Point option (see Figure 1.80) basically gives you the standard Curves dialog box. Notice that it has a slightly different look and that the histogram is included in the background to help you assess visually where the tones are on the graph.

The second option, Parametric, not only gives you the standard Curves, but it also gives you the sliders for adjusting the shadows, midtones, and highlight information (see Figure 1.81). You adjust these sliders just as you do in Levels.

FIGURE 1.80 The Point option for Tone Curve.

FIGURE 1.81 The Parametric option for Tone Curve.

Now, take a look at the Hue (A), Saturation (B), and Luminance (C) options in Figure 1.82. Each has its own set of sliders to apply changes to primary and secondary colors. Dividing up all these colors for each aspect gives you incredible control over the color balance, white balance, and the overall color scheme.

FIGURE 1.82 The Hue (A), Saturation (B), and Luminance (C) options.

The Hue gives you access to both the primary and secondary colors in your image. If your intention is to isolate a particular color in your photograph and alter that color, then you would choose the designated slider and make your changes to that color only. For example, if you would like to have green leaves take on a warmer appearance, then you would select the slider for the Green Hues and pull that slider to the left toward a yellowish, green look.

The Saturation option increases or decreases the saturation of each individual color that is present in your image. Finally, the Luminance option selects a certain color that is present in the photograph and alters that color toward white or black.

Let's take a look at a few other nice features in the new ACR. For instance, the Detail feature applies an Unsharp Mask to sharpen your imagery (see Figure 1.83).

Next, Split Toning allows you to create images that are dominated by two colors (see Figure 1.84). Traditionally, this was a common technique created by using two types of toner baths to add color to black-and-white prints.

FIGURE 1.83 View of the Detail panel to sharpen your image.

FIGURE 1.84 The Split Toning panel.

Finally, options are available for chromatic aberrations (see Figure 1.85A) and color corrections for your camera profile (see Figure 1.85B). You can also apply any presets (see Figure 1.85C) that were created in ACR.

When you have applied the settings and are satisfied with the results, you can save them as XMP data presets. In this example, a new preset is titled "High Key Dunes" (see Figure 1.86).

When you save your new preset, you'll be asked what subsets to save with the file. From this list, you can simply check the options to be included and uncheck any options that you do not want attached (see Figure 1.87).

Now, if you open any other file in ACR and access the Presets tab, as shown in Figure 1.88, you can select any preset that you have created.

FIGURE 1.85 Lens Correction, Camera Calibration, and Presets.

FIGURE 1.86 Saving your XMP data.

FIGURE 1.87 Select your subset options.

FIGURE 1.88 Apply preset.

Since you are dealing with the Raw file data, you have more information to experiment with than if it were formatted. In other words, you have at your command the Raw 1s and 0s that the camera originally captured. After your adjustments are applied and you save the file, it is formatted as a TIFF, JPEG, or PSD of your choice. In addition, the new ACR can open not only Raw files but also both TIFF and JPEG file formats. Just locate a thumbnail in Bridge, right-click it and select Open in Adobe Camera Raw or just click the shortcut icon listed below the menus on the top-left side of the interface (see Figure 1.89).

FIGURE 1.89 Right-click the thumbnail and select Open in Camera Raw.

Finally, we can't end this chapter without mentioning the smaller Bridge in CS5 called *Mini Bridge*. It's basically Bridge *lite* that takes fewer system resources, giving you quicker access to your images. To access Mini Bridge, go to File > Browse in Mini Bridge (see Figure 1.90).

Click on the Browse Files icon to get the expanded view (see Figure 1.91). As you can see, it functions exactly the same as Bridge with the thumbnail display of your images and a preview window that displays the selected image.

You'll see shortcuts to your menu items for Recent Folders, My Documents, and My Pictures. You even have an icon shaped like a house to take you back Home, as shown in Figure 1.92.

On the top right you have an icon that will take you directly to the standard Bridge (see Figure 1.93).

FIGURE 1.90 Initial view of Mini Bridge.

FIGURE 1.91 Expanded view of Mini Bridge.

FIGURE 1.92 View of shortcuts in Mini Bridge.

FIGURE 1.93 Click this icon to go to Adobe Bridge.

The next icon enables you to toggle the view of the Path Bar, Navigation Pod, or the Preview Pod (see Figure 1.94).

The magnifying glass is the symbol for searching your documents. When you click it, you will see what is shown in Figure 1.95.

Figures 1.96 thru 1.98 show the menus that you will access to rate and categorize your images.

FIGURE 1.94 Toggle the different views in Mini Bridge.

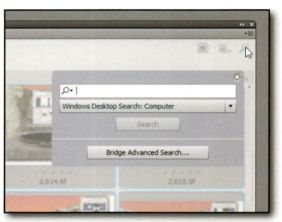

FIGURE 1.95 Toggle the search menu in Mini Bridge.

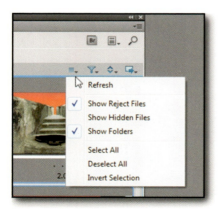

FIGURE 1.96 Menu to show, hide, and select files.

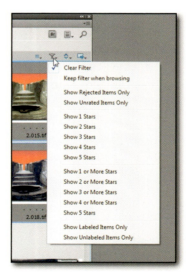

FIGURE 1.97 View of the various rating systems for imagery.

Finally, through the Photoshop submenu in Mini Bridge, you can apply some of the most popular commands that photographers will use, such as Batch, Image Processor, Load Files into Photoshop Layers, Merge to HDR Pro, and Photomerge (see Figure 1.99).

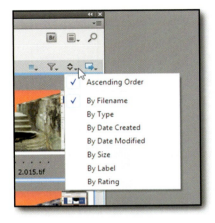

FIGURE 1.98 Organize your images using various criteria.

FIGURE 1.99 Mini Bridge gives you access to the most popular image commands.

WHAT YOU HAVE LEARNED

- How to use the Wacom tablet to improve workflow.
- How the CS5 interface is organized.
- The Photoshop interface has only three sections to access all your commands.
- How to use the Tools Palette.
- How to use cascading menus.
- The command palettes are shortcuts to what can be accessed in the cascading menus.
- ACR is an invaluable tool for editing Raw files.
- ACR and Bridge work together.
- Mini Bridge takes fewer resources than Bridge to preview your images.

CREATING YOUR CONCEPT USING A CUSTOM PERSPECTIVE

IN THIS CHAPTER

- Create perspective lines
- Alter images to match your chosen perspective
- Integrate custom textures into a photographic scene
- Create custom brushes from existing textures

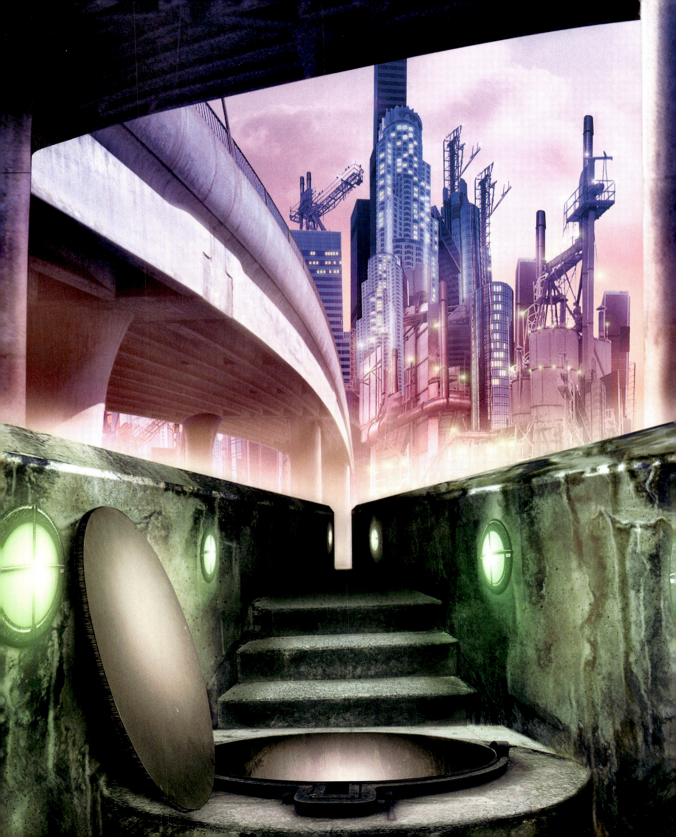

ESTABLISHING A CUSTOM PERSPECTIVE

In this chapter, the goal is to get you away from using the photograph exactly the way the camera has recorded it. Any photographic material that you choose to use will be subject to the perspective of the lens that recorded it. Here you will create a custom perspective using perspective lines, which have their own vanishing points. Then you will create the scene according to that perspective.

We will also create a metropolitan scene with the use of a chosen perspective. You will establish the foreground elements that will be the focal point and then add a cityscape that will provide the backdrop.

1. Create a new file with the dimensions of 8 × 11 inches with a resolution of 150ppi (pixels per inch). Even though you always want a resolution of 300 ppi if you intend to print your work, for tutorial purposes, keep the file size low. Use your Line tool or your paint brush to draw horizontal lines across your canvas, as shown in Figure 2.1. You will use them to create a perspective grid of your choosing. In this case, use the Free Transform tool (Ctrl+T/Cmd+T) and while holding down the Shift and Control/Command key (shortcut for Perspective), pull the top-right corner upward so that the lines appear to flair outward. Duplicate this layer and flip it horizontally (Edit > Transform > Flip Horizontally); then position it so that the inside seams meet. Use Figure 2.2 as a guide. When done, place the layers into a layer group titled "guides."

FIGURE 2.1 Draw horizontal lines.

FIGURE 2.2 Duplicate lines and flip layer horizontally.

2. Open a file (Ctrl+O/Cmd+O). Access Tutorials/ch 2 and select "stairs.tif." Place the image into the new file and position it so that the top of the stairs meets one-third of the way into the composition from the bottom. Next, transform the image as best you can to align the edges to the perspective lines (see Figure 2.3). You want only a portion of the wall above the top stair. Use your Polygonal Selection tool to cut away the top portion, making sure that the cut is aligned to the perspective lines.

FIGURE 2.3 Transform stairs to match perspective lines.

3. As you can see, each stair does not match the lines because the camera lens that was used was working along a different perspective. Since you want everything to match your chosen perspective, you will have to transform each stair individually. Use your Polygonal Transform tool to select the bottom stair and copy it to a new layer (Ctrl+J/Cmd+J), as shown in Figure 2.4.

FIGURE 2.4 Select stairs.

4. Now use Free Transform to shape it to align with the perspective. Apply a mask as needed to shape the edges of the stair so that they blend with the wall on each side (see Figure 2.5).

FIGURE 2.5 Transform stairs.

5. Follow steps 3 and 4 on each stair, and you should end up with something like Figure 2.6.

FIGURE 2.6 Final results of transforming stairs.

6. Open a file (Ctrl+O/Cmd+O). Access Tutorials/ch 2 and select ground "entrance.tif." Place and transform the image so that it sits at the base of the stairs, as shown in Figure 2.7.

FIGURE 2.7 Place ground entrance.tif at the base of the stairs.

7. You will use ground "entrance.tif" to create a tube-shaped structure with a circular steel door as an entrance at the base of the stairs. Apply a layer mask to sculpt the shape similar to what you see in Figure 2.8. To create a sense of depth inside the entrance, create a new layer beneath the entrance and add a circular black-filled shape. Having the black shape will remind you that this is a location that leads to another space.

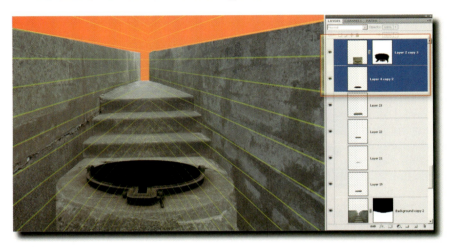

FIGURE 2.8 Create the circular entrance.

8. To match the perspective, widen the structure using your transform tools. Make sure that both the entrance and the circular, black-filled layer are selected, as shown in Figure 2.8, so that the transformation is applied to both, as shown in Figure 2.9.

FIGURE 2.9 Transform the entrance.

9. The texture here is interesting, but not interesting enough. You could use Adjustment layers to enhance the contrast and character of the wall, but you can get better results by adding texture from another image. Let's make it more dynamic. Open a file (Ctrl+O/Cmd+O). Access Tutorials/ch 2 and select "wall 01.tif." Use the Perspective Command (Edit > Transform > Perspective) to make the texture in the foreground appear to be coming toward the camera. Using a layer mask, isolate the texture to match the shape of the right wall (see Figure 2.10). You don't want to completely ignore the texture underneath so edit the mask using your Brush tool to create a blend of the two. To finish this task, change the Blend Mode to Overlay.

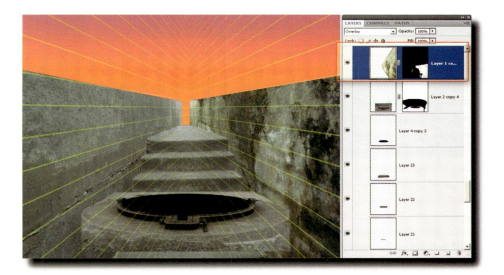

FIGURE 2.10 Isolate the texture to the right wall.

10. Let's add a little more variety. The texture from step 9 is now in the Overlay Blend Mode. Let's use it again to further add details to the wall, so duplicate this texture layer and change its Blend Mode to Normal. Use a layer mask to reveal this new texture in the foreground areas of the wall, but leave the rear section untouched (see Figure 2.11). This addition will help catch the viewer's attention in the foreground to guide the person toward the rear of scene.

11. Continue to use this texture to create a ledge along the top of the wall, similar to what you see in Figure 2.12. Don't forget to use the perspective lines as a guide to assist you in transforming the texture.

FIGURE 2.11. Isolate the texture to the front part of the wall.

FIGURE 2.12 Transform the entrance.

12. Use steps 10 through 11 to create additional texture for the wall on the left side of the composition, as shown in Figure 2.13.

FIGURE 2.13 Create the texture on the left.

TEXTURING THE LOWER ENTRANCE

Next, you will add texturing to the lower entrance in much the same way as you did for the wall. The purpose is to integrate it with the rest of the scene. You will also extend the shape so that it appears to be extending up further from the ground. Your results do not have to be the same as shown here so feel free to experiment as much as possible. Have fun with this one.

1. Turn off the perspective grid. Extend the cylindrical entrance by selecting a portion of the concrete at the bottom of the original circular entrance and copying and pasting that texture into a new layer (see Figure 2.14). Give it a layer mask and blend the two textures together.
2. Let's balance the scene so that everything has one consistent color. The color of the stairs and the entrance is too bluish so apply a Curves Adjustment layer to apply both some contrast as well as to shift the color toward yellow to match the rest of the scene. The black line in the Curves Palette represents the contrast adjustment and the lowering of the blue line represents the addition of yellow (see Figure 2.15).

FIGURE 2.14 Extend the cylindrical entrance.

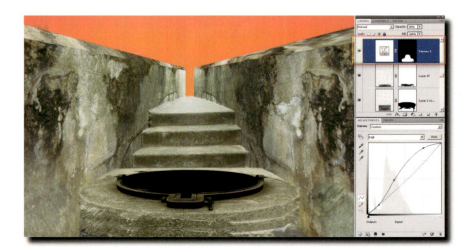

FIGURE 2.15 Use Curves to increase contrast and add yellow.

3. The circular entrance needs some separation from the rest of the scene. Apply a Curves Adjustment to make it a richer value and edit the mask to isolate the effect to the wall, similar to what you see in Figure 2.16.

4. Apply step 3 to both of the walls to add some slight contrast, as shown in Figure 2.17.

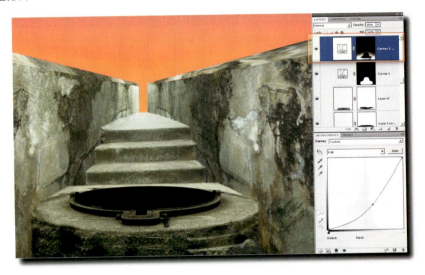

FIGURE 2.16 Use Curves to add density to the wall of the entrance.

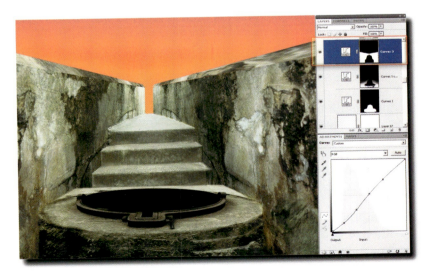

FIGURE 2.17 Use Curves to add contrast to the walls.

5. Now with everything looking pretty consistent, it will be easy to adjust the color for the entire corridor with a single adjustment. You only want to apply the effect to the corridor and not the entire scene. So apply a Color Balance Adjustment layer to give it a cooler tonality and then isolate its effect to the corridor by editing the mask (see Figure 2.18).

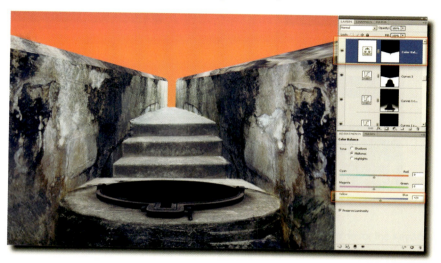

FIGURE 2.18 Apply a bluish cast to the corridor.

6. Add some more texture details to the manhole entrance by applying the same texture, but this time give it a Blend Mode of Hard Light to allow the original texture's character to be of some value (see Figure 2.19).

FIGURE 2.19 Apply additional texture to the walls of the manhole.

7. It's time to give the entrance some character. Continue to use the texture that you used for the wall for consistency's sake. Apply a mask that has the shape of the inside portion of the circular entrance and stretch the texture vertically to give the appearance that the shape is moving downward (see Figure 2.20). Duplicate it and change the Blend Mode of the second one to Overlay to enhance the contrast.

FIGURE 2.20 Use texture to create the inner walls of the circular entrance.

8. Since we are looking slightly inside the entrance, it should appear darker. So create a new layer and change its Blend Mode to Multiply. Paint along the outer edges and the top edge with black to give it a sense of roundness (see Figure 2.21). Now let's use this technique to create more depth for the hallway in the next step.

FIGURE 2.21 Paint with black to create depth.

9. Create another layer and paint with black using a soft-edged brush on the rear portion of the hallway (see Figure 2.22).

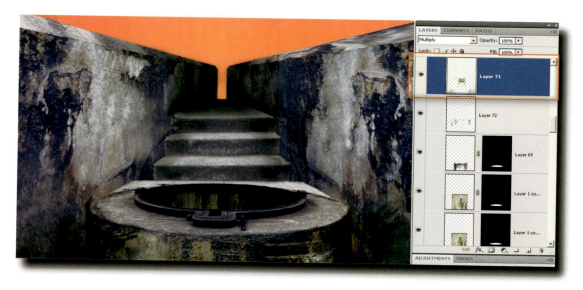

FIGURE 2.22 Darken the rear of the hallway.

10. Create a light source coming from within the manhole by painting a reddish glow inside of the entrance using a large, soft-edged paint brush (see Figure 2.23). Use a layer mask to restrict the effect to the entrance.

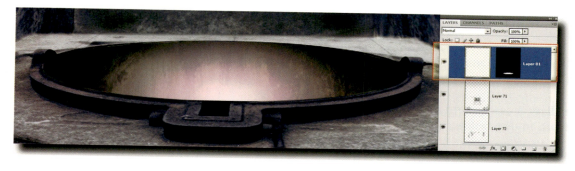

FIGURE 2.23 Add a glow emanating from within the entrance.

CREATING THE WALL LAMPS TO ILLUMINATE THE HALLWAY

We have created a scene where stairs lead up a distant hallway, which has dilapidated textures on its walls. In the foreground, we have an underground entrance that should have some sort of security hatch associated with it. We will create that in just a bit, but for now let's add some lamps that will be embedded into the wall of the hallway that will illuminate its interior. We will start by creating the lamp housing, and then we will add the light source.

1. Create a new layer and fill it with 50% gray (Edit > Fill > 50% Gray). Then add some noise (Filter > Noise > Add Noise), as shown in Figure 2.24.
2. Apply some Motion Blur to get a pattern of streaks (see Figure 2.25).

FIGURE 2.24 Create a new layer and add noise after filling with 50% gray.

FIGURE 2.25 Use Motion Blur to add some streaks.

3. Increase the contrast of the texture using Curves, as shown in Figure 2.26.
4. Use your Elliptical Marquee tools to make a ring shape. After you have the ringed selection, copy (Ctrl+C/Cmd+C) and paste (Ctrl+V/Cmd+V) your texture into a new layer. Now give it a 3D look by adding the Bevel and Emboss style, as shown in Figure 2.27. This is the beginning of your lamp housing.
5. Use your Rectangular Marquee to cut thin slices into the side of the ring, each at 45 degree locations (see Figure 2.28).

FIGURE 2.26 Apply Curves to increase contrast.

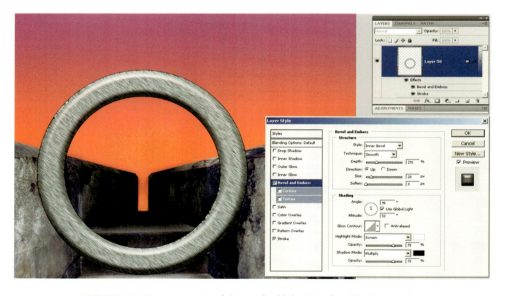

FIGURE 2.27 Create a textured ring and add the Bevel and Emboss style.

6. Using steps 4 and 5, make a thin cross on a new layer where the ends will fit into the slot locations that you had created. This will be part of the protection plate that sits on top of the light (see Figure 2.29).

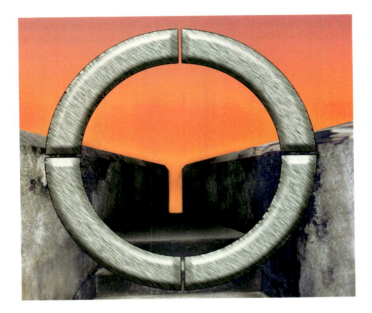

FIGURE 2.28 Cut slices out of the ring.

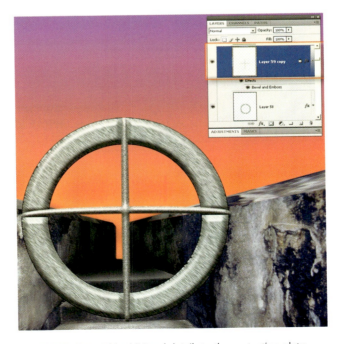

FIGURE 2.29 Add additional details to the protection plate.

7. It's time to add the light source. Start by using your Curves to darken the lamp housing plate. Then use the Elliptical Marquee tool to create a circular gradient within the diameter of the housing that starts from white and progresses to a light green. Apply the gradient to a new layer underneath the lamp housing. Place them into a new layer group titled "front." You will eventually have a row of lights, and this one will sit in the very front. Since everything is in a group, select the "front" layer group and transform it into an ellipse and place it in the foreground, as shown in Figure 2.30.

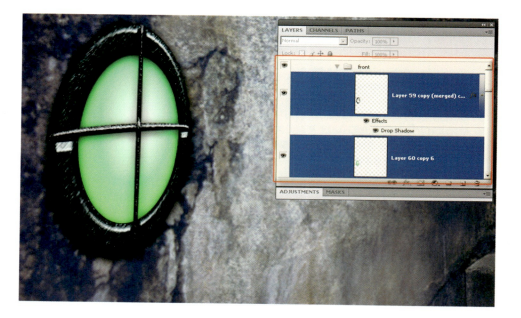

FIGURE 2.30 Add additional details to the protection plate.

8. Next, duplicate the greenish gradient that you created for the light and place it on top of the light housing. Change its Blend Mode to Hard Light. This will give the effect of glare coming from the lights, as shown in Figure 2.31.
9. Let's keep organized (as shown in Figure 2.32) and create a new layer group titled "corridor lights left." In this group, place the "front" layer group and duplicate it twice. Rename the new layer groups "middle" and "rear." Resize each one and place one on the center and the other to the rear. Resize them so that they will get smaller as they recede into the background. Use your perspective guides to help you with this task. Turn them on from time to time to facilitate the process.

FIGURE 2.31 Add glare to lights.

FIGURE 2.32 Organize layer groups.

10. Next, apply lights to the right side by duplicating the "corridor lights left" layer group and rename it to "corridor lights right." Flip the new group horizontally and place them as shown in Figure 2.33.

FIGURE 2.33 Place lights on the right side.

CREATING THE LID TO THE UNDERGROUND ENTRANCE

I have added a little more detail to the scene by adding lights. To help make the scene a little more believable, you are going to create the circular hatch that will sit against the wall to the side of the entrance.

1. Open the "ground entrance.tif" image and draw an oval selection around the lid. Copy and paste it into a new layer (see Figure 2.34).
2. The lid is too flat looking so you will need to give it some depth by creating an edge for the lid. Duplicate the lid, add noise, and give it motion blur. Use Figure 2.35 as a guide.
3. Place the texturized lid underneath the original and offset it to the left and downward a bit (see Figure 2.36).
4. Add another layer and use it to paint in details on the side of the lid. This is great for adding more texture or highlights. Experiment with this and add your own vision. Now, add another layer beneath them all and paint in a shadow (see Figure 2.37).

FIGURE 2.34 Copy and paste the lid. **FIGURE 2.35** Texturize the lid. **FIGURE 2.36** Offset the lid.

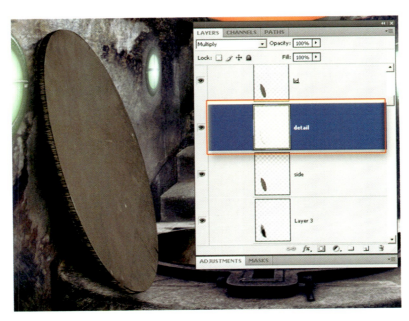

FIGURE 2.37 Create a new layer to add more detail and shadows.

5. The reddish glow coming from the entrance should spill over onto the lid. You can simulate this by adding the highlight to an additional layer that sits above the lid (see Figure 2.38).

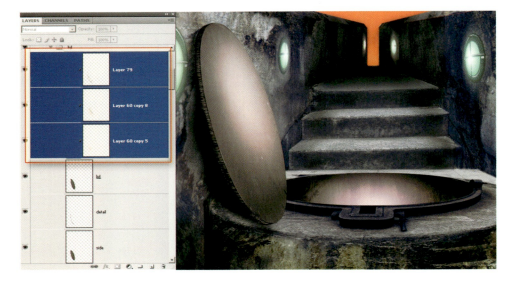

FIGURE 2.38 Add a glow reflection to the lid.

FINAL FINISHES TO THE FOREGROUND

Often as you come close to completion of one compositional element, you will notice that all it needs is one additional thing to make it work. In this case, the texture on the wall looks a bit too repetitive so you will need to create a custom brush and alter the texture's contour by using the paint brush and the Stamp tool.

1. Open "Wall 01.tif" and desaturate the image (Ctrl+Shift+U/Cmd+Shift+U). Since Photoshop only recognizes black-and-white imagery for creating brushes, you will use its tonal values to create the initial brush (see Figure 2.39).
2. You will create a brush from the texture that you are going to enhance (see Figure 2.40). Use your Elliptical selection to select an area that will give you some randomness in the brush. Save this as a brush (Edit > Define Brush Preset).
3. Then edit the edges so that you do not have a circular shape. Figures 2.41 and 2.42 display the properties for the brush that you can use to edit the sides of the circular texture. When done, save this as a brush as well.

FIGURE 2.39 Desaturate the texture.

FIGURE 2.40 Select a location and define the brush.

FIGURE 2.41 View of initial brush.

FIGURE 2.42 Variable Brush properties chosen from the Brush Palette.

4. Use the Eraser tool to knock out the smooth edge to create one that is ragged by using the brush that you created in step 3. When you are done editing the edges, select the shape and define it as a brush as well, and you should have something similar to Figure 2.43. Next, apply the Brush properties shown in Figure 2.44. After your properties are set, save this brush and give it a name of your choice.

FIGURE 2.43 Edit the initial brush.

 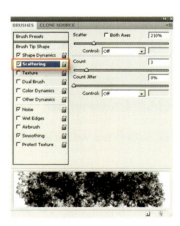 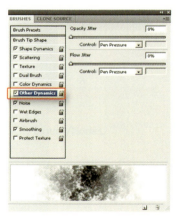

FIGURE 2.44 Variable Brush properties for the edited brush.

5. Use the Stamp tool with the new brush created in step 4 and clone details from other areas to get rid of the repetitiveness from using similar textures for the wall. Clone the textures onto a new layer and make sure that All Layers is chosen on the Options bar under the Sample submenu (see Figure 2.45).

6. Switch the Blend Mode for the brush to Multiply (see Figure 2.46).

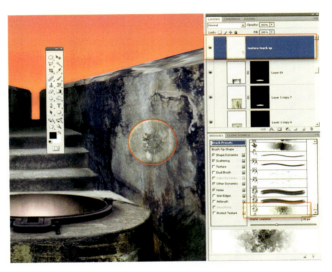

FIGURE 2.45 Clone textures.

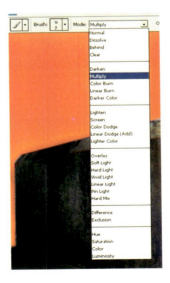

FIGURE 2.46 Switch to Multiply for the brush.

7. With the brush in Multiply Mode, it will clone textures so they have a much deeper tonality, as shown in Figure 2.47.

8. Create a new brush based on custom settings shown in Figure 2.48. This is a series of dots that will serve as dents to the concrete. Don't forget to save your brush.

FIGURE 2.47 Clone the textures with the brush in Multiply Blend Mode.

FIGURE 2.48 Create a new brush made up of dots.

9. Apply the properties shown in Figure 2.49 to the new brush in the Brush Palette similar to what you did in step 3.
10. Next, paint using black to apply speckles throughout the concrete, as shown in Figure 2.50.

FIGURE 2.49 Add variable properties to the new brush.

FIGURE 2.50 Apply speckles to the concrete.

11. Create a new layer and make sure that its Blend Mode is set to Overlay. With white as the selected foreground color, paint a thin strip along the upper-right wall where the wall and the ledge meet. This will create a corner (see Figure 2.51). Use a slightly hard-edged brush for this.
12. Underneath the layers for the lid, add a reddish glow that will simulate glows that are coming from the entrance of the manhole (see Figure 2.52). Change the Layer Blend Modes to Hard Light. Now let's go forward to add the cityscape in the background.

FIGURE 2.51 Create a wall corner.

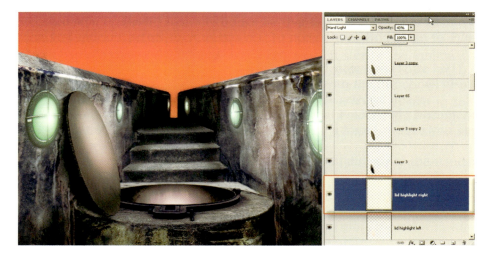

FIGURE 2.52 Create reddish highlights.

CREATING THE OVERPASS

The hallway is going to rest beneath a freeway overpass. Its freeway system extends toward the city to make a connection with it. With the focus on the underground hatch and entrance, you'll see a city in the rear of the composition with a background that is lit by a sunset. You will add the elements of the city and overpass next.

1. Open a file (Ctrl+O/Cmd+O). Access Tutorials/ch 2 and select "city.tif" and place it into a layer group called "city merged." Place "layer merged" underneath the "wall" layer group. Use Figure 2.53 to help you.
2. The basic sunset gradient starts with red and gradates to blue. This will affect the atmospheric haze around the city, so in order to simulate this effect, apply a Gradient Overlay to the city using the Layer Style, as shown in Figure 2.54.

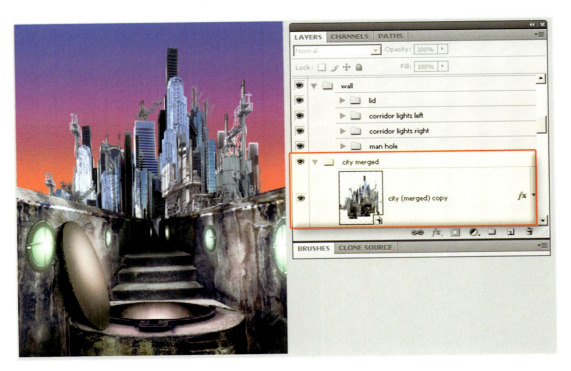

FIGURE 2.53 Add the city to the scene.

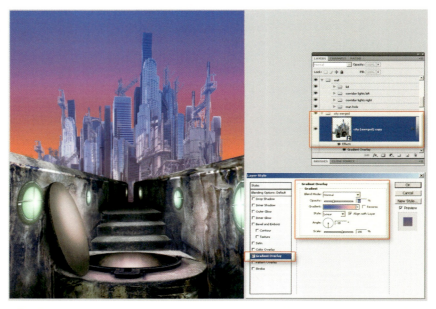

FIGURE 2.54 Add gradient to the city to reflect the sunset lighting in the background.

3. Now, add your lights and lens flare to liven up the city, as shown in Figure 2.55.

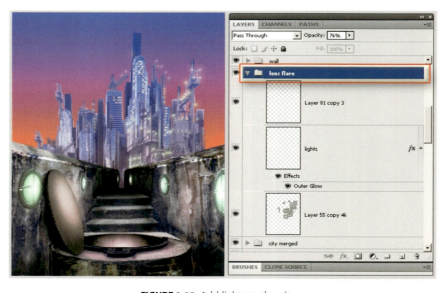

FIGURE 2.55 Add lights to the city.

4. Open a file (Ctrl+O/Cmd+O). Access Tutorials/ch 2 and select "overpass.tif" (see Figure 2.56).
5. Place the overpass image on top of the "city" layer group but below the "wall" group. Use Warp (Edit > Transform > Warp) to cause it to curve into the scene a bit, which helps to offset the linear lines in the scene (see Figure 2.57).

FIGURE 2.56 Open "overpass.tif."

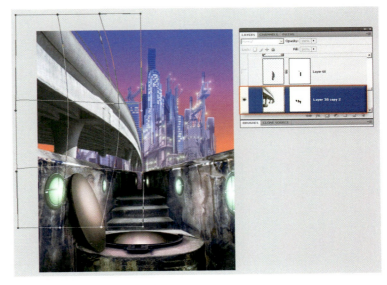

FIGURE 2.57 Warp the overpass.

6. The Warp caused the bridge supports to distort greatly; you can remove them by using a layer mask. Copy and paste the supports from the original file onto a new layer above the bridge. Elongate them to extend further toward the ground. Use a layer mask to integrate them with the bridge, as shown in Figure 2.58.
7. Duplicate the overpass, flip it horizontally, and compose it the way that it is shown in Figure 2.59.
8. Create additional supports to the rear and the foreground location of the bridge that does not display directional lighting from the photograph. This will assist you in establishing your own lighting effects without being at the mercy of the photo. Just select an untainted section of the bridge support and use Free Transform and Warp to shape it to the existing leg, similar to what you see in Figures 2.60 and 2.61.

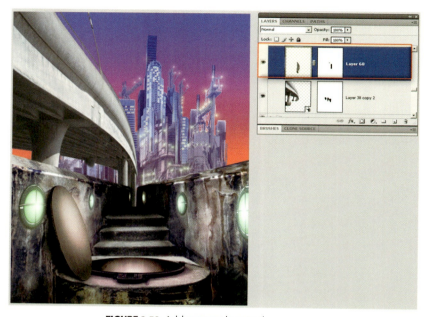

FIGURE 2.58 Add support legs to the overpass.

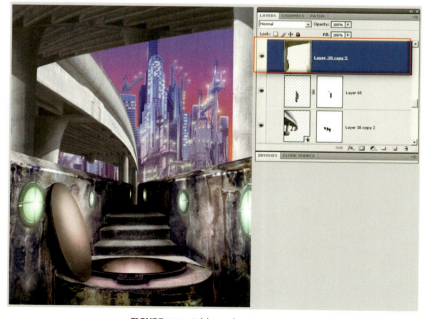

FIGURE 2.59 Add another overpass.

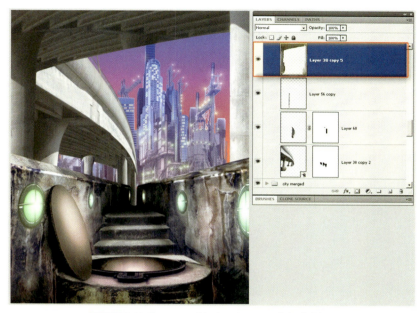

FIGURE 2.60 Support added to the rear of the bridge.

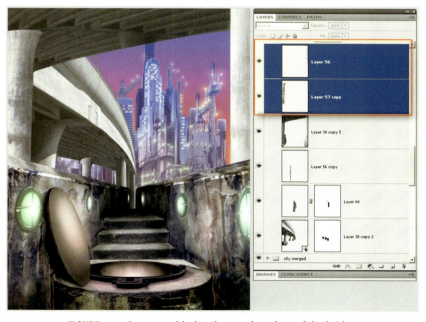

FIGURE 2.61 Support added to the two front legs of the bridge.

9. Create a new layer with a Blend Mode of Multiply and add shading to the legs using a soft-edged paint brush (see Figure 2.62).

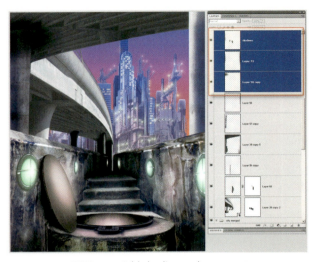

FIGURE 2.62 Add shading to the supports.

10. Add a Color Balance Adjustment layer that will give the overpass a bluish tint. Anything in shadows will take on a bluish color, so use the mask to apply this effect to just the overpass (see Figure 2.63).

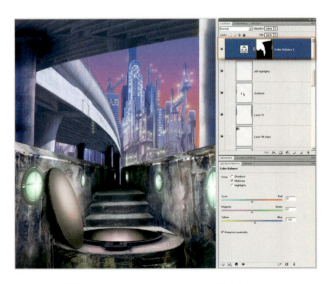

FIGURE 2.63 Give the overpass a bluish hue.

11. It's time to add some haze, and it should reflect the color of the sunset (see Figure 2.64). Use a soft-edge brush and lightly apply a haze to the lower section of the city. Change the Layer Blend Mode to Hard Light.

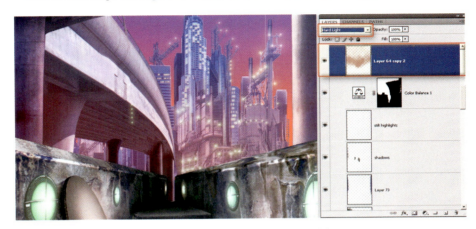

FIGURE 2.64 Give the overpass a reddish hue.

12. Add another layer, and this time paint with white with the Blend Mode set at Normal. Vary the Brush properties so that Scatter and Shape Dynamics are added. This will help get a more fog-like effect (see Figure 2.65). In addition, add some contrast to both the overpass and the city using the Curves Adjustment layer, which will add depth to the scene.

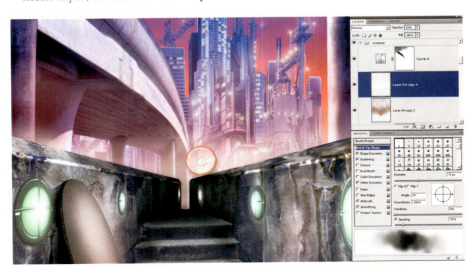

FIGURE 2.65 Add more haze.

13. Now, add some clouds (Tutorials/ch2/clouds 0019.tif) to liven up the sky. Give it a Layer Blend Mode of Screen and place it above the red to blue gradient in the "sky" layer group (see Figure 2.66).

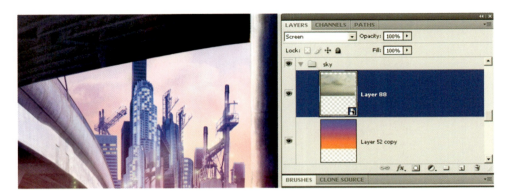

FIGURE 2.66 Add clouds to the sky.

14. After adding the additional color effects in the sky and city regions, the hallway gets a little lost. You will often not notice this until the completion of the image when you will see that some areas need a little more color or contrast boost to work. Boost the hallway's color by adding new layers to paint a greenish glow on portions that will receive the greenish light glow (see Figure 2.67).

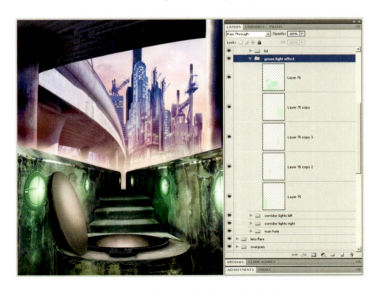

FIGURE 2.67 Add greenish glow to the hallway.

15. To further balance things out, add a red to blue gradient to the overpass and city areas using your gradient tool (see Figure 2.68). Change the layer's Opacity to 20% and the Blend Mode to Overlay.

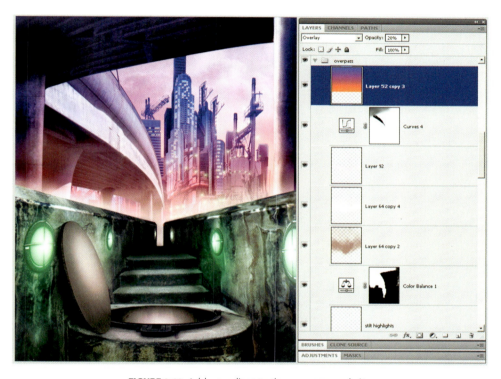

FIGURE 2.68 Add a gradient to the overpass and city.

16. Finally, add a slight shallow depth of field. Make sure that the uppermost layer is selected. This should be the "wall" layer group. On your keyboard, press Ctrl+Shift+Alt+E/Cmd+Shift+Opt+E. This will merge all visible layers into a new layer. Make this layer a Smart Object and apply a Gaussian Blur (see Figure 2.69).

17. The Gaussian Blur will be a Smart Filter, which will have a mask attached to it. Edit the mask so that the blur only takes place on the overpass, city, and a small portion of the rear wall. The haze and the Gaussian Blur will help to establish the shallow focal point (see Figure 2.70).

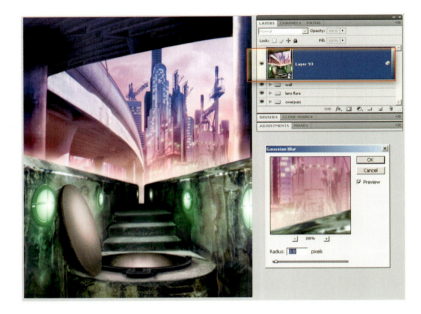

FIGURE 2.69 Create a new merged layer and apply a Smart Filter.

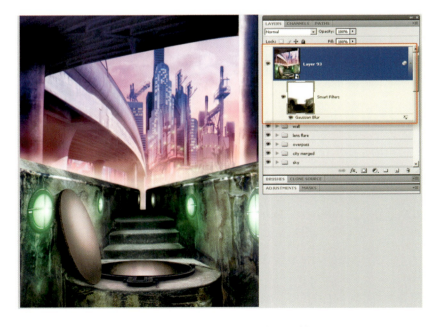

FIGURE 2.70 Apply a shallow depth of field.

Figure 2.71 shows the final results.

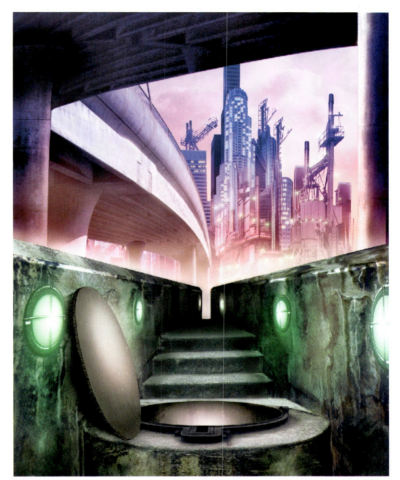

FIGURE 2.71 Final view of the cityscape.

WHAT YOU HAVE LEARNED

- How not to be submissive to the photos and instead create according to your own perspective.
- How to use brushes created from photographic textures.
- How to create foreground compositional objects to give the scene greater depth.
- How to create ambient light sources.
- How to create depth using atmospheric haze.

CREATING 3D LOGOS WITH REPOUSSÉ

GET TO KNOW REPOUSSÉ

Learning 3D software applications has always been a time consuming and intimidating process for most 2D designers, who don't necessarily want to consider using it as part of their own workflow. However, these designers are finding an increased need for visually engaging graphics and for those same graphics to be interactive, such as those on the Web where users might be engaged with graphics in a similar manner to that of a video game. For example, 3D is an ideal solution for online 3D Web galleries, where the user can navigate through a virtual environment with the aid of the mouse. Adobe has always understood this, and has diligently stepped up to the plate to provide a 3D solution for such designers. Their answer is Repoussé, which is only part of CS5 Extended. Repoussé represents the beginning of a custom 3D program in Photoshop.

Speeding Up Navigational Functionality in CS5

You are going to discover some improved features with the 3D engine in CS5. Repoussé is the first feature that will allow you to custom create 3D objects natively in Photoshop. Keep in mind that a video card with OpenGL and 3D capabilities is crucial. CS5 utilizes the Open GL capabilities of your graphics card more than any of its predecessors. As you use the standard magnifying zoom (Z), you will notice that the performance of navigating the 3D object will slow down. Also, if you zoom out to make the 3D object smaller in your interface, the performance on your graphics card and processor is lessened.

CREATING A 3D LOGO IN REPOUSSÉ

In this chapter, we are going to learn how to use text to create a 3D logo, but we are going to add a little pizzazz to it. What you will learn in this chapter will serve as the basis for using Repoussé to create any of your text- or shape-based logos. Let's get started.

1. Create a 7.5 × 9-inch file with a resolution of 150ppi. Use your text tool (T) to type the words "3D Rules" and resize your text (Ctrl+T/Cmd+T) so that it spans three-quarters of the length of the document.

In this example, I've used the font Agency FB, but feel free to use a font of your own choice. I have found that using a bold body font will give you more flexibility with creating bevels on the face of your text. Fill your background layer with a bluish hue to use as contrast for your text. For this exercise, choose a font that is blocky and bold. Also, keep in mind that in general the minimum

resolution for print is 300ppi at the size that you intend to output. But since not everyone will have higher performing systems, like quadcore processors, it is a good idea to keep the resolution low for learning purposes. When you are producing for a client, then you may consider bumping up the resolution if the job calls for it. If you are creating for the Web, however, 150ppi is more than enough information since the Web relies on 72ppi resolution. Start with a new document, as shown in Figure 3.1.

2. Let's alter the text into a 3D object. Go to 3D > Repoussé to open it (see Figure 3.2).

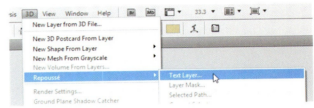

FIGURE 3.1 Create a new document and text.

FIGURE 3.2 Activate Repoussé.

3. Since your text is vector in nature, you will get a notification that Photoshop needs to rasterize the text. Just click OK. In addition, check "Don't show me again." See Figure 3.3.

FIGURE 3.3 Acknowledge the notification.

4. Immediately, you will see the Repoussé interface where a basic extrusion has been created (see Figure 3.4).
5. On the top left, you will see presets for various surface bevels (see Figure 3.5). Click through each of them to get familiar as to what each will do. When you are done experimenting, click on the surface that removes the bevels to give you a flat surface (the uppermost left icon). We are not going to use these presets, but instead create our own. But it's good to be aware that they are there.
6. On the center right, you will see the Bevel section. Apply a bevel to the face of the text. You can use the settings shown in Figure 3.6 or experiment with one of your own.

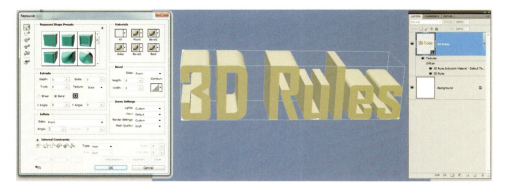

FIGURE 3.4 Repoussé creates a basic extruded text.

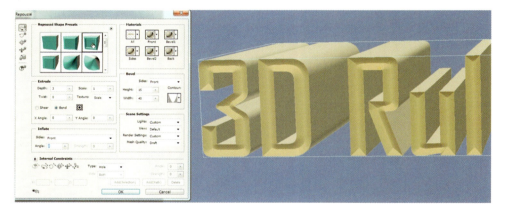

FIGURE 3.5 Experiment with surface bevel presets.

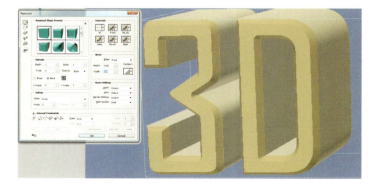

FIGURE 3.6 Apply bevel to text.

7. Not only can you apply bevel, but you can change its contour as well. Access the contour submenu, which is located to the right side of the bevel dimensions and select the arched preset for now, as shown in Figure 3.7.

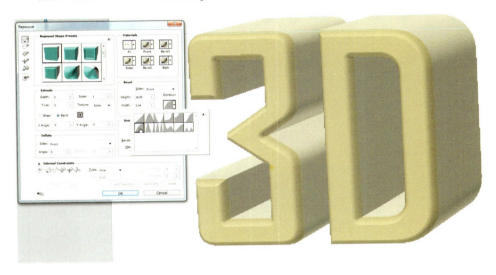

FIGURE 3.7 Apply a curved surface to the contour of the bevel.

8. Next, let's apply a custom bevel (see Figure 3.8). Just click on the Contour icon, and you will get a Curves dialog box. By placing points and dragging them to different positions, you can create your own bevel. Play with this to get something different from a standard curved bevel.

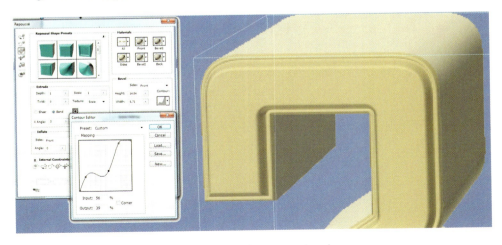

FIGURE 3.8 Apply a custom bevel.

9. Above the bevel, you will see the Materials section, which allows you to apply a texture to the different surfaces of your text. Apply a different surface for the Front, Sides, and Bevel so that you can see how Repoussé organized its surfaces (see Figure 3.9).

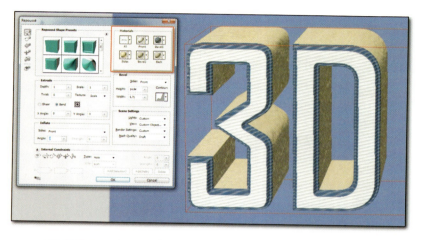

FIGURE 3.9 Apply textures to the surfaces or the Front, Sides, and Bevel.

10. Repoussé also gives you control over the length extrusion located below the Bevel presets. Here you can apply the following settings:

- **Depth:** Distance of extrusion (Figure 3.10)

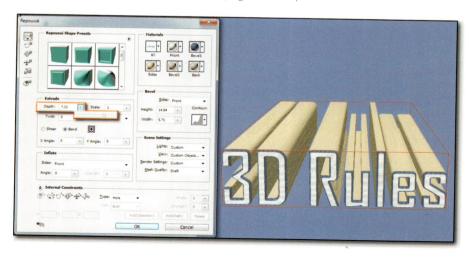

FIGURE 3.10 Extrude length.

- **Twist:** Rotate extrusion on Z axis (Figure 3.11)

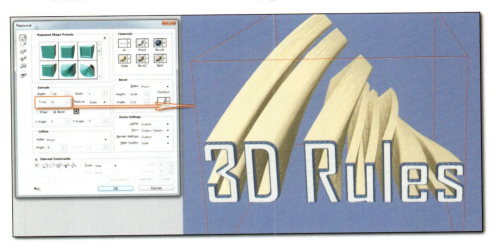

FIGURE 3.11 Rotate extrusion.

- **Bend:** Bend extrusion on X or Y axis (Figure 3.12)

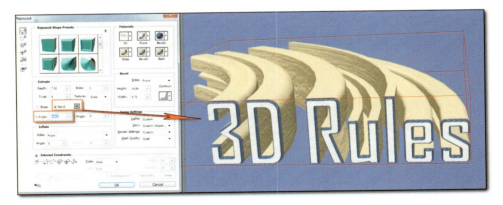

FIGURE 3.12 Bend extrusion.

- **Size:** Enlarging the extrusion (Figure 3.13)

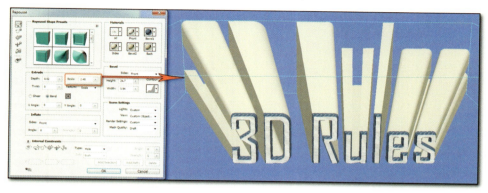

FIGURE 3.13 Enlarging the extrusion.

- **Shear:** Offset extrusion to the right or left (Figure 3.14)

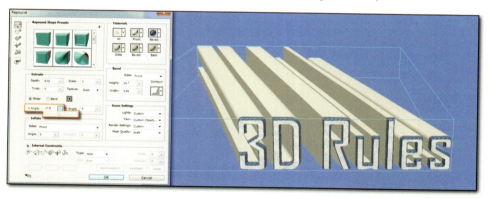

FIGURE 3.14 Offset extrusion.

11. You can change the shape of the surface with the Inflate section. Figures 3.15 and 3.16 show an example of the Angle and Strength applied in combination. Experiment with these and get a surface to your liking.
12. Finally, you have presets for lighting styles. Click through them all to get familiar with the effects of each one. These can be used as starting points for lighting your 3D object. Figures 3.17 to 3.21 show a few of the options.

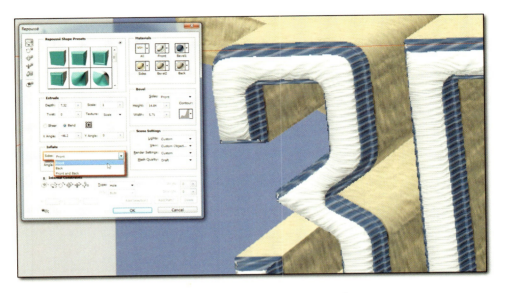

FIGURE 3.15 Angle applied to the surface inflation.

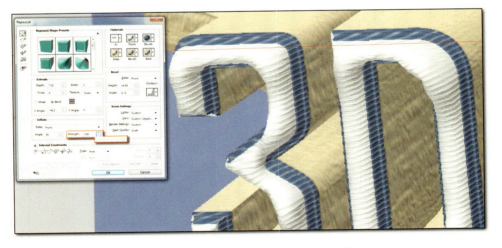

FIGURE 3.16 Strength applied to the surface inflation.

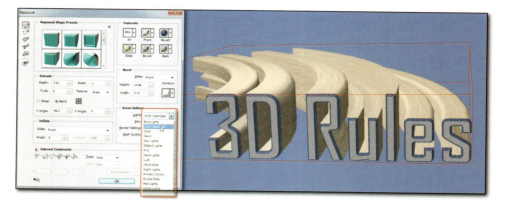

FIGURE 3.17 CAD optimized.

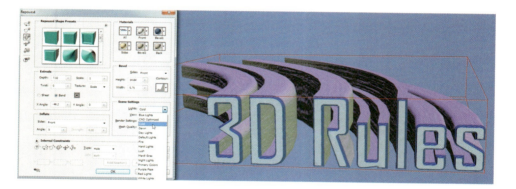

FIGURE 3.18 Cold.

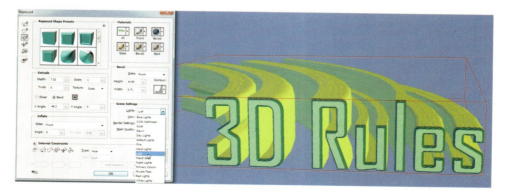

FIGURE 3.19 Lush.

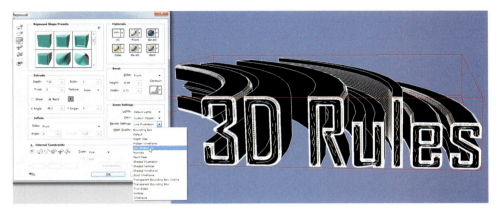

FIGURE 3.20 Line illustration.

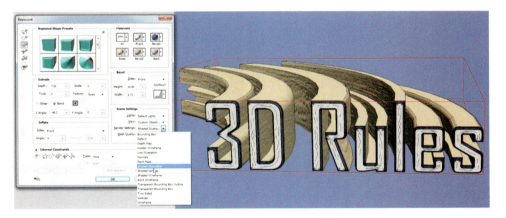

FIGURE 3.21 Shaded illustration.

13. For now, select Default because we will customize our lights and click OK.

CREATE THE BASE FOR THE TEXT LOGO

The goal is to put the 3D text on top of a watery platform that will reflect the shape of the text in its surface. In this step, we are going to use Repoussé to create the base platform from a selection.

The 3D environment is primarily vector-based. So to create 3D objects, Adobe designed Repoussé to start with a vector form, such as text, vector shapes, vector masks, standard masks, and selections.

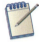

Use Selections to Create 3D Shapes in Repoussé

If you try to apply Repoussé to a painted shape you will not have the ability to do so because it is in raster (pixel) form. You can, however, create a selection of your painted shape by clicking on the layer while holding down the Ctrl/Cmd key. Then Repoussé will be available to create a 3D shape from the selection.

1. Duplicate the background layer and press Ctrl+A/Cmd+A to select the entire document. Then activate Repoussé (3D > Repoussé), as shown in Figure 3.22. Repoussé creates an extruded object based on the selection. We will use this simple shape for the watery base.
2. Let's keep this simple and apply one of the presets. Choose one of the yellow textured options and click OK (see Figure 3.23).
3. Use your 3D navigational tools and position the text over the new base object (see Figure 3.24).

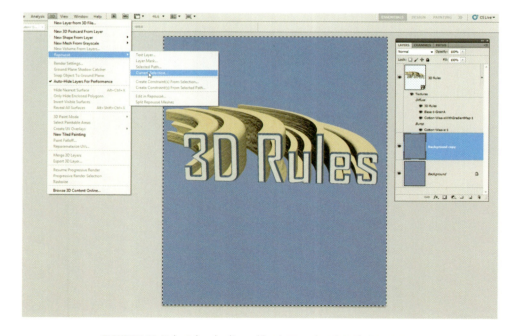

FIGURE 3.22 Select the duplicated background and apply Repoussé.

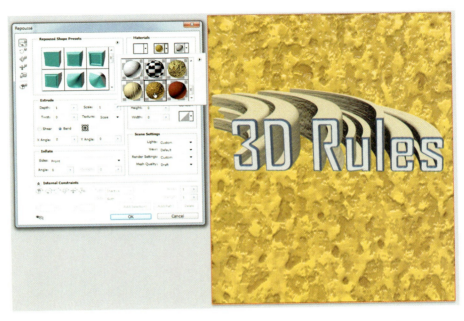

FIGURE 3.23 Apply Repoussé to the selection and apply a preset to its surface.

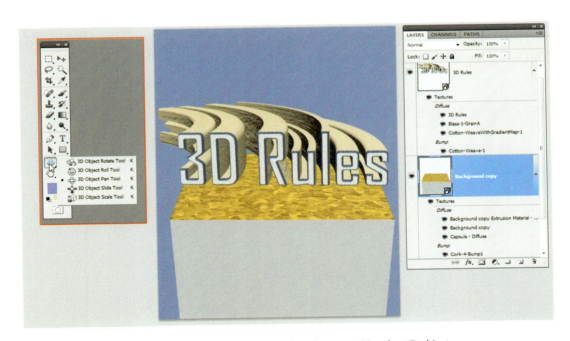

FIGURE 3.24 Use the 3D navigational tools to reposition the 3D objects.

4. The two 3D objects are on their own individual layers. What we need is for the two objects to interact with one another in terms of how they are lit with 3D lighting and how the text is reflected in the watery base. So let's merge the two objects into a single 3D scene, as shown in Figure 3.25. Select both 3D objects and merge them together (3D > Merge 3D Layers).

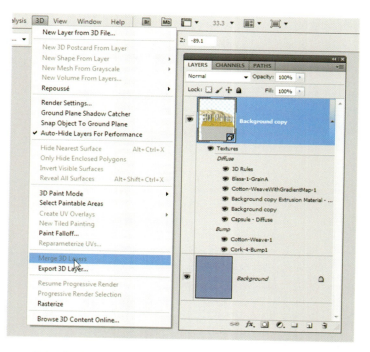

FIGURE 3.25 Merge the two 3D objects into a single 3D scene.

If you access the 3D Mesh panel (Window > 3D), you can select Show All by clicking the 3D visuals icon (see Figure 3.26A). Immediately, you can see some great improvements in the 3D engine as you zoom out past the document size. You will now have the ability to see the ground plane, 3D lights, and the bounding box around your 3D object beyond the borders of the document (see Figure 3.26B). This is a fantastic improvement for 3D navigational functionality. Unlike the previous version of Photoshop, you aren't restricted to the size of the document in order to work effectively with 3D content. Notice that in the 3D Mesh panel, you will see the two objects displayed with their surface properties (Figure 3.26C). This is where you will select each one to navigate them within your scene. Also, on the bottom left side of the 3D Mesh panel are the navigational tools that you can use to position your 3D objects.

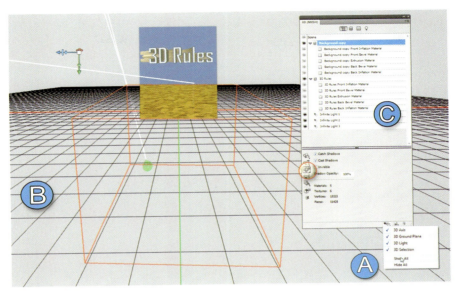

FIGURE 3.26 New 3D functionality for ease of navigation.

You can see another new feature in CS5 when you click on a surface or material in the 3D Materials panel, as that area will be highlighted with a color stroke around the selected surface on the 3D model. You can designate the color coordination in the 3D Preferences inside of the Preferences panel (Ctrl+K/Cmd+K), as shown in Figure 3.27. In this example, the designated color for the material is red, and the color of the 3D lights is green.

FIGURE 3.27 Set 3D preferences.

5. Use the navigational tools in the 3D Mesh panel to position the text logo over its base (see Figure 3.28).

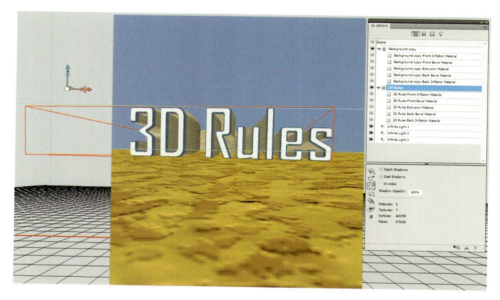

FIGURE 3.28 Position the text logo.

CREATE A BACKGROUND FOR YOUR SCENE

Let's add a background to our scene. We are going to use this background in a couple of different ways. One will be to create the final visual element needed to pull the entire image together, and the other will be to use it as an environment map to reflect in the water base below the text. You are going to have fun.

1. New to CS5 is Mini Bridge. The idea is that it will take up fewer resources than Bridge and be more like the old Browse in CS. So open Mini Bridge (File > Browse in Mini Bridge) and navigate to Tutorials/ch 3 on the DVD to select "sunset 1 thru 3." Go to the submenu to activate Merge to HDR, as shown in Figure 3.29.

You will now see the three images located on the bottom filmstrip. Notice that you have a greater amount of control sliders at your disposal than in the previous version of Photoshop. By default, you'll get a flatter looking image. Because Merge to HDR's primary purpose is to extend tonal range, it naturally gives you a result where the shadow, midtone, and highlight information has lots of visual details (see Figure 3.30). As a consequence, your image will look flat.

FIGURE 3.29 Open Mini Bridge and select images to Merge to HDR.

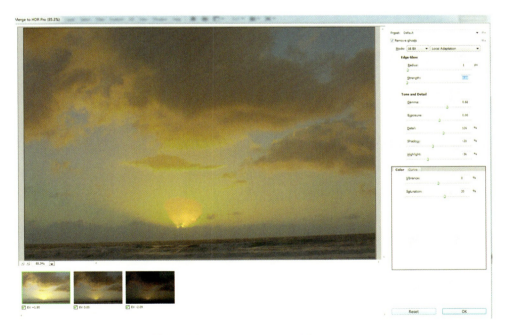

FIGURE 3.30 View of the new HDR interface.

Figure 3.31 shows various slider positions that will give you more contrast to the image while maintaining detail throughout. Play with these to get the effect that you like best.

As a brief introduction, remember these descriptions:

- Radius affects the range of pixels that are being affected.
- Strength affects the intensity highlights.
- Gamma affects the luminance of midtone values.
- Exposure affects the brightness of all three tonal values of shadows, midtones, and highlights equally.
- Detail creates contrast and sharpness simultaneously.
- Finally, Shadows and Highlights are self-explanatory in that they allow you to increase or decrease the shadow or highlight intensity.

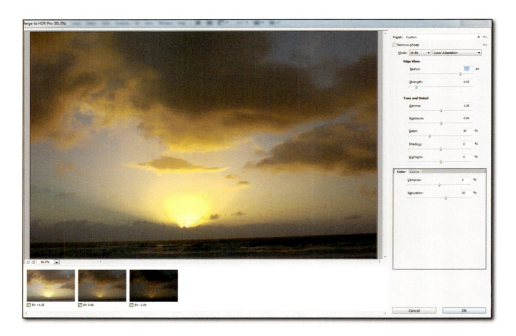

FIGURE 3.31 Sliders enable you to have more contrast while maintaining details.

2. Now play with the Strength slider and notice how the highlighted portions of the image show more detail or intensify the brighter portions of the sunset (see Figure 3.32).
3. Play with Gamma to see how the middle range luminance is affected overall. Also, play with Exposure to see how you can use it in combination with Gamma for more midtone control. Try out the Details slider to get some additional sharpness, as shown in Figures 3.33 and 3.34.

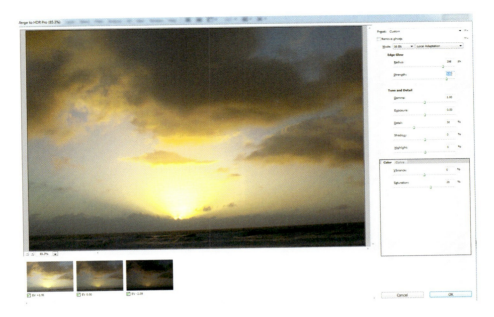

FIGURE 3.32 Play with the Strength slider to affect the highlights.

FIGURE 3.33 Play with Gamma and Exposure.

FIGURE 3.34 Experiment with Gamma and Exposure with Details added.

4. Next, play with the Shadow and Highlight slider to get the low and high values the way that you like them (see Figure 3.35).

FIGURE 3.35 Experiment with Shadow and Highlight.

5. Vibrance is a good slider to use because it will saturate or desaturate the colors in the midtonal range of your image. Use Figure 3.36 as a guide.

FIGURE 3.36 Use Vibrance to Saturate or desaturate your image.

6. As a final step, access the Curves to apply any additional changes that you feel are needed. Using sliders can get you close to what you may desire, but Curves is even more accurate. Now save the image as an 8-bit TIFF file and use this to place behind the 3D objects, as shown in Figure 3.37.

FIGURE 3.37 Apply Curves to image and save it as 8 bit.

TEXTURE AND RENDER THE FINAL IMAGE

Now we will go back to the 3D text and base to modify their surfaces and render the reflections and water details.

1. Select the 3D Rules surface in the 3D Materials panel titled "3D Rules Front Bevel Material." On the bottom of the panel, you will see the various surface attributes. Click on the texture preset for the Diffuse color and select the yellowish texture (see Figure 3.38).

FIGURE 3.38 Apply a preset to the surface of the text.

This is a good time to apply the new background to the surface of the watery platform, so under Background Copy in the 3D Materials panel, select the surface titled Background Copy Front Inflation Material. On the bottom of the 3D Materials panel, you will see a menu titled Environment. Select it and load in the "sunset.tif" file that you created using the Merge HDR. This will allow the sky to reflect in the watery surface when it becomes time to render.

2. Let's edit the surface of this texture. Underneath the 3D layer, you will see the various texture surfaces for your objects. Double-click on the one titled OrangePeel-Diffuse, as you see in Figure 3.39.

FIGURE 3.39 Access OrangePeel-Diffuse texture layer.

3. You will now see the layer used to create the color for the surface. The color is controlled by the Curves Adjustment layer so bring down its opacity to 23% (see Figure 3.40). The surface is now less saturated. Click Ctrl+S/Cmd+S to save the new results to the 3D surface.

FIGURE 3.40 Alter the 3D text diffuse surface.

4. Stretch the text upward so that it takes on a more monolithic look. To do this, select the 3D Scale tool and while holding the Alt/Opt key, click and drag to stretch the text upward, as shown in Figure 3.41.

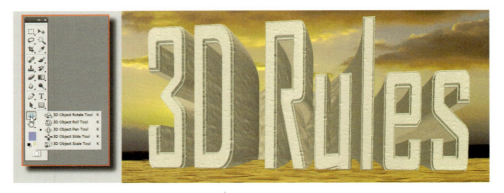

FIGURE 3.41 Resize the text upward.

5. Select the middle light in the 3D panel and use the 3D Lights navigation tools to position it to illuminate the text from behind the scene. Now that the light source is behind the text, this will create the shadow that will fall toward the viewer. Make sure that the Shadow Softness is set to 0% to decrease render times (see Figure 3.42).

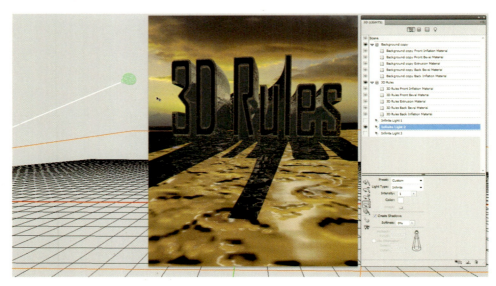

FIGURE 3.42 Rotate the Infinite Light 2 to illuminate from behind the scene.

6. Now access the 3D scene panel and select the Scene folder. Next select Ray Traced Draft from the Quality menu to get a quick render of your scene, as shown in Figure 3.43.

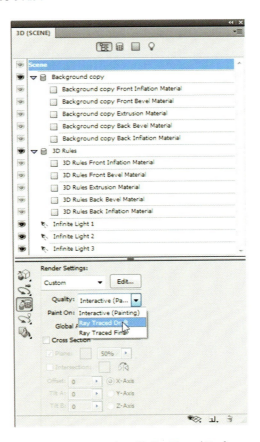

FIGURE 3.43 Render with Ray Traced Draft.

7. Now, add another light to the background and give it an orange light source. Do a quick render to see the results, as shown in Figure 3.44.

8. Now, use the third light to skim the surface across the face of the text to accentuate the texture on the face of the text. Change its properties so that it will be a Spot Light where you can change the angle of projection. Use Figure 3.45 as an example.

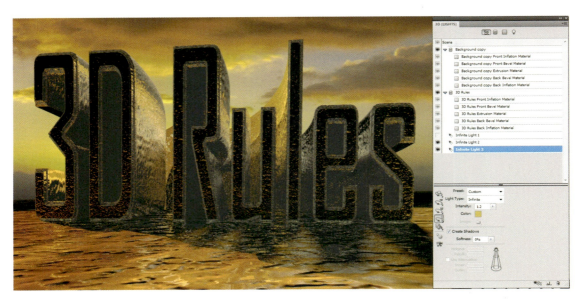

FIGURE 3.44 View of the rendered scene with second light added.

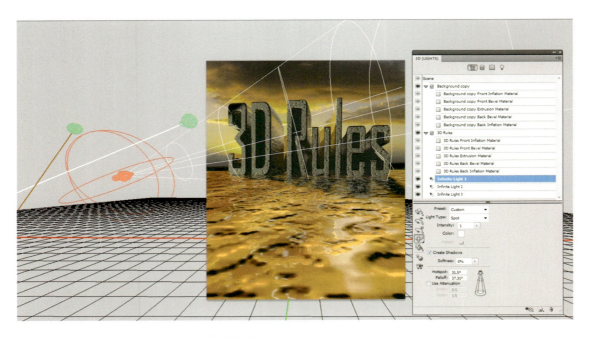

FIGURE 3.45 Add a Spot Light to the text.

9. Next, let's simulate the water on the surface of the platform. Double-click on the Background copy surface texture on the layers panel and fill the layer with a bluish color to make it look more like water. Now in the 3D Scene Panel (Window > 3D), select the Reflection surface (Background copy front inflation material) and set it to 70%. Set the Shine to 77% to make the specular reflections more prominent and set the Gloss to 30% to get a glossier feel.

Again, I can't say enough about experimenting with these settings. You should see something similar to Figure 3.46 when you are finished. Notice that you can see the background image that we created in Figure 3.37 in the reflection. Now render the entire scene, but this time, select Ray Traced Final under the Quality setting. Also, set the Shadows Softness to 20% to get a softened edge. This will increase render times, but the results are more realistic. Depending on your system, it may take a while to render so give it 15 minutes or longer to render the scene. You will see a blue grid traveling across your 3D objects, which shows you where the program is concentrating on rendering. At first, you will see a noisy render but let it keep going without disturbing it, and the render will become more photo-realistic.

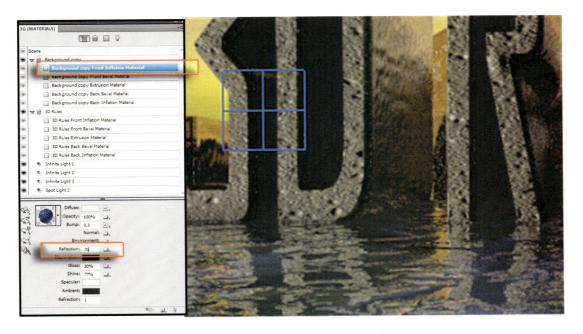

FIGURE 3.46 Apply render with Ray Traced Final under the Quality setting.

ADD THE FINISHING DETAILS

Now we can add some finishing touches to complete the scene. We will add some additional lighting on the surface of the text to help it stand out more prominently. We will use Adjustment layers to do this.

1. Add a Curve Adjustment layer that will increase the contrast of the entire scene. Duplicate it and fill its layer mask with black to block out the effects. Use your paint brush to paint with white on the mask to illuminate only the face of the text. Next, duplicate the Curves Adjustment layer again and fill it with a gradient (G) where the water is affected and the sky and text is not affected. All three adjustments are shown in Figure 3.47.

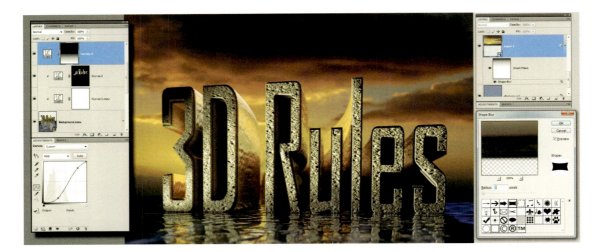

FIGURE 3.47 Apply various Curve adjustments to the scene.

2. Finally, create a new layer above the Adjustment layers and use your paint brush to paint in some haze so that a fog effect appears to lie near the horizon in front of the text (see Figure 3.48). Use a color that closely resembles the color of the sunset background.

In the next chapter, we will explore the use of IBL lighting for 3D.

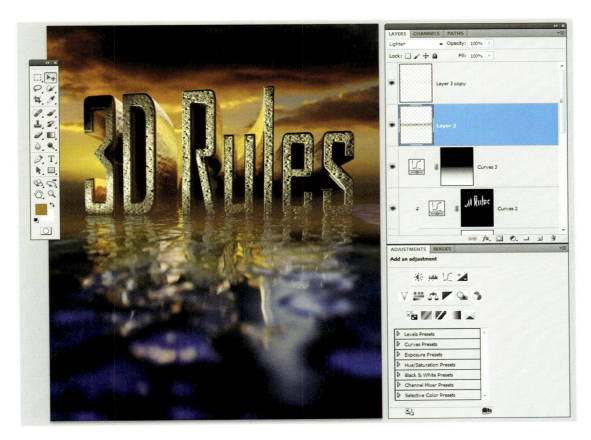

FIGURE 3.48 Surface haze applied to the scene.

WHAT YOU HAVE LEARNED

- Repoussé needs a vector object to create 3D shapes.
- Repoussé is ideal for 3D logos.
- You can set color schemes to 3D objects in the preference.
- You can twist and bend extruded objects in Repoussé.
- Merge to HDR has new and improved tools to manage tone mapping.
- Images can be used as environment maps to reflect into reflective surfaces.

LIGHTING AND IMAGE BASED LIGHTING (IBL)

IN THIS CHAPTER

- Export your 3D object for CS5
- Learn a practical application of Refine Edge
- Import your 3D object for CS5
- How to use IBL lights to integrate a 3D object into a scene
- How to use standard lights in conjunction with Image Based Lights

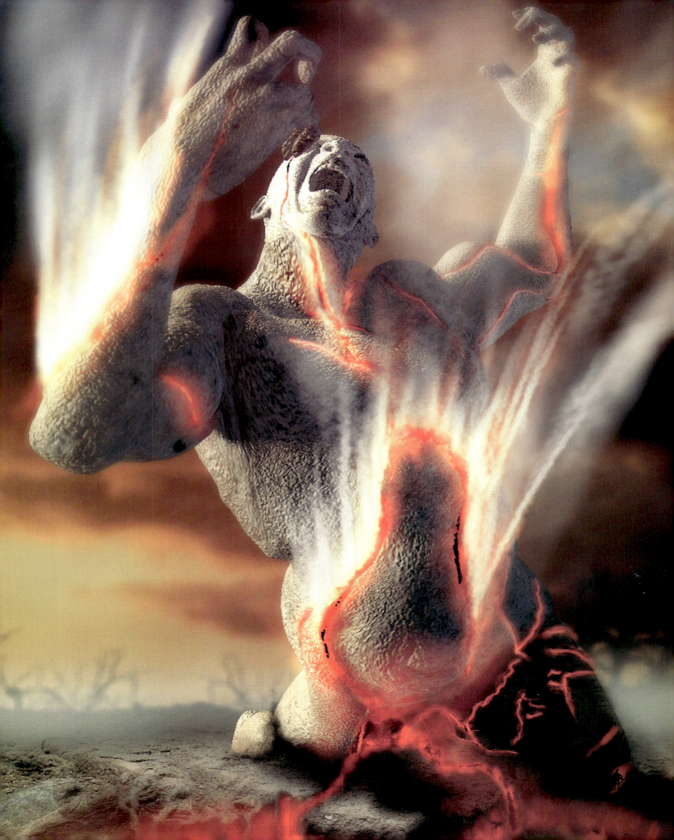

A Quick Look at Exporting Models

IBL (Image Based Lighting) is defined simply as lighting your 3D objects using the luminance and hues of a digital image. We are going to use IBL lighting alongside standard 3D lights as part of a technique for illuminating an object to match the lighting of the scene that we create.

We will keep this scene simple and create a basic backdrop to integrate the Poser 3D model. Why Poser? Because although most will not admit it, it is a popular program and fun and easy to use, which makes it ideal for designers who have little experience with 3D to integrate it into their workflow. In addition, it has an exporter just for Photoshop called *Export CS3 OBJ*. If you are using Poser, and you do not have the Export CS3 OBJ plug-in, then go to www.chromeallusion.com/downloads.html and click on the Poser Photoshop Content Exporter for Windows or Mac.

Make sure that you have downloaded the example files from my Web site (www.chromeallusion.com/downloads.html) or the DVD included with this book and onto your desktop, because you will be using them.

In this example, we'll use Poser's Export CS3 OBJ to alter the Poser file into a format that CS5 understands. In the example, it says CS3 because that was the version of Photoshop from which it was originally created; however, it works wonderfully for exporting the Obj file and image maps for CS5 to import as well. So let's take a quick look at the export procedures.

CS5 will read Obj files from any 3D program, so use this as a guide for any program from which you are exporting 3D. The original Poser file titled "character4.pz3.psd" is included in the 3D Object folder located in Tutorials/ch 4, in the event that you would like to view it in Poser. But you do not have to have Poser to follow along with this tutorial. I already have the finished product in a PSD document in the "work files" folder titled "character4.pz3.psd."

If you have Poser, feel free to open the "character 4.pz3.psd" in the 3D object folder. You will see that the character has already been posed for you, as shown in Figure 4.1. The purpose is not to go in depth into Poser, but to shed some light on exporting the model.

Now, for the really easy part of exporting the Poser character. Go to the Scripts menu and select Export CS3 OBJ (see Figure 4.2). Select a location on your hard drive and make a new folder to place the files into. This script will not only convert the Poser file into an Obj, but it will also export all of the textures associated with it. The textures are in the form of a UV Map that Photoshop will have no problem reading. We will take a look at those a little later in this chapter, but for now, let's create the backdrop for our character.

FIGURE 4.1 View of the 3D model in the Poser interface.

FIGURE 4.2 View of the Export CS3 OBJ command.

CREATING THE STAGE FOR OUR ACTOR

We will create a background that will resemble a desert landscape with a sunset. We will composite several images that will include desert trees and textures photographed near the Salton Sea.

1. Create a new file with the dimensions of 7.5 × 11.5 inches at 150ppi (pixels per inch). Place a horizontal guide in the lower one-third of the composition. This will be where we will establish the horizon. In the Tutorials/ch 4 folder, open "sunset 1.jpg" and place it into your new file. Right-click on the sunset layer and select Convert to Smart Object. Resize it (Ctrl+T/Cmd+T) so that the base of the mountain matches up with the horizon line that you established with the guide, as shown in Figure 4.3. Also, fill the background layer with black. You will see why in just a bit.

2. Open another sunset file titled "sunset 2.jpg" and place it on top of the "sunset 1" layer. Make this a Smart Object as well. Change its Layer Blend Mode to Hard Light so that the cloud textures blend dynamically with one another (see Figure 4.4). Altering a file into a Smart Object will give you the flexibility to resize and make changes to your images.

FIGURE 4.3 Create a new file and add the sky.

FIGURE 4.4 Duplicate the clouds layer and change the Blend Mode to Hard Light.

3. Use the Magic Wand (W) to select the mountain range and then copy and paste (Ctrl/Cmd+C and Ctrl/Cmd+V) it into a new layer above the sunsets (see Figure 4.5). Make sure it's in registration with the original mountain range.

FIGURE 4.5 Select, copy, and paste the mountain range into a new layer.

4. The backdrop is still a little drab so to hold the viewers' attention, we'll add some trees to infuse some interesting texture to break up the horizon a bit. Open the file titled "trees.jpg."
This was shot on the Salton Sea particularly for the interesting look of the trees. We need to isolate the trees from their background so that we can utilize them in our scene. We will use a couple of techniques to accomplish that task. Let's start by looking at the channels to determine which one will give us the best separation between our trees and the background. It appears that the blue channel works the best, so duplicate the channel to make Blue copy (see Figure 4.6).

5. Since the trees are mostly dark, the goal is to create a mask where our main subject is black and the rest of the image is white. We will use our Layer Blend Modes with the use of the Apply Image command to achieve our goal. Select the blue channel copy and access the Apply Image Command (Image > Apply Image), as shown in Figure 4.7. Make sure that under the Channel list, you have Blue copy selected. We are going to blend the layer against itself using the Color Dodge Blend Mode, so select it under the Blending submenu.

FIGURE 4.6 Duplicate the blue channel.

FIGURE 4.7 Use Apply Image and apply Color Dodge to the Blue copy channel.

6. As you can see, the Color Dodge Blend Mode made the whites even brighter with very little effect on the darker tonality. This has gotten us very close to our goal already, so let's do it again. This time, choose Multiply for the Blend Mode so that the lower tones are made darker and the brighter tonalities are barely affected (see Figure 4.8).

FIGURE 4.8 Use Apply Image and apply Multiply to the Blue copy channel.

7. We can see just a little bit of middle tonal values in the white areas. Let's use Apply Image once again, and this time use Screen as the Blend Mode (see Figure 4.9). This will make the whites brighter, but not to such a harsh degree as Color Dodge. OK, this looks pretty close to what we want, so let's move forward.

8. Duplicate your layer (Ctrl+J/Cmd+J) and use Ctrl+Click/Cmd+Click on the Blue copy to get a selection; then apply a layer mask to the background copy. You have just transferred your channel into a layer mask. We need to see the trees and block out everything else, so invert the layer mask (Ctrl+I/Cmd+I). We will work on the layer mask next to refine the edges.

9. Now, Alt+Click/Option+Click on the mask to see it in your main document window. Zoom in close to the trees, and you will see that the edges of the trees are a little harsh (see Figure 4.10).

FIGURE 4.9 Use Apply Image and apply Screen to the Blue copy channel.

FIGURE 4.10 Close-up view of harsh edges.

9. It looks pretty good, but the edges could use a little work. Activate Refine Edge (Edit > Refine Edge), as shown in Figure 4.11.

 Refine Edge has been improved in that it's a lot faster with an interface that is easier to read. By default, you will get a white background, but you can change that.

 Modify the edge of the mask starting with Edge Detection and then with the Adjust Edge section. Play with the Smooth, Feather, Contrast, and Shift Edge slider until you get the results you want. In this example, small adjustments were made since the tree branches were fairly thin. The more pixels that you have to define your details, the more flexibility you will have with Refine Edge. Since we are working on a layer mask, make sure that Layer Mask is selected for Output To.

10. Under the View Mode section, access the View submenu and choose On Black to see the edge results against a darker value (see Figure 4.12). Toggle through all of these modes to get familiar with your options. Since we are satisfied with the results, click OK. You should see something like Figure 4.13.

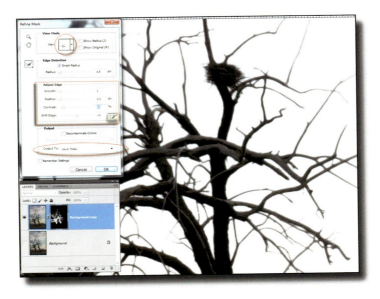

FIGURE 4.11 Apply Refine Edge.

FIGURE 4.12 Use Black to view against the trees.

FIGURE 4.13 Results of Refine Edge.

11. Now that you are happy with the results of the mask, make sure that the tree layer is selected and not the mask itself. Ctrl+click/Cmd+Click on the mask to get a selection and drag the tree via the move tool (V) onto the tutorial document (see Figure 4.14). Duplicate the tree layers and resize them so that they are small along the horizon, to give a feeling of depth. In an effort to create more depth, create a black-filled layer below the sunset background and make sure that you merge the two layers together that you used to create the sunset. Reduce the opacity of the sunset layer to about 53%. This brings out some of the darker colors and gives the sky a little more drama.

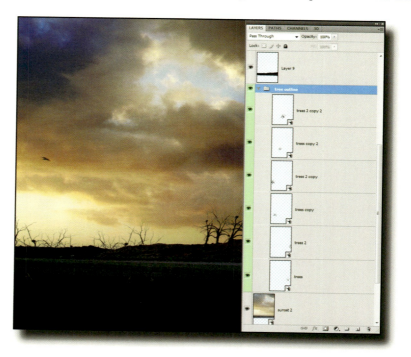

FIGURE 4.14 Place tree into the main document.

IMPORT THE 3D CHARACTER

Let's bring in the 3D character and edit the UV map with a texture of our choosing.

1. Import the model (3D > New Layer From 3D File). Choose the "character 4.pz3.obj" in the work files > 3D folder (see Figure 4.15). In addition, select the Camera tools on the Tools Palette. Select the 3D Zoom Tool and set the focal length to 31mm to match the camera's focal length from Poser (see Figure 4.16).

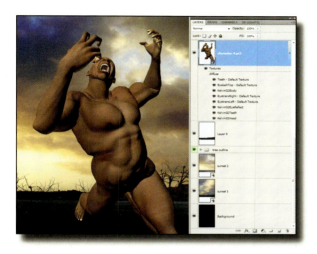

FIGURE 4.16 Set the camera's focal
length to 31mm.

FIGURE 4.15 Import "character 4.pz3.obj."

2. Let's edit the UV map for our character and alter the surface to resemble the stone from the desert. Take a look at textures for the 3D character in the Layers Palette. If you place your mouse over the texture that reads "KelvinG2Body," Photoshop will display a thumbnail of the image currently being used for the body (see Figure 4.17). Double-click on the texture to open the file used to create the character's skin. This single map defines the textures for the body, arms, legs, and fingernails. Use the Magic Wand (W) to select the white background, invert it (Shift+Ctrl+I/Shift+Cmd+I), and press Ctrl+J/Cmd+J to copy the selected contents into a new layer, as shown in Figure 4.18.

FIGURE 4.17 Thumbnail view of the texture
being used for the body.

FIGURE 4.18 Copy UV map into a new layer.

The UV map is simply the horizontal (U) and vertical (V) coordinates of the 3D model that is unfolded as a flat surface. This will then make it easier for us to use our painting and texturing techniques to surface any area of the object.

3. Access the work files folder and open the "texure1.jpg." Let's subdue the contrast on the texture by using the Shadow Highlights command under Image > Adjustments. Use the settings similar to Figure 4.19 to brighten the shadow details. Experiment with this filter. It can be useful for quickly flattening out your textures for color maps.

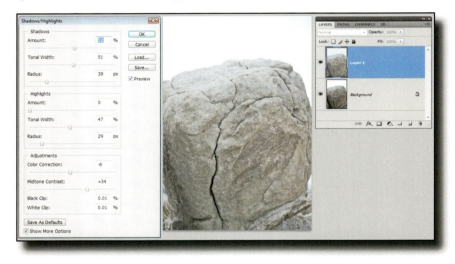

FIGURE 4.19 Apply the Shadow Highlights command to the texture.

4. Place the texture above the UV map layer and apply it as a clipping path. Do this by holding down the Alt/Opt key and placing your mouse in between the texture layer and the UV map layer. When you see the double circle, click your mouse, and the results will be what you see in Figure 4.20.

5. The Texture does not encompass the entire map. In fact, you really don't want it to because it's a good idea to have control of the size of the texture over various areas of the character. Since you want the crack details in the stone to be smaller in size for the arms, hands, and feet, duplicate the layer and use the Free Transform (Ctrl+T/Cmd+T) command to achieve this. Next, use layer masks to merge the textures so that they blend seamlessly. Use a soft-edged brush with a lower opacity for this. This is where the Wacom Intuos 4 will come in handy (see Figure 4.21). The pressure sensitive pen will allow you to apply the opacity of the blend quickly while you are working on the mask. Press Ctrl+S/Cmd+S to update the character with the completed UV map (see Figure 4.22). You should see something like Figure 4.23 when you see the 3D character.

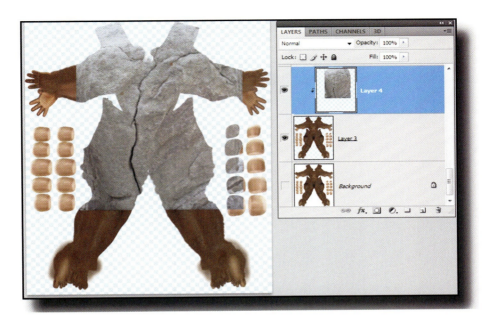

FIGURE 4.20 Apply texture as a clipping path to UV texture.

FIGURE 4.21 View of the Intuos 4.

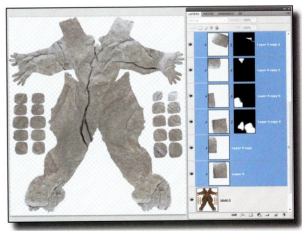

FIGURE 4.22 Duplicate and blend textures for the entire body.

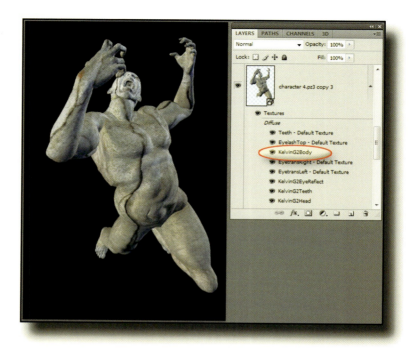

FIGURE 4.23 Results of the texture on the character.

6. Finally, place all of the textures into a layer group titled "body UV map." Select the group and merge it into a new layer (press Ctrl+Shift+Alt+E/Cmd+Shift+Opt+E). Next, desaturate this new layer (Ctrl+Shift+U/Cmd+Shift+U) and use Levels (Ctrl+L/Cmd+L) directly on the layer to increase the contrast. This will be the bump texture. Save this as a JPEG (Ctrl+Shift+S/Cmd+Shift+S), and we will use this for the bump channel in CS5 (see Figure 4.24).

7. Duplicate the bump and apply a Levels adjustment once again to gain a little more brightness from the map. This will be our specular map that will be applied to the Shininess channel in CS5 (see Figure 4.25). Save it as a JPEG as well.

8. Apply, the bump and the shininess map to their respective channels in the 3D Materials panel. Give shininess a 30% effect and give it a strength of 1 for the Bump channel. Play around with different numbers here so that you get an idea how the texture layers affect the end result of the surface visually. Note that CS5 has improved how it displays the 3D content. In Figure 4.26, the image is zoomed out quite a bit, and if you select Show All of the 3D content, you will have them visible beyond the borders of the document.

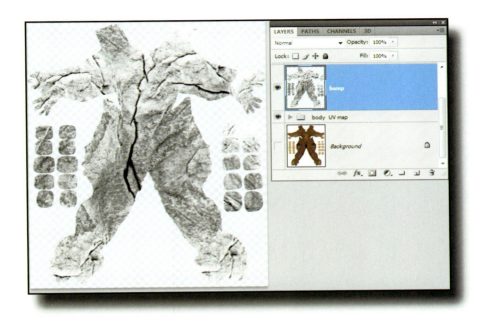

FIGURE 4.24 Place the texture layer into a layer group and create the bump map.

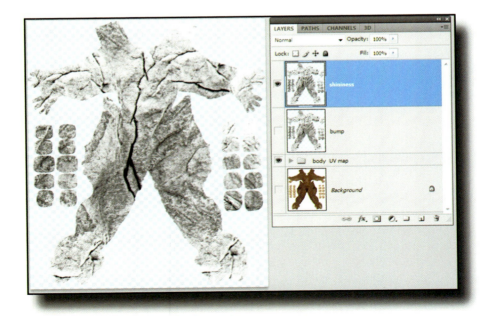

FIGURE 4.25 Create Specular map.

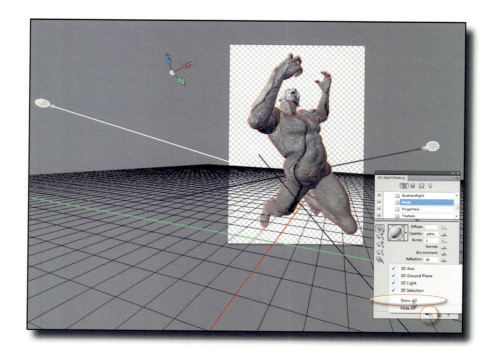

FIGURE 4.26 New 3D functionality for ease of navigation.

This is a very nice functionality that allows for easier 3D navigation when composing your scene. Another new feature in CS5 occurs when you click on a surface or material in the 3D Materials panel and that area is highlighted with a color stroke around the selected surface on the 3D model. You can designate the color coordination in the 3D Preferences inside of the Preferences panel (Ctrl+K/Cmd+K). In Figure 4.27, the designated color for the material is red, and the color of the 3D lights is green.

As you start adding materials to the surfaces of your models, you might want to save them as a preset so that you can use them with other models in the future because CS5 now has visual presets. Once you apply a custom surface, you can save all of its attributes as a preset, as shown in Figure 4.28.

When you save a preset, it automatically uses the material name that was given to it within the 3D program (see Figure 4.29).

When saved, the preset shows up as the last in the list (see Figure 4.30).

Now that we have composed our 3D object and have a better insight into our new 3D improvements, let's compose it into a story.

FIGURE 4.27 Set your 3D Preferences.

FIGURE 4.28 Create New Material preset.

FIGURE 4.29 Original name saved as preset.

FIGURE 4.30 View of the saved preset.

Using Photography for the Foreground

We are going to add the foreground elements using images that were taken in Salton Sea, California. You will use two images and blend them together to create some foreground interest that will pull the viewers' focus toward the character.

1. Access the Work Files folder and open "salton sea 1.jpg" and "salton sea 2.jpg." Resize and stack the layers so that they create more of a stair-stepping effect and use the layer mask to blend them. Duplicate one of the layers if you need to do so to accomplish this, as shown in Figure 4.31. Be creative here and don't be afraid to create something that looks a little bit different.

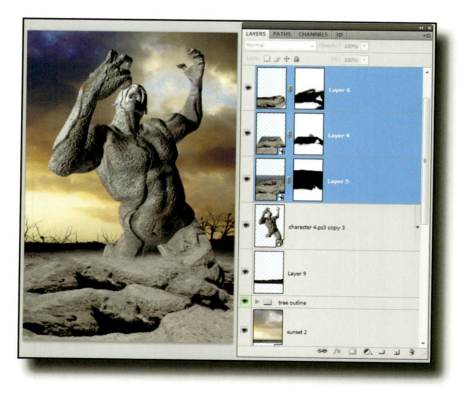

FIGURE 4.31 Composite the Salton Sea images to represent the foreground.

2. We are going to alter the look of the stones in the foreground by adding a simple painting technique to redefine the surface and crevice of each stone. To do this, create a brush with the settings that you see in Figures 4.32–4.34.

FIGURE 4.32 Set Angle Jitter to 36%. **FIGURE 4.33** Set Scattering to 61%. **FIGURE 4.34** Set Opacity and Flow to Pen Pressure.

3. Create a new layer and call it "sculpting"; change its Blend Mode to Multiply. Select your Brush (B) and apply gentle pressure at first with your Wacom pen to define where the cracks and separation will be for the stones. Since the texture originally had a slightly jagged edge, we created a brush with similar characteristics. This helps make the blend more convincing. Your results do not have to match mine, so use your imagination to sculpt in the details.

4. We need some detail in those dark crevices. Bring in the "texure 1" image that we used for the body and stretch it vertically, as shown in Figure 4.35. Give it a black-filled layer mask and use the brush to paint the texture into the shadow areas to define the ledge or sides of the stone, as shown in Figure 4.36.

5. As a final step to add a little contrast to the texture, select the three layers that you used to create the foreground textures. Merge them into a single additional layer by holding down the Alt/Option key and selecting Merge Layers from the Layers submenu. You now have an additional layer consisting of just your foreground stone. Change its Blend Mode to Hard Light so that there is more contrast to the stone.

Finally, let's add just a little more crack detail to the model. After painting in some of the crack texture on the ground, it's OK to go ahead and match the scene with more embedded cracks in the character. Use your brush to paint directly onto the character with black to define the crack. Make sure that you paint onto both the Diffuse and Bump channels. You can select this in the Paint On menu inside the 3D Scene panel, shown in Figure 4.37. For the Bump channel, black will create valleys in the surface, while painting with white will raise the surface upward. Practice with this and have fun with it.

FIGURE 4.35 Stretch the texture vertically.

FIGURE 4.36 Edit the mask to apply the texture to the shaded areas.

The particular brush used in this example takes advantage of pressure capabilities of the Wacom tablet by setting the sizing properties of the brush to Pen Pressure in the Shape Dynamics menu. In other words, if you use a slight pressure with your Wacom pen, you will get a small stroke. However, if you increase your pressure, the crevice will enlarge. Play with this and create additional cracks in the character's body.

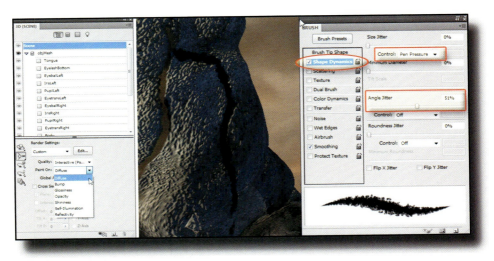

FIGURE 4.37 Paint in more crevices onto the character.

ADDING IBL TO THE SCENE

Here is where we will introduce the new IBL (Image Based Lighting) so that we can alter the directions and color of the lighting on the 3D character to match the scene. We will use both the IBL and the standard 3D lights in CS5 to achieve our goal. The IBL lights will establish a light quality that will blend the character into the scene. Photoshop will use an image with which to light the scene.

Normally, images that represent a 360-degree panoramic are traditionally used for IBL. However, it is important to understand that you can use any image to do this, and that includes 8-, 16-, and 32-bit images. Since this is a customized scene, we will use the composite of the background to light the model.

1. On the bottom of the 3D Lights panel, click the Add Lights button that is next to the Garbage Can button. Add a New Image Based Light, as shown in Figure 4.38.
2. A new IBL will show up in your 3D Light Panel (see Figure 4.39). On top of your document, you will see a spherical representation of your Image Based Light.

In fact, the way that it works is that the image is wrapped on a sphere that encompasses the entire 3D space. The luminance values and hues in your image will be used to light the 3D object. Currently, no image has been assigned to the light so all you see is a white globe.

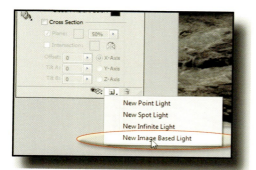

FIGURE 4.38 Add a New Image Based Light.

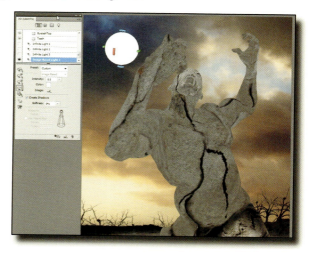

FIGURE 4.39 View of the added Image Based Light.

3. Now, let's add the image from which we will light the character. In the Tutorials/ ch 4 folder, you will see an image of the merged background titled "IBL image.tif," as shown in Figure 4.40.

FIGURE 4.40 View of "IBL image.tif."

4. In your 3D Lights panel, add the image to the Image Based Light (see Figure 4.41).

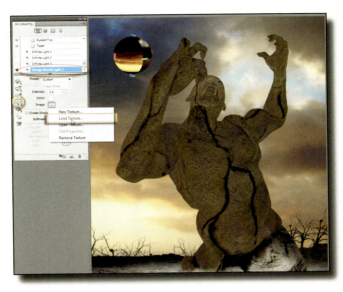

FIGURE 4.41 Add "IBL image.tif" to the Image Based Light.

Where we once had a white globe is now wrapped with our image and lighting the character with the color and luminance from that file. Your character will take on the colors that are in the background that we used for our scene. Click the button on the 3D Lights panel to rotate your light source. Notice that as you turn the globe, the color and brightness shown on the globe will light the region of the model that it sits in front of. This is a nice feature to help you anticipate how to light the scene.

USING ADDITIONAL 3D LIGHTING STYLES TO MATCH THE SCENE

Since the IBL light behaves like a light source that illuminates the 3D object from all sides, the lighting will be fairly nondirectional to favor an evenly lit object. Because our scene calls for some directional lighting, let's add some other styles of 3D lights to match the directional sunset light style.

1. On the bottom of the 3D Lights panel, you will see the three default 3D lights that are designated as Infinite Lights. Select Infinite Light 3 and rotate it so that it lights the model from the bottom right. This will represent the bounced

light in the shadows, which will have a bluish hue, so set its color to a shade of blue (see Figure 4.42). Notice that the light guide becomes the color of the light source that you chose. Also, notice that the active light is highlighted green, as was designated in the 3D Preferences (Ctrl+K/Cmd+K). Let's set the other two lights.

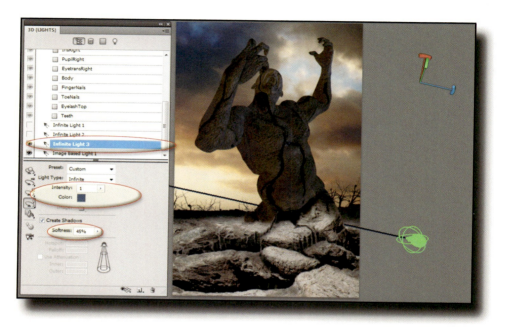

FIGURE 4.42 Rotate the Infinite Light 3 and set its color to blue.

2. Now, select the center one and change its color to that of the brightest portion of the sunset. Do this by clicking on the color swatch and then use your Eye Dropper tool to choose the color of the sunset (see Figure 4.43).
3. Select Infinite Light 1 and rotate the light so that the character is illuminated from the left rear (see Figure 4.44). Match the color of the sunset, which, in this example, is a bright orange. Set the shadow's Softness to something around 44%, but experiment with this to get something that you like.
4. Let's give the foreground stone the appearance that it is receiving some of the orange glow from the sunset (see Figure 4.45). Fill a new layer with orange sampled from the sunset and change its Blend Mode to Multiply. Use a layer mask to isolate the effect to the foreground.

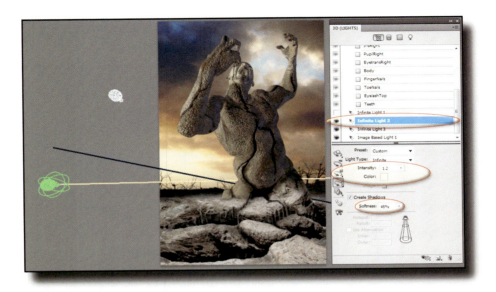

FIGURE 4.43 Change the color of the Infinite Light to the color of the sunset.

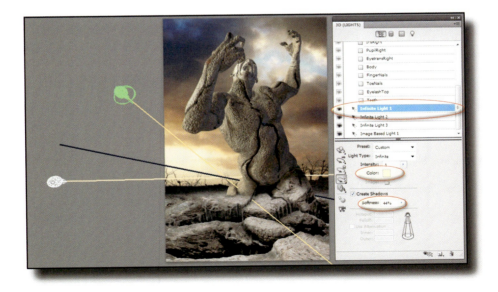

FIGURE 4.44 Rotate the Infinite Light 1 and set its color to a bright orange.

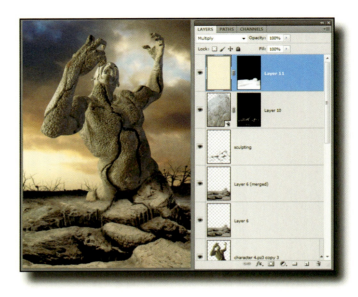

FIGURE 4.45 Add an orange glow to the foreground.

5. The clouds are just a little too sharp so let's blur them a bit to establish a shallower depth of field. Select the cloud layers and apply a Shape Blur of 6 pixels (see Figure 4.46). This now softens the background and brings more focus to the character.

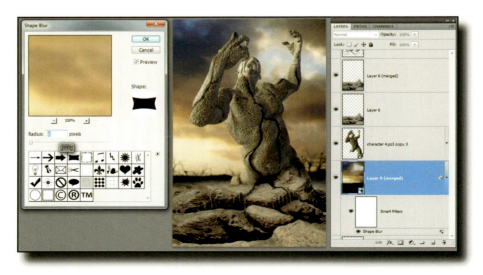

FIGURE 4.46 Apply Shape Blur to the clouds.

ADD THE FINISHING DETAILS

Now we can add some finishing touches to complete the scene. We will need a shadow so that the character becomes one with the scene. Then we will add some wispy smoke emanating from the cracks of the stone figure.

1. Duplicate the 3D figure and rasterize the layer (right+click > Rasterize 3D Layer). Fill the layer with black (Shift+F5 > Fill with Black). Make sure when you are in the Fill dialog box that you check Preserve Transparency so that only the pixels are filled with black.
 Use your Free Transform tool (Ctrl+T/Cmd+T) to flip the shadow upside down. Then use a new command called Puppet Warp (Edit > Puppet Warp), as shown in Figure 4.47. This is going to be a transform favorite. You will first see a mesh covering your shape. The way that it works is that you will need to lay down pins to anchor the edges of the shape, and once anchored, they will not move unless you drag them to warp the shape that they are attached to.

2. Now let's create the effect of the stone heating to a red-hot temperature. Create a new layer above all of the other layers and change the Blend Mode to Color Dodge. Choose a reddish-orange color of your choice and paint along the crevices of the model, as shown in Figure 4.48. Apply the color with a low opacity at first and build on top of it until you get a brighter orange glow.

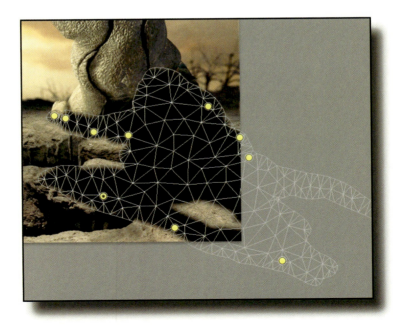

FIGURE 4.47 Puppet Warp applied to shadow.

The Color Dodge Blend Mode will saturate and brighten the color as you apply it on each pass. For now, just use a standard soft-edged brush. We will cover brushes and the new brush tips in particular in the next chapter.

3. To enhance the heat effect, let's add an orange glow around the painted areas. Create a new layer and change the Blend Mode to Color Dodge. Use the same reddish-orange color and apply it with an enlarged soft-edged brush. Keep the opacity low so the brush will enhance the heat glow that you already created without overpowering it, as shown in Figure 4.49.

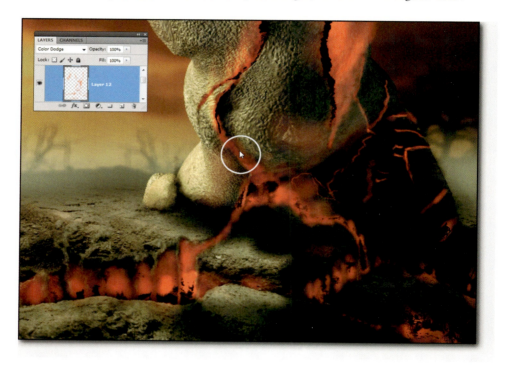

FIGURE 4.48 Set the new layer to Color Dodge and apply a reddish-orange paint to create a heated glow to the rocks.

4. Finally, use your paint brush to paint in some white smoke using a standard soft-edged brush so that it appears to emanate from the cracks in the body (see Figure 4.50). Keep in mind that the Wacom Pen will be invaluable for assisting you. However, use a low opacity at first and build on the smoke similar to what you did in Figures 4.48 and 4.49. Use 4.50 as a guide.

I hope that you enjoyed this tutorial. In the next chapter, we will explore CS5's new Brush features.

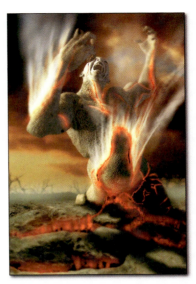

FIGURE 4.49 Create another layer with Blend Mode set to Color Dodge and apply a reddish-orange glow around the initial glow.

FIGURE 4.50 Smoke applied to figure.

WHAT YOU HAVE LEARNED

- IBL stands for Image Based Lighting.
- IBL lighting uses the luminance and hue values of an image to light the 3D object.
- IBL lighting is nondirectional.
- Bump maps use black-and-white values to create textures.
- CS5 has new texture presets.
- You can save any of your surfaces as a texture preset.

USING THE NEW BRUSHES

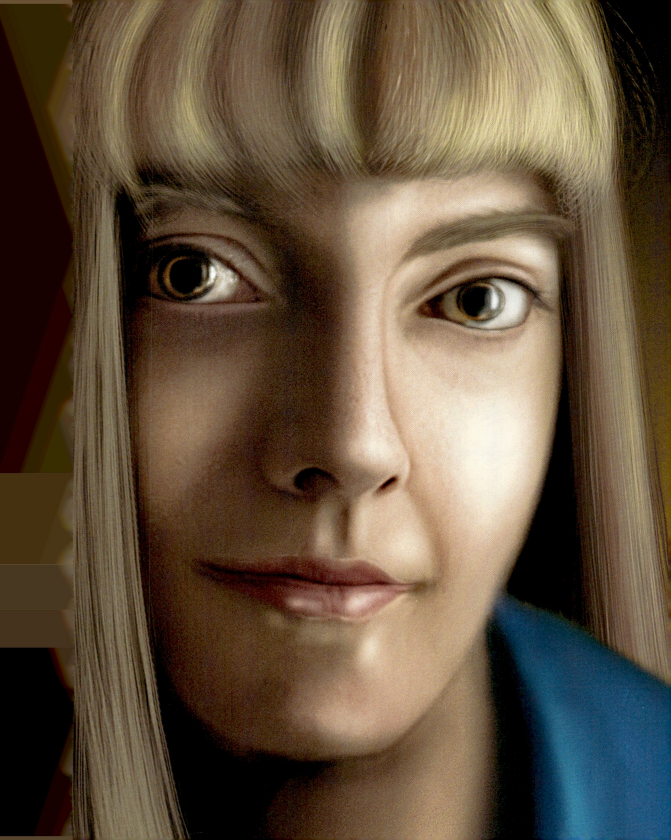

W hen it comes to getting the realistic look of traditional paint media, Corel's Painter has always been the choice program when it came to transitioning from the canvas to the computer. Although Photoshop's brushes sufficed, users made it clear that they would like to see something close to what Painter had provided. We will now explore what CS5 has to offer in creating painterly images from photographs.

SETTING UP THE WACOM TABLET

Since CS5 Extended has begun to address the need for realistic media brush strokes, we will explore the new brushes by creating a portrait from a photo reference. The brushes are even more powerful with the use of the Wacom tablet (see Figure 5.1). The image for this exercise was created with the Intuos 4 Wireless. This product merges the traditional artistic methods of creation with the computer's techniques to give you a more intuitive means of creation.

FIGURE 5.1 View of the Wacom I4 Wireless.

1. We are going to explore setting up the tablet properties for working in CS5. If you are using dual monitors, you can choose to have the table surface mapped so that the two monitors are treated as a single monitor (see Figure 5.2). You can also have the tablet recognize each of the monitors individually, as shown in Figure 5.3.

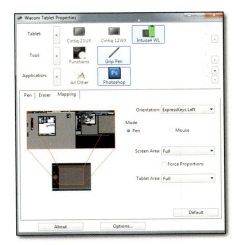

FIGURE 5.2 Two monitors recognized as one.

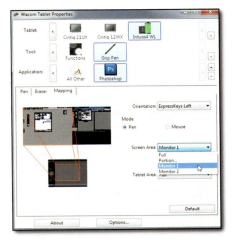

FIGURE 5.3 Each monitor is mapped to the tablet individually.

2. If you choose to map the tablet to each monitor individually, then you will need to set up a button that will toggle the functionality between both monitors. Figure 5.4 displays how to set the toggle function to any of your buttons.

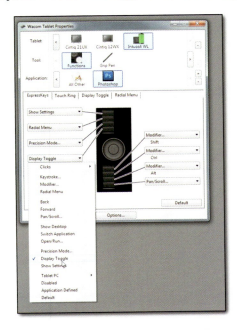

FIGURE 5.4 Set the toggle properties to a button.

3. In the past, I have employed the top and bottom button on the pen to enlarge or decrease the brush size. But with the new subpixel adjustment feature of the brush, you can hold down the Alt/Opt key on the keyboard while you right-click and drag your mouse to get a smooth resizing of your brush. When employing this feature to the Wacom pen, designate the top button of the Wacom pen as a Right Click. Do this by going to your Wacom Properties (Program > Wacom Tablet on PC /Preferences > Wacom on MAC) to designate it as a Right Click, as shown in Figure 5.5.

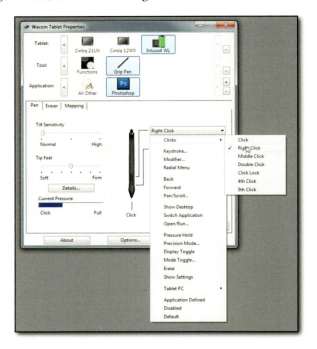

FIGURE 5.5 Set top button to a Right Click.

4. Now for the lower button, set the shortcut to switch the foreground and background color (X), as shown in Figures 5.6 and 5.7. This will be very handy for switching between two colors as you paint.
5. Give the shortcut a name that you will be able to identify easily (see Figure 5.8).
6. Keep in mind that everyone has a different feel for how heavy the pressure they place on the mouse will be. So use the Tip Feel to adjust the slider to match your personal choice in pressure sensitivity (see Figure 5.9).

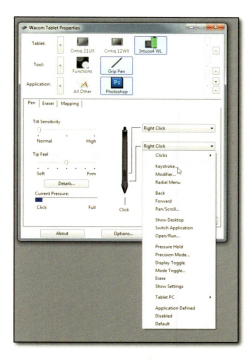

FIGURE 5.6 Set the lower button to take advantage of a keystroke.

FIGURE 5.7 Set the lower button to switch between the foreground and background colors.

FIGURE 5.8 Give the shortcut a name.

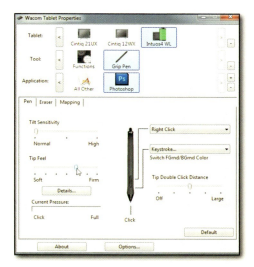

FIGURE 5.9 Adjust Tip Feel.

SETTING UP THE INITIAL PORTRAIT

We are going to take a snapshot of a portrait and alter it into a painting. We will use it as a reference as we apply the brush techniques. The idea is not to make an exact representation of the photo but only to use it as a reference. We will alter the shape and features of the portrait to thin the face and cheekbones a bit. Then we will apply some of the new Brush options to define the portrait.

1. Open "portrait.jpg" in the Tutorials/ch 5 folder. We are going to thin out the face a bit using Content Aware Scale, but first we need to define the area that we would like to be untouched by the transformation. Select the Lasso tool (L) and use it on the eyes, nose, and mouth, as shown in Figure 5.10. Save the selection as an Alpha Channel (Select > Save Selection). As you can see, Photoshop has given it a default name of Alpha 1.

FIGURE 5.10 Select the eyes, nose, and mouth to protect from any transformations.

2. Next, apply Content Aware Scale (Edit > Content Aware Scale) and on the Options bar, make sure that you have Alpha 1 as the channel to use to protect the face. Place the rotation point to the left side of the portrait, as you see in Figure 5.11. Now hold down the Alt+Shift/Opt+Shift key together while you drag the frame inward. This shortcut will force the frame to resize toward the rotation point, thus forcing the right side of the face to become thinner faster than the left. Get something close to what you see in the example and press Enter on the keyboard to commit your changes.

3. Use Liquify (Filter > Liquify) to shape the cheeks and chin a bit toward the thinner side. Your results do not have to match what you see in Figure 5.12, so play around with this to get your own interpretation.

4. We are going to use the Mixer Brush tool (B) to smooth the skin toward a more painterly result. Figure 5.13 shows the settings that were used to create the painting effect; set the preferences as you see in the example. Make sure that the "Sample All Layers" check box is selected so that you can place the contents onto a blank layer.

FIGURE 5.11 Apply Content Aware Scale.

FIGURE 5.12 Apply Liquify to face.

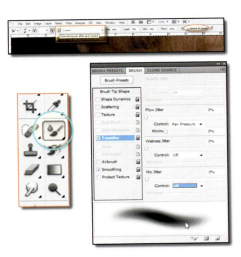

FIGURE 5.13 Set up the Mixer Brush tool.

Brush Shortcut Toggle

The shortcut for the Brush is "B;" however, there are a variety of other brushes within the same submenu with the same shortcut. For ease of access, click the check box next to "Use Shift Key for Tool Switch" under the General tab in the Preferences menu (Ctrl+K/Cmd+K).

5. Now we are ready to begin the first step in altering the photo. Resize the Brush by holding down the Alt/Opt key while holding down the top button on the Wacom pen, which we designated as a right click. Just navigate the pen from left to right with the pen hovering one-quarter inch from your pad without it touching the pad to resize the Brush (see Figure 5.14).

FIGURE 5.14 Resize the Brush.

6. For now, use a soft-edged brush at a low opacity to smooth the skin. If you are using the Wacom tablet, just press gently on the pen to take advantage of the subtle opacities. Focus mostly on the face and shoulders, as shown in Figure 5.15. The background is not as critical since it will be removed later on and replaced with another. The hair we will re-create in another layer.

Mixer Brush Functionality

The Mixer Brush was created to give a realistic mixing of colors as if they were actual paint. It utilizes the subtractive process of mixing. However, it is an ideal tool for giving painterly textures to portraits.

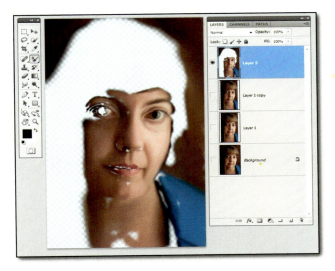

FIGURE 5.15 Add portrait to another layer using the Mixer Brush.

Figure 5.16 shows the completed results. The idea is to get a very smooth look to the skin. Your portrait does not have to look exactly like the example, and you are encouraged to experiment with other brush styles for this as well.

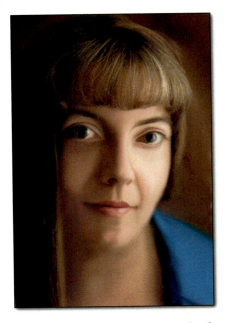

FIGURE 5.16 Results of transforming the portrait using the Mixer Brush.

7. Take a look at the lapel on the lower right (see Figure 5.17). Using the Mixer Brush, move the shaded area across the neck, as shown in Figure 5.18. Do the same for the edge of the lapel to match the location of the shadow (see Figure 5.19). We lost the edge of the collar, so use a standard brush and paint in white along the top edge of the lapel, as shown in Figure 5.20. Now go back to the Mixer Brush and smooth out the highlights across the lapel, similar to what you see in Figure 5.21. Try to get something that resembles Figure 5.22.

FIGURE 5.17 Close-up view of the lapel.

FIGURE 5.18 Move shaded portion across the neck.

FIGURE 5.19 Move lapel to match the shadow.

FIGURE 5.20 Add white paint using the standard brush.

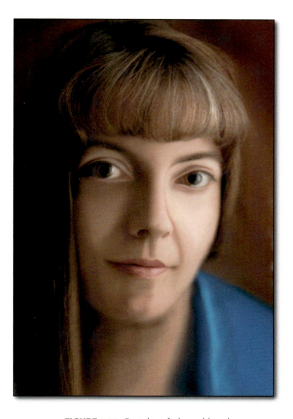

FIGURE 5.21 Smooth the highlights using the Mixer Brush.

FIGURE 5.22 Results of altered lapel.

8. Let's add some depth to the portrait by defining the lower tonalities a little better. Select your standard brush and set its Blend Mode to Multiply, as shown in Figure 5.23. You are going to paint over the shaded areas, which includes the nostrils and lips. Sample the richer color of the location that you are going to paint onto. Just hold down the Alt/Opt key to get the Eyedropper while you are in Brush mode and click on the area that you want to select. In this example, it will be the deeper red color.

9. Use your Rotation command (R) to assist you in applying the paint (see Figure 5.24). With the Blend Mode set to Multiply, the colors become darker, making it ideal for establishing a deeper tone. Figure 5.25 shows the completed results.

10. Now let's quickly add some highlights. Create a new layer and change its Blend Mode to Screen. Use white to paint on top of the brighter areas of the portrait like you see in Figure 5.26.

11. Next add Gaussian Blur (Filter > Blur > Gaussian Blur) to smooth out the highlights (see Figure 5.27). Let's move on to create the hair.

FIGURE 5.23 Select the standard brush and sample the color.

FIGURE 5.24 Use the Rotation command to assist your efforts.

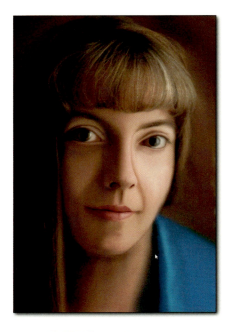

FIGURE 5.25 Results of painting in the darker tonalities.

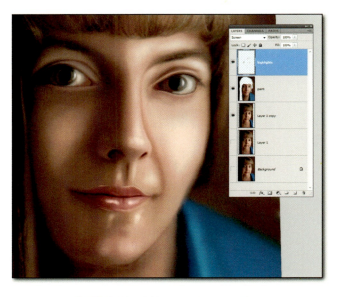

FIGURE 5.26 Add layer with Screen Blend Mode to paint in white.

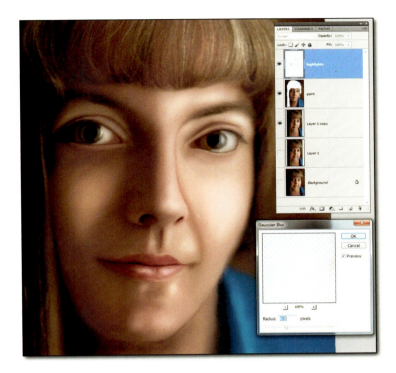

FIGURE 5.27 Add Gaussian Blur to highlights.

CREATING THE HAIR USING THE NEW BRUSHES

We are going to explore the new Brush engine to see what capabilities we have for creating some realistic hair. We will start by exploring properties of a brush that are closest to our goals. Figures 5.28 thru 5.37 display the Brush menu with the changes that were made to get the particular stroke technique that you will see in each of the examples. Take note that the Brush preview icon is displayed as well for you to see the results of the changes. If this is not turned on, then go to View > Show > Brush Preview. This will be visible only for the new brushes in CS5 Extended.

On the canvas, you will see that one stroke shows the outcome of the curvilinear technique and the other shows a linear application. Let's explore each of the settings used to create the hairbrush.

1. In the Brush option on the Option palette, you will see several new brushes that are shown in Figure 5.28. The Flat Blunt Brush is the one that you need to choose, so select that one.

2. Change the angle of the brush to Flat Angle, as shown in Figure 5.29.

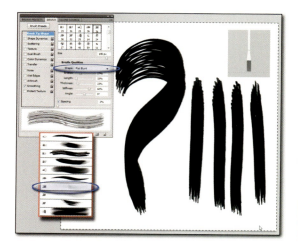

FIGURE 5.28 Select the Flat Blunt Brush: these are the results of the default settings.

FIGURE 5.29 Under the Shape menu, change it to Flat Angle.

3. For the Bristles slider, change the percentage to 12% and 27% for finer hair as you see in Figure 5.30.
4. Set the Length of the Bristles to 25% (see Figure 5.31).

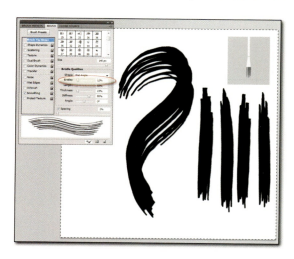

FIGURE 5.30 Set Bristles slider to 12% and 27% for finer hair.

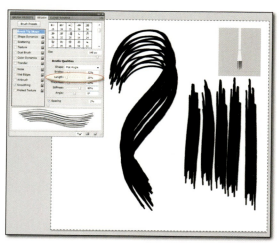

FIGURE 5.31 Set the Length of the Bristles to 25%.

5. Set the Thickness of the bristles to 1% to assist with getting even finer hair, as shown in Figure 5.32.

6. You'll want a harder brush for more definitive hair strokes, so set the Stiffness to 1% (see Figure 5.33).

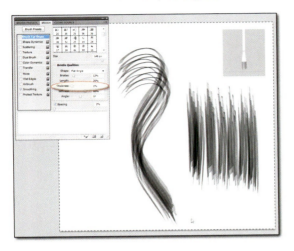

FIGURE 5.32 Set the Thickness of the bristles to 1%.

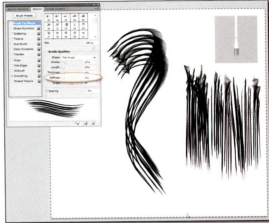

FIGURE 5.33 Set the Stiffness to 1%.

7. Set the Angle to 75 Degrees (see Figure 5.34).

8. To give a strand of hair a more individual look, set the spacing to 10%, as shown in Figure 5.35.

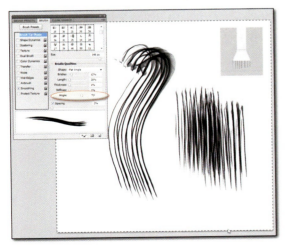
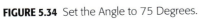

FIGURE 5.34 Set the Angle to 75 Degrees.

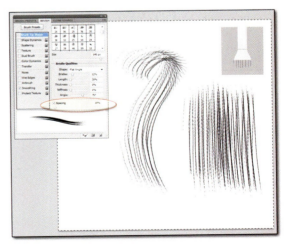

FIGURE 5.35 Set the spacing to 10%.

9. To get more of a frizzy effect, when you rotate the Wacom pen, set the Angle Jitter to Initial Direction located under the Shape Dynamics, as shown in Figure 5.36.

10. To control the opacity of the hair edges, set the Opacity and Flow to Pen Pressure, which is located under the Transfer menu (see Figure 5.37).

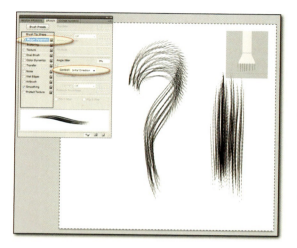

FIGURE 5.36 Set the Angle Jitter to Initial Direction. **FIGURE 5.37** Set the Opacity and Flow to Pen Pressure.

11. Apply the new brush changes as a preset (see Figure 5.38).

FIGURE 5.38 Apply changes as a preset.

APPLYING THE HAIR

We are going to give the hair several new layers. One will be for brown hair, another for even darker hair, and the last for bright highlights.

1. Make three layers to start—one will be the application of darker hair, one for brown hair, and the last for highlights. In this example, the layers are titled shadows, highlights, and hair. Sample the colors from beneath the layer you are working on and then start painting with light strokes while keeping your pen at an upright angle for linear hair-like stokes, as shown in Figure 5.39.

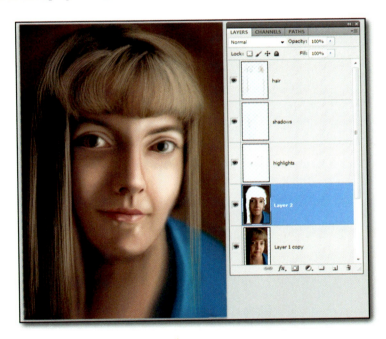

FIGURE 5.39 Hair strokes applied to different layers.

2. If you need them, you can add additional layers to assist you in building the hair (see Figure 5.40). You can follow the contour of the original hair, or you can create something on your own. Just use your imagination and have fun.

3. We are going to create a new brush to smudge the colors of the hair in order to force it to look more integrated with the portrait. Make a new document with the dimensions of 5 × 5 inches at 200ppi. Place small black dots throughout the document, as shown in Figure 5.41. Make only small dots of varying sizes. Select them and define them as a new Brush Preset (Edit > Define Brush Preset).

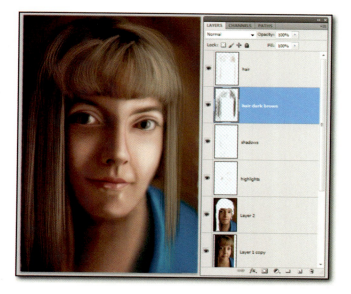

FIGURE 5.40 Add additional layers to build your hair.

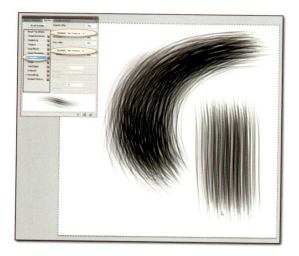

FIGURE 5.41 Define a new brush.

4. Open the Brush Palette (Window > Brush) and apply the Spacing under Brush Tip Shape so that the dots become a single linear set of lines that resemble hair. Set the Transfer properties so that the pressure of the pen can be applied to the brush. Figure 5.42 shows the stroke example and Brush properties.
5. Now save this brush as a preset as well (see Figure 5.43).

FIGURE 5.42 Set the properties for pressure sensitivity.

FIGURE 5.43 Save Brush as a preset.

6. Merge all of the hair layers into one single layer so that you can use the brush to smudge the colors together (see Figure 5.44). Apply the new brush that we created to the Smudge Brush and lightly blend the hair, making sure that the stroke moves with the flow of the hair. The idea is to integrate the colors together better and not reshape the hair.

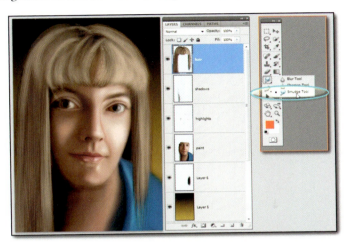

FIGURE 5.44 Merge hair layers and apply the Smudge tool.

7. To define the edge of the hairline, apply the new brush to the Eraser tool (E) and gently erase into the hairline to keep the hair edges (see Figure 5.45).
8. Now add in the eyebrows in the same way that you created the hair (see Figure 5.46).

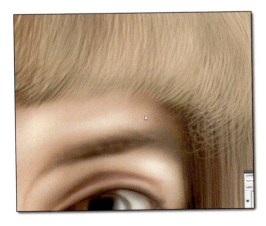

FIGURE 5.45 Shape the hairline with the Eraser tool. **FIGURE 5.46** Create the eyebrows.

9. Use the Warp tool to reshape the hair so that the ends flair out a bit, as shown in Figure 5.47.

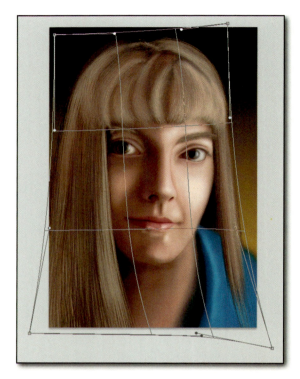

FIGURE 5.47 Use the Warp tool to reshape the hair.

10. Duplicate the hair layer and fill it with black (Edit > Fill > Fill with Black). In the Fill dialog box, make sure to check Preserve Transparency. Position the shadow so that it overlaps the forehead and face slightly, as shown in Figure 5.48.

11. Add Gaussian Blur to soften the edges of the shadow (see Figure 5.49). Figure 5.50 displays the final results.

12. The skin is so smooth that it would help to place some texture back into it from the original skin. Figure 5.51 shows a close-up of the current results. We will create a texture layer to place some of the texture back in and then show you the outcome. Duplicate the layer that we transformed in Figure 5.11 and place it on top of the painted layer. Then apply High Pass (Filter > Other > High Pass) to it (see Figures 5.52 and 5.53). Next, change the Blend Mode to Linear Light and adjust opacity as desired. You have just added the original textures to the painted portions of the skin.

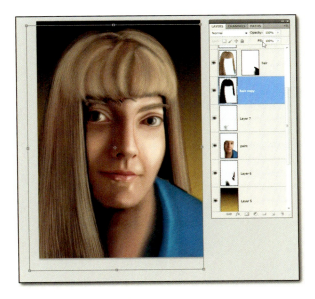

FIGURE 5.48 Create drop shadow from hair.

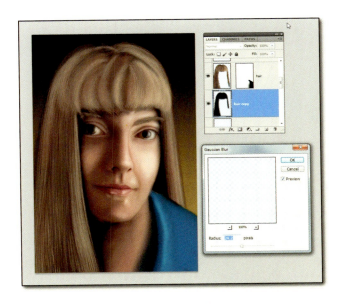

FIGURE 5.49 Add Gaussian Blur to shadow.

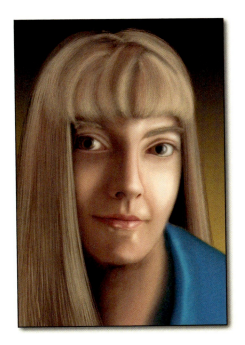

FIGURE 5.50 Results of Gaussian Blur to shadow.

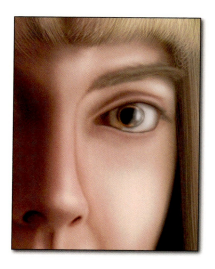

FIGURE 5.51 Close-up of the current results.

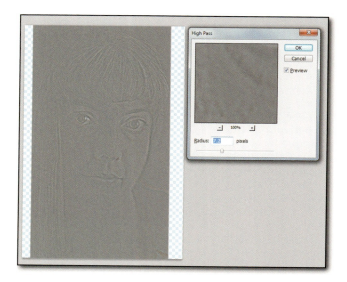

FIGURE 5.52 Apply High Pass.

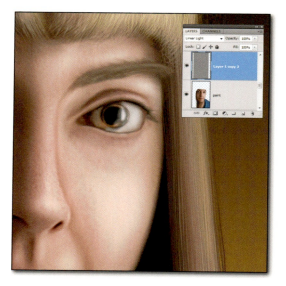

FIGURE 5.53 Close-up of the High Pass results.

Figure 5.54 shows the final results with a little shading on the left side of the hair to honor the direction of the light.

We have just explored one way to re-create paintings from photographs using different types of texture brushes to get more of a paint-stroke effect.

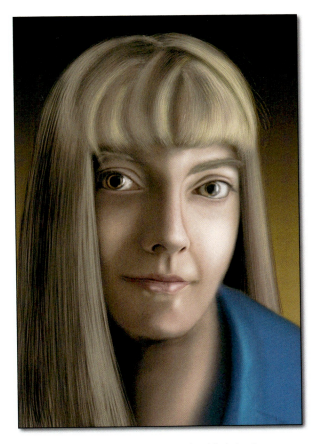

FIGURE 5.54 Final results with added shading.

WHAT YOU HAVE LEARNED

- The Wacom pad can facilitate the use of the Brush tools.
- You can assign shortcuts to the Wacom pen to resize the mouse.
- You can set the pressure sensitivity to the Wacom pen to compensate for softer or heavier-handed personalities through the Pen Properties.
- The Mixer Brush is a good tool to start with when applying paint texture to a photograph.
- The new Brush preview is very handy in displaying the type of brush you are working with.
- Using the High Pass technique is good for applying original texture back into the painted portrait.

INTEGRATING 3D OBJECTS INTO A PHOTOGRAPHIC SCENE

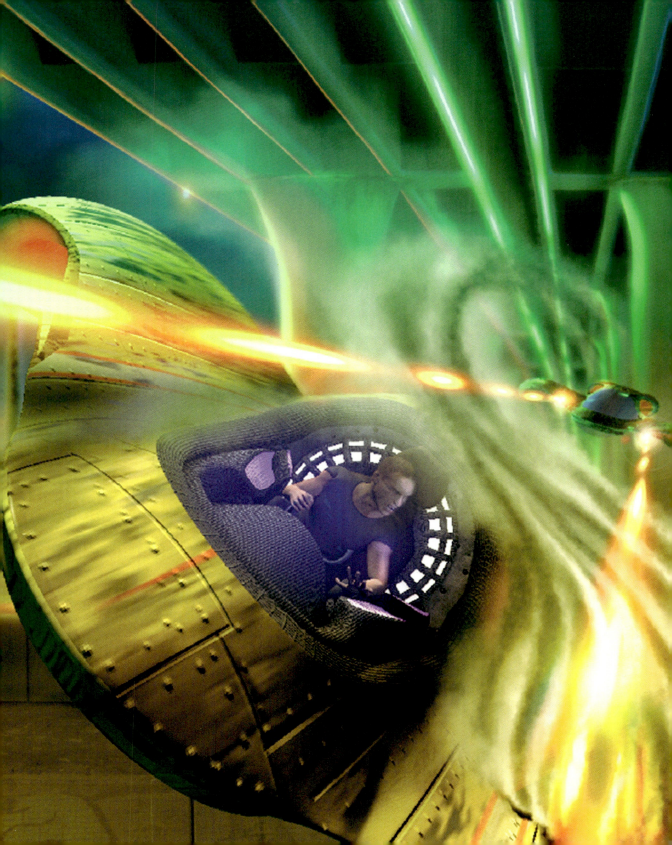

In this chapter, we will create the concept called *Pursuit*. Pursuit will illustrate a pilot in a spaceship, who is desperately trying to escape the pursuit of another ship. This exercise will demonstrate the flexibility of CS5 to use 3D content from multiple programs and combine that content into a singular vision. We will call upon several traditions of 3D (photographic and painting) to produce the final result. Keep in mind that this image was originally created at the request of *Photoshop User's Magazine* and what you are about to explore is my original vision. However, sometimes publishers like to add a few adjustments of their own to suit what they feel will work best for their publication, and you will see the end results of that change at the end of this tutorial. For now, let's go have some fun.

Two 3D programs were used to create this tutorial. One is Smith Micro's Poser 8 (http://poser8.smithmicro.com) and the other is NewTek"s LightWave 3D 9.6 (www.newtek.com). The images have been provided for you in PSD files in the Tutorials/ch 6 folder called "flier.psd" and "pilot.psd." By now, you should have downloaded all of the contents onto your desktop into a folder called "tutorial." So feel free to use those images to follow along with this tutorial.

3D CONTENT LIGHTWAVE

Let's take a look at the 3D models that were used to complete this tutorial. Figure 6.1 displays the completed version of the 3D ship within the LightWave interface.

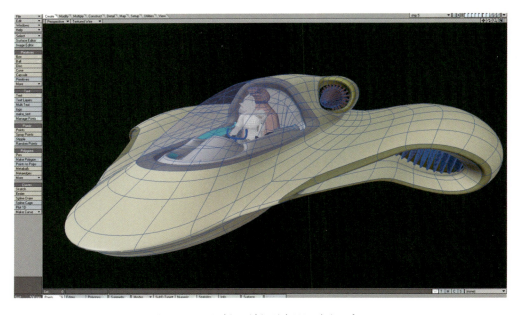

FIGURE 6.1 3D ship within LightWave's interface.

I created the ship using the basic rectangular primitives and sculpted the basic shape of the ship. Afterward, I applied subdivision surfaces, which is a command that will round out the corners toward a more organic shape, as shown in Figure 6.2.

When the overall design was completed, I designed a simple cockpit where the pilot could be placed, as shown in Figure 6.3.

FIGURE 6.2 Basic rounded shape of the 3D ship.

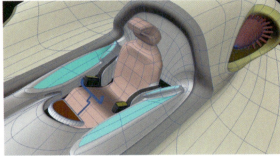

FIGURE 6.3 View of the cockpit of the 3D ship.

Just like Photoshop, LightWave utilizes layers to place individual objects into the scene. So additional details were added to add a little more interest, such as the pilot's chair, steering wheel, and viewing panel. In addition, UV maps were assigned to the surfaces of the individual components to add the textures that you might want to use later in Photoshop (see Figure 6.4).

Now, let's take a brief look at Poser.

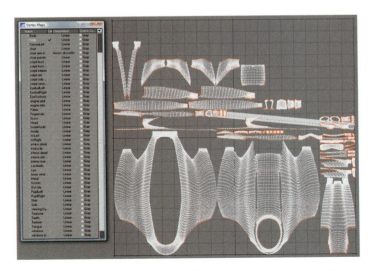

FIGURE 6.4 Additional detail is added and UV maps are applied.

A QUICK LOOK AT 3D CONTENT IN POSER

Poser is not a modeling program. It is a posing and animation program that uses predesigned characters, which will be ideal for this exercise. The pilot in the aircraft is escaping another ship in pursuit. The ship's wing will be hit by a laser blast, and fire and smoke will emanate from it. The pilot's face is designed to display angst. I used the Poser 8 Ryan character.

I began by designing facial emotions by using the Morph properties to apply a series of angry and pain emotions, as shown in Figure 6.5.

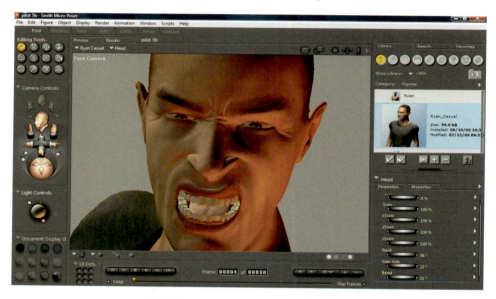

FIGURE 6.5 Created anger on the pilot's face.

Then I created the pose in Figure 6.6. Next, the character is posed to fit in the reclining chair of the cockpit.

As mentioned earlier every 3D object has to have a UV map applied in order for Photoshop to recognize it in its 3D layers. You can access the UV map in the Materials room as shown in Figure 6.7. All of Poser's 3D content will already come attached with UV textures, as shown in the close-up view in Figure 6.8. You can export the model as an OBJ using the "Poser Photoshop Content Exporter for Windows," which you will find for Windows or Mac on my Web site at http://www.chromeallusion.com/tutorials.html. Install it on your machine. You will find the command in Poser under the Script > Export CS3 OBJ. This will export the 3D object and all textures into your chosen folder. LightWave and Photoshop alike can import the Poser character imported earlier from Poser 8.

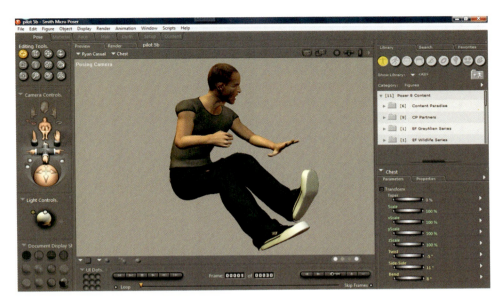

FIGURE 6.6 View of the pilot posed for the reclining chair.

FIGURE 6.7 View of the pilot's UV map.

FIGURE 6.8 View of the pilot's 3D map.

CREATING THE BACKGROUND

The ship in the foreground will be running from the one on the background under-neath the overpass architecture. I wanted the scene to have dynamic composition so I created a single-point perspective and placed the bridge underneath to view how it conformed to the custom perspective, as shown in Figure 6.9. As you can see, the lines of the bridge do not conform to the perspective so that will have to be altered next.

Portions of the bridge were cut and pasted into a new layer. I used Free Transform (Ctrl+T/Cmd+T) and Warp (Edit > Transform Warp) to conform the bridge to the perspective lines (see Figure 6.10).

When reshaping the bridge was complete, a Color Overlay of the bluish tint of the night sky was added using the Layer Styles dialog (see Figure 6.11). This tinting helped conform the lighting of the overpass to the night sky.

Several 3D objects of buildings were created in LightWave and placed as secondary compositional elements in the lower left-hand corner (see Figure 6.12). You can get the objects from tutorials/ch 6 3D city.psd. These objects add some interest in the background and help add to the story. In addition, I used Photo-shop's primitives to create a 3D plane (3D > New Shape From Layer) to work as the surface for the buildings, and then I placed the base of the buildings on the hori-zon of the ground plane. The buildings were placed into two layer groups titled "3D buildings with lights" and "3D buildings with lights 2."

FIGURE 6.9 Single-point perspective applied.

FIGURE 6.10 Aligning the bridge to the chosen perspective.

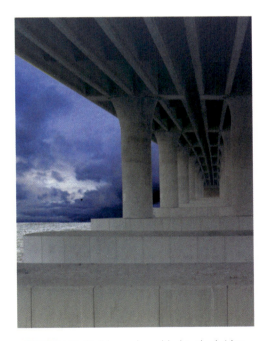

FIGURE 6.11 Bluish overlay added to the bridge.

The opacity for "3D buildings with lights 2" was reduced to gain some depth. Next, point lights were added to the top of the antennas and placed in the layer group titled "lights." Let's move on.

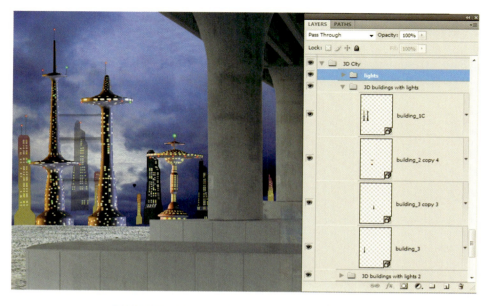

FIGURE 6.12 Additional 3D buildings added to the scene.

Creating a new layer above the 3D buildings, the paint brush was used to paint in a yellowish haze to add some atmosphere to the scene (see Figure 6.13). I used a soft-edged brush for this.

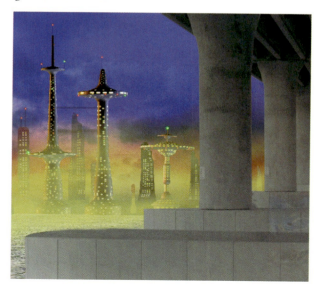

FIGURE 6.13 Add atmosphere to the background.

ADDING LIGHTING TO THE SCENE

Lighting is added to the underpass by creating several layer groups that represent the area of focus. You can easily use a single layer if you like. I did this for better control. The Layer Blend mode of each layer was set to Color Dodge so that the color illuminated the structure. I created a red and yellow glow on the edges of the overpass by hand painting onto it with a soft-edged brush. Next, I added some greenish glows to reflect the fluorescent light that I will create in the next example. Figure 6.14 shows the Brush properties that were used as well. As you can see, it is a simple soft brush.

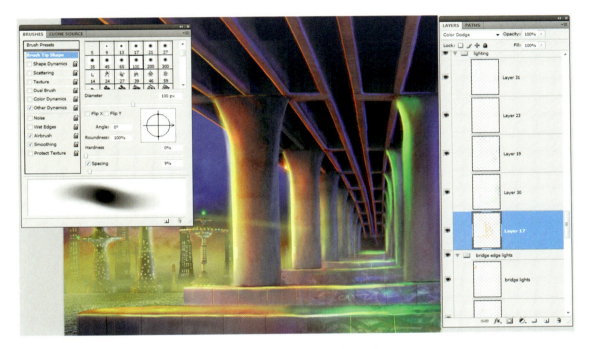

FIGURE 6.14 Colored lighting is painted onto the overpass.

I created the fluorescent lighting using the same technique shown in Figure 6.15. I just drew in the linear light shapes on a layer that was set to the Color Dodge Layer Blend mode. I then added the light as greenish glows to the inside of the pillars to simulate the light spill off. Let's go add the 3D models to the scene.

FIGURE 6.15 Green fluorescent lighting is painted onto the pillars.

CREATING THE BACKGROUND

Now here comes the really fun stuff—3D in Photoshop! I imported the ship from LightWave and the pilot from Poser 8 (see Figure 6.16). I used Poser 8 to export the pilot as a LWO (Lightwave 3D object) object and imported him into a layer in LightWave and positioned him into the chair. Now that all of my objects are together, I exported them as an OBJ into the folder where Photoshop could import them.

The 3D ship is imported into a 3D layer via 3D > New Layer from 3D File. In the layers palette, you will see the surface textures listed as they were shown in LightWave.

When I double-click on the "cockpit rim bump" texture layer, I will see the UV Map that produces the stippling surface of the cockpit. Bump maps only work off black-and-white values. Medium gray causes no effect, white produces peaks lifting away from the surface, and black values produce valleys moving below the surface. Figure 6.17 shows how I textured the cockpit using those values where the back grid produced the indentations in the cockpit.

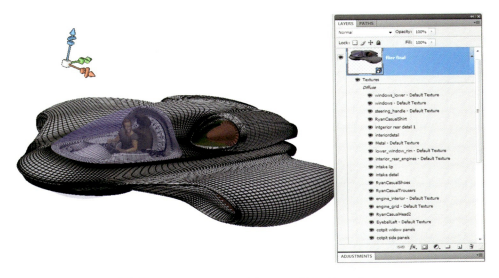

FIGURE 6.16 LightWave model imported into Photoshop.

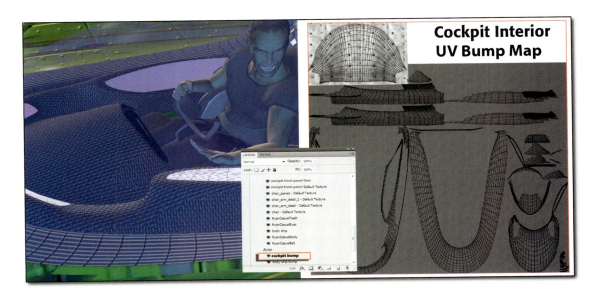

FIGURE 6.17 View of the bump map for the cockpit.

By double-clicking on the "body ship" texture, the UV map is displayed representing the ship's color surface (see Figure 6.18). I chose to texture it using a photograph of dilapidated metal with fading yellow paint. Using Free Transform (Ctrl+T/Cmd+T), I resized it to elongate the scratches along the length of the body to show that the forward motion of the ship produced linear wear (see Figure 6.19). Figure 6.20A displays a close-up view of the top portion of the ship where I added pinstripe details on the wing.

I did not just restrict myself to working on the UV Map. Photoshop CS5 also gives me the ability to edit the texture directly on any surface of the 3D model, as shown in Figure 6.20B. So I used the Stamp tool to clone additional textures on the surface. I made sure that the "Paint On" option in the 3D panel was set to "Diffuse" so that the painting effect only affects that channel.

For the final touches, I added a bump map where the rivets are painted with white dots so that they protrude forward, and the paneling is painted with black to show separation. I made the initial drawing on the Diffuse map and then renamed it as "body ship bump." I then imported it into the bump channel (see Figure 6.20C). I began working on the UV map directly at first, but later I painted directly onto the model making sure that the "Paint On" option was set to "Bump."

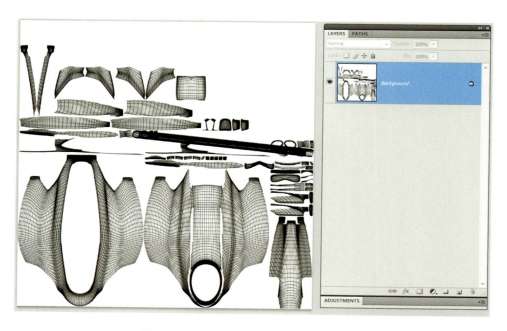

FIGURE 6.18 View of the UV map in Photoshop.

FIGURE 6.19 Place texture into the UV map.

FIGURE 6.20 Close-up view of the top of the ship.

Next, the ship is placed into the topmost layer of the underpass scene and composed so that it is flying out toward the viewer from the lower-left corner of the frame. This is also a good time to merge the layers used to produce the background to conserve on memory. Graffiti is added to the pillar walkways to add some human interest.

Using Your Texture Library

It's important to build up a library of textures of all types because you never know when you will need a particular type of image. I simply chose shots from my graffiti library that I documented over the years. I can't say enough about always carrying your camera to record textures that could be useful for 3D texturing.

Then the images were Free Transformed to match the size and perspective of the concrete face. I altered the Layer Blend mode to Hard Light and lowered the opacity to integrate the texture into the scene more effectively. Use Figure 6.21 as a guide.

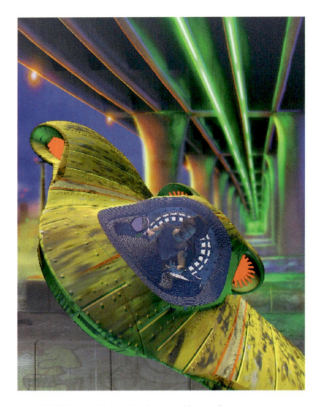

FIGURE 6.21 Place 3D ship into the underpass scene.

Now, I played with the 3D lighting to create some cross lighting from the left side of the ship (see Figure 6.22). As you start to complete your digital painting, you will want to experiment as much as possible with the quality and color of light that will make the 3D object integrate with the scene more believably.

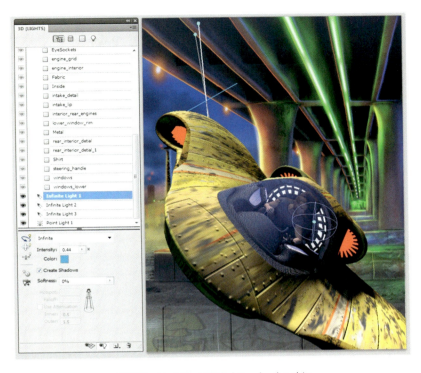

FIGURE 6.22 Adjust 3D lighting for the ship.

CREATING SMOKE AND LASERS

The ship has been hit on one of its wings from a laser blast from behind. Figure 6.23 shows the Brush options that I used. I simply used a soft-edged brush and altered its Scattering properties to create the main effect of the brush. The Other Dynamics option was set to "Pen Pressure" so that I could adjust the opacity of the smoke. With my foreground and background color set to Black and White (D), I alternated between the two colors (X) to paint in white or black smoke coming from the surface of the wing. I included a brush called "smoke brush.abr" for your use in the Tutorials/ch 6 folder. Just load it by using the Load Brushes command through the Brush submenu and chose Append to add the brush to your existing palette.

To create fire, apply red or orange colors into the smoke, as shown in Figure 6.23. To get the Glow effect, change the Blend Mode of the brush to Color Dodge and watch the fire glow over any area to which you apply the brush. I made sure that the color used to paint with matched the color of the area that I would apply it to. Next, Puppet Warp (Edit > Puppet Warp) is used to transform the smoke.

This is one of the new Transform tools in CS5 that I feel will be a favorite among users. It works well here to allow you to shape the direction and flow of the smoke in any direction that you choose.

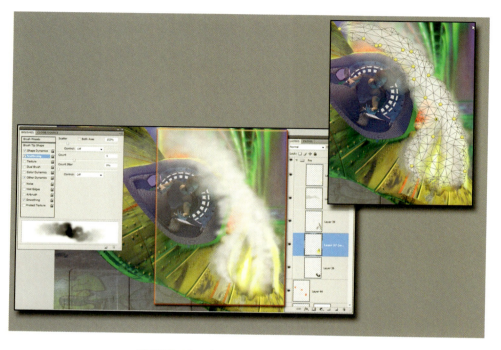

FIGURE 6.23 Paint smoke and fire on the wing.

Now to create a series of laser blasts, I used a simple circular shape created with a soft-edged brush. Start with a rich color on the outside and then apply lighter colors on the inside using a soft-edged brush. When completed, I used the Layer Styles dialog to apply an Outer Glow to the shape (see Figure 6.24). When done, it is elongated into a thin laser-like shape, as shown in Figure 6.25.

I finally added a ship or two to experiment with the placement, in order to accentuate the action in the scene. In addition, the laser was duplicated and adjusted to match the perspective of the shape traveling from the background toward the foreground. One laser hit the wing (see Figure 6.26).

For finishing touches, I felt that the colors were too independent, so I added a gradient with green on top and yellow on the bottom to blend all of the colors more harmoniously (see Figure 6.27). I changed the Blend Mode to Screen and added a layer mask to allow only select elements to come forward with their original color.

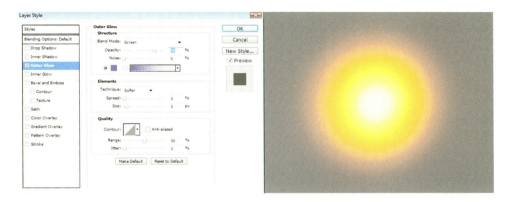

FIGURE 6.24 Initial start for the laser.

FIGURE 6.25 Elongate the shape.

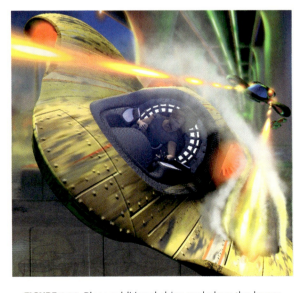

FIGURE 6.26 Place additional ships and place the lasers.

That's it. Figure 6.28 displays the final view with a little extra added smoke, contrast, and the background darkened to bring out the ship visually toward the foreground.

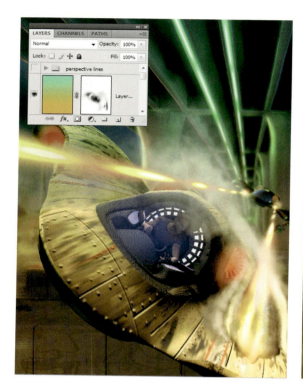

FIGURE 6.27 Gradient added to harmonize the colors in the scene.

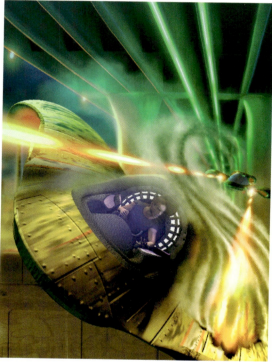

FIGURE 6.28 Jan./Feb. 2010 *Photoshop Users* magazine cover.

As you can see, *Photoshop User's Magazine* chose to flip the image to lead the eye into the pages. Figure 6.29 shows the cover shot of the image.

FIGURE 6.29 Final results.

WHAT YOU HAVE LEARNED

- CS5 will accept any 3D object from any program as an Obj.
- You can apply lighting techniques using Layer Blend Modes.
- You can conform your scene to a custom perspective.
- UV maps created in a 3D program will be recognized in CS5's 3D texture layers.
- Puppet Warp is a very reliable tool for transforming smoke.

3D INTEGRATION FOR DESIGNERS

IN THIS CHAPTER

- Use 3DVIA to import 3D models
- Composite 3D objects into another 3D scene
- Texture your model using photographs
- Edit the surfaces of third-party 3D objects
- Create reflection maps
- Create bump maps using photographs

This chapter is written for the artist who has little or no knowledge in 3D creation but desires to add 3D content to his or her workflow. We will accomplish this through the use of an online database that will provide quite a bit of the 3D content that you can use for your personal projects. Although we will provide a few companies for you to consider, we will focus on one online company that has created a plug-in for CS5 that can import 3D objects directly into the 3D layers. The company is 3DVIA (www.3dvia.com).

We are going illustrate an automobile that is downloaded from 3DVIA to use as the main character in our scene. We will illustrate it by showing it speeding through a downtown street of a city block that we will also download through the 3DVIA database.

IMPORTING 3D USING 3DVIA

Let's look at some potential online databases where you can download 3D objects and import and texture them to your needs. There are a few companies that use 3D content for you to consider: 3DVIA (www.3dvia.com), Artist 3D (http://artist-3d .com/), Quality 3D Models (www.quality3dmodels.com/), 3D ContentCentral (www.3dcontentcentral.com), DAZ 3D (www.daz3d.com), and Content Paradise (www.contentparadise.com/) to mention a few.

The one that we will focus on for this tutorial is 3DVIA. 3DVIA is owned by Dassault Systèmes (www.3ds.com), which specializes in CAD-based products. After seeing the need for an extensive 3D database similar to what Corbis & Getty Images had done for photography, Dassault Systèmes created 3DVIA. We will use their 3D importer plug-in for Photoshop to import the models for this tutorial. You can find their plug-in on 3DVIA's Web site at www.3dvia.com/ products/3dvia-for-adobe-photoshop or on my personal Web site at www.chromeallusion.com/tutorials.html. Please download the plug-in and install it. The plug-ins are designed to function on versions CS3 through CS5 so download and install the one that matches your version of Photoshop and let's begin the importing process.

IMPORTING THIRD-PARTY 3D OBJECTS

We are going to create a scene with a concept automobile speeding through the wet streets of a downtown city.

1. Access the import command (File > Import) and select "search 3DVIA" (see Figure 7.1).

Content Files for This Chapter

You can follow along with this tutorial by downloading the content files from www.chromeallusion.com/tutorials.html so look for the section titled "3D IN PHOTOSHOP EXTENDED." Download and expand the zipped files into a folder titled "downloads," because I will refer to this for any content files that you will need for this tutorial. Also, the 3D files used in this tutorial are included in the content files as well. So, let's download a 3D city and a sporty automobile through 3DVIA.

2. The "search 3DVIA" importer will open the model Search dialog box that will allow you to search by model type and by the name of the model. You will also be given options to search through the store where you will usually find some of the better models; however, I have found that the Community models are quite detailed. In this example "Porsche" was entered into the search box and a fairly attractive model was chosen (see Figure 7.2).

3. Notice that the format of this model is 3D XML. This is a proprietary format designed by Dassault Systèmes for a seamless transfer from their Web-based system (3DVIA) into Photoshop's 3D layers. After you have imported the concept car, browse through the database to acquire your city titled "City Block." We have provided both files for you in a PSD format so access your downloads folder and open "skyscaper.psd" and "Porsche.psd" (see Figures 7.3 and 7.4).

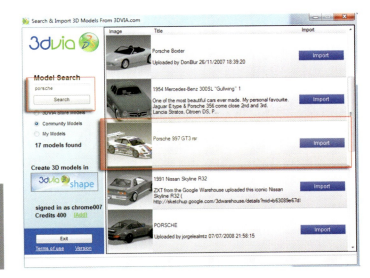

FIGURE 7.1 Access the Import command.

FIGURE 7.2 Choose from the 3DVIA database.

FIGURE 7.3 Open "porsche.psd."

FIGURE 7.4 Open "skyscraper.psd."

CREATING THE LAYOUT

Now we are going to position the 3D models to be in line with the concept of the car speeding through city streets.

1. Create a new document with the dimensions of 7.25" × 9" with 150ppi resolution. This resolution is just for tutorial purposes so that we can work quickly together.
2. Place both the car and the skyscraper objects in the new document. Each 3D object will occupy its own layer, as shown in Figure 7.5.
3. Access the 3D Mesh panel (Window > 3D), as shown in Figure 7.6. Along the top of the panel, click the first icon on the left to display the 3D Mesh options. On the bottom right of the panel, click and hold on the icon on the far left to see the visibility options for the varied 3D components. Select Show All and instantly you can see outlines that represent 3D Axis, 3D Ground Plane, 3D Light, and 3D Selection. This will help you to keep track of where things are as we navigate through the scene to compose it and give it texture.

Zoom out of the document to observe the changes as to how your 3D space is displayed (see Figure 7.7). CS5 will keep all 3D elements visual, even beyond the borders of the document.

Now zoom in a little closer to get a better view of the streets from overhead (see Figure 7.8). We will set up the scene for the car to be placed on one of roads and have it surrounded by buildings.

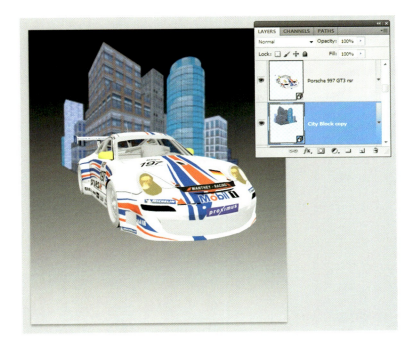

FIGURE 7.5 Place the 3D objects into the new document.

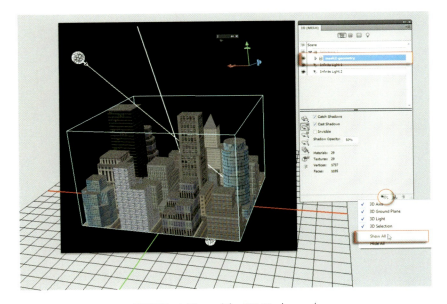

FIGURE 7.6 View of the 3D Mesh panel.

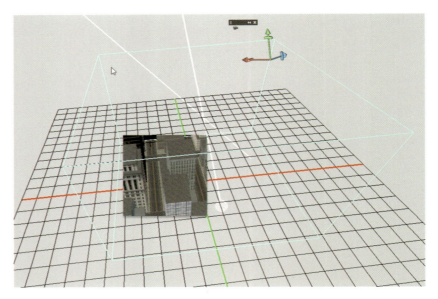

FIGURE 7.7 View of the zoomed-out document.

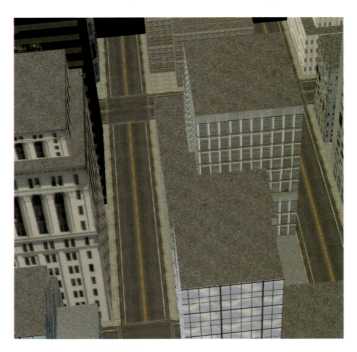

FIGURE 7.8 Get a closer view of the street.

 Merging 3D Layers

CS5 has the capability to merge both objects into a single layer using the Merge 3D Layers command so that both can be lit with the same light source with the shadows and reflections affecting one another. However, third-party models created by a community of artists are not always reliable. This could be due to how well the mesh of a 3D object was constructed, so to keep matters simple, let's keep each object on its own 3D layer.

4. Make sure that the skyscraper layer is selected and navigate the Camera (N) so that it is close to street level with the front of the buildings in the background, as shown in Figure 7.9. Select the camera zoom option on the Options bar. This is where we will set the focal length of the camera. To consolidate the field of view for both of the 3D layers, you will need to adjust the focal length of the camera toward a unified focal length, so set the focal length to 100 for both objects. Now select the car layer and access the 3D Navigation tools (K) and navigate the 3D object itself to be positioned over the street. Try to get something close to what you see in Figure 7.9.

FIGURE 7.9 Compose the scene.

5. The light source will come from slightly behind the car, so position two of the infinite lights in such a way that one will be the main light from behind and the other will be a fill light from the right side.

CS5 generally allows for the shadow of the 3D object to appear on the ground plane of the 3D model, but this is not always the case with third-party 3D objects like the ones that we just downloaded from 3DVIA. These models have been created by individuals and submitted to the Web site, so depending on the settings and the 3D application that created the objects, CS5 may or may not recognize the ground plane. To give our concept car a sense of placement on the ground plane, add a shadow on a separate layer beneath the car, as shown in Figure 7.10. Change the layer's Blend Mode to Multiply and reduce the opacity a bit and let's continue.

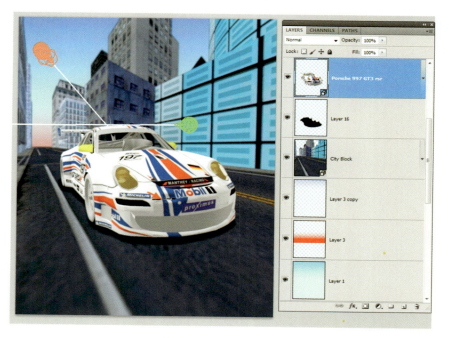

FIGURE 7.10 Add shadow for the car.

6. Now let's add the sky to the background. This is done with gradients situated on their own layers. Create the gradient on a new layer using a light to darker blue color. On top of that, create a reddish gradient that falls off to 0% opacity toward the top of the composition. Create another layer on top of the red gradient and create a dark blue to 0% transparency toward the lower three-quarter portion of the image. Use Figure 7.11 as a guide.

7. Next, let's add some clouds to add some interest in the sky (see Figure 7.12). Access the downloads folder and open the "clouds.jpg" and place it above the blue gradient. Resize and place the clouds into the sky behind the skyscrapers and reduce the opacity to allow some of the sky colors to come through. Duplicate the clouds and then resize and offset them to get more interesting visuals in the sky region. Experiment with this.

FIGURE 7.11 Add sky to the scene.

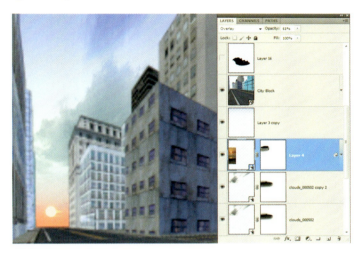

FIGURE 7.12 Add clouds to the scene.

8. Now, focus on the layer titled "City Block" and look at the textures associated with it. If you place your cursor on the second one down with "road straight" in the title, you will get a thumbnail view of the texture. Double-click this texture and let's edit it (see Figure 7.13)

FIGURE 7.13 View road texture.

9. By default, many of these textures will have a resolution of 72ppi. To get more details, we need to redefine the texture to a higher resolution. Change the Resolution in the Image Size properties (Image > Image Size) to 200ppi instead (see Figure 7.14).

FIGURE 7.14 Change texture resolution to 200ppi.

10. When we resize the texture in step 9, we have essentially interpolated the image, giving it a low-resolution look. This works because we are now going to add a custom texture to this at a higher resolution starting with vector shapes. Re-create the orange and yellow paint guides using the rectangular vector tools (U), as shown in Figure 7.15. Just simply match the original line's colors. In this example, each vector shape is on its own layer. Next, we will add a higher resolution image to add concrete-like texture to the street and sidewalk.

11. Access your downloads folder and open "concrete.jpg." Place the texture below the vector shapes, as shown in Figure 7.16.

12. Use the Stamp and the Patch tool to get an even consistent texture, as shown in Figure 7.17. When using the Patch tool, just draw a selection around the crack and click and hold your mouse from inside the selection and drag toward an area that has good texture. You will see a preview of what you will get as an end result. When satisfied, just release your mouse to see a more seamless result.

FIGURE 7.15 Re-create lines using a vector shape tool.

FIGURE 7.16 Place "concrete.jpg" into a new layer.

FIGURE 7.17 Use the Stamp and the Patch tool to edit the texture.

13. The goal is to use the new texture to match the size of the texture informa-
tion in the base image. Use Free Transform (Ctrl+T/Cmd+T) and resize it.
Then select it and create a new pattern, as shown in Figure 7.18. Then fill the
layer with that texture (Edit > Define Pattern). Under the Content menu,
choose the pattern that you just created and click OK.
14. Fill the layer with the newly defined pattern and add some noise (see Figure
7.19).

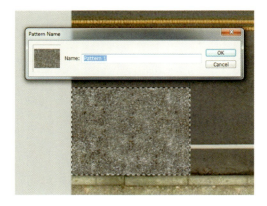
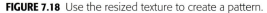
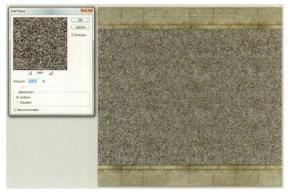

FIGURE 7.18 Use the resized texture to create a pattern.

FIGURE 7.19 Fill the layer with the
new pattern and add noise.

15. Let's get the painted stripes to blend with the texture, so change the Blend Modes of the vector shapes to Overlay. To keep organized, place the painted shapes and texture into a new layer group titled "painted stripes" (see Figure 7.20).

FIGURE 7.20 Change the Blend Modes of the vector shapes to Overlay.

16. Create a new layer above the "painted stripes" layer group and change the Blend Mode to Multiply. Use a soft-edged paint brush to paint black into the layer to give a feeling of ground-in dirt into the road, as shown in Figure 7.21.

17. We are going to use another texture to add more detail to the street. Open "wall texture 002.jpg.," as shown in Figure 7.22.
 Use the Patch tool to make a seamless texture similar to what was done in Figure 7.23. Just as you did in Figure 7.17, draw a selection around the crack and click and hold your mouse from inside the selection; then drag toward an area that has good texture. When satisfied, just release your mouse to see a more seamless result.

18. Change the Blend Mode to Overlay to increase the contrast so the texture integrates with the road underneath it harmoniously. Position the texture to the top half of the composition and duplicate it to cover the bottom half. Use layer masks to blend the two layers seamlessly, as shown in Figure 7.24.

FIGURE 7.21 Apply dirt to the road.

FIGURE 7.22 Open "wall texture 002.jpg."

FIGURE 7.23 Edit "wall texture 002.jpg" with the Patch tool.

FIGURE 7.24 Increase the texture's contrast and duplicate it to cover the entire canvas.

19. The car will be driving along a rundown section of town, and the roads need some repair so let's illustrate this further (see Figure 7.25). Select a portion of the "wall texture 002.jpg" that represents the long crack and place it in a new layer of the street texture. Change its Blend Mode to Hard Light and position it so the crack is inside the double yellow line.

FIGURE 7.25 Apply a cracked surface to the center of the street.

20. Use the layer mask to soften the edges to blend into the scene (see Figure 7.26).

FIGURE 7.26 Use layer mask to edit the texture.

21. Finally, add another texture from the downloads folder titled "wall texture 003.jpg." Place this on its own layer and change its Blend Mode to Linear Light. This Blend Mode will help the highlights in the texture jump out in a stronger fashion (see Figure 7.27). Since we want to have some control of the lighter tones, reduce the opacity to approximately 26%.

FIGURE 7.27 Apply additional texture to the road.

22. Now, click Ctrl+S/Cmd+S to save the texture and take a look at the 3D object to see the results (see Figure 7.28).

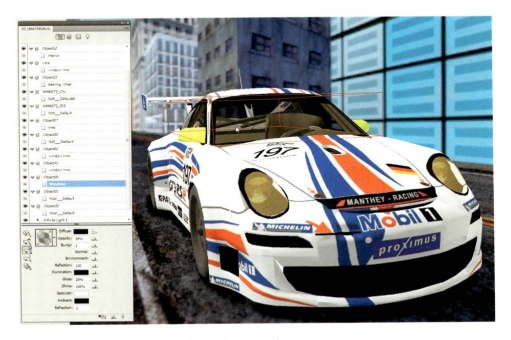

FIGURE 7.28 Save the texture.

ALTERING THE SURFACE OF THE CAR

In this exercise, we will add a little more character to the car by altering its color and surface attributes to receive reflections.

1. Select the Porsche layer, access the 3D Mesh panel (Window > 3D), and look for the "object 11" object. Underneath it, you will see two textures. The one that you are interested in is "N19r___Default." To differentiate it from the other textures, rename it "car body." Access the Diffuse submenu and select Open Texture. The texture will be white so duplicate the layer and change the Blend Mode to Darken More. Now create a new layer underneath it and fill with a yellow hue similar to what you see in Figure 7.29.

2. Press Ctrl+S/Cmd+S to save the texture, and you should see something similar to Figure 7.30.

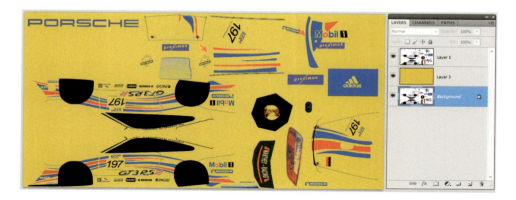

FIGURE 7.29 Access the Porsche texture and change the body color to yellow.

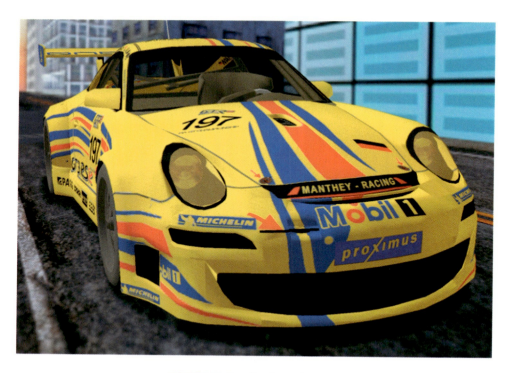

FIGURE 7.30 Results of saved texture.

3. Next, we will add some reflection to the body of the car. Make sure that the "car body" material is still selected. The idea is to get the background to reflect into the surface of the car. Hide the car layer so that all you see is the city and the sky. Now just save this as a JPG and name it "IBL background.jpg." Open the submenu for Environment and load the background image.

Turn on the Reflection to 80%, and you will see the reflection of the background show up on the surface of the Porsche (see Figure 7.31).

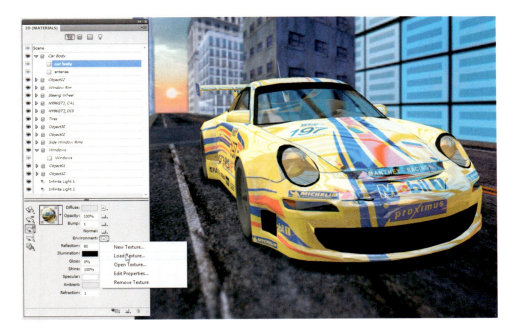

FIGURE 7.31 Add reflection to the car's surface.

4. Now add a new IBL source and use the same background as the image to light the car.

Click on the Add New Light Source icon and select "New Image Based Lights." Now that the light has been added to the scene, all you need to do is select the image that it will use and light the model. Take note that a 3D navigational sphere for the IBL will be displayed to facilitate navigating the light.

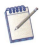

Using Any Image for Image Based Lights

Although it is customary to add 360-degree panoramic HDR images, it is important to know that you can use any bitmap image. That is what we will do in this situation.

5. Inside the 3D Lighting panel, click on the add image icon that is next to the "Image" title located below the color swatch (see Figure 7.32). Navigate to your downloads folder and select "ibl ligtsource.jpg." This is the merged imagery of the background scene.

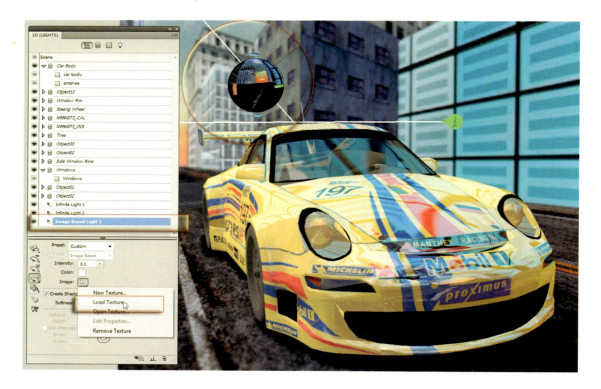

FIGURE 7.32 Add image-based lighting to the automobile.

6. It is a good idea to match the ambient light in the scene. You can select any color you like and see how this feature will affect the car, so play around with it. In this example, the bluish horizon was chosen (see Figure 7.33).

7. Now let's add some ambient lighting to the city block (see Figure 7.34). Select that layer, and this time, choose a more bluish color within the clouds. Since this portion of the buildings is mostly in shadow, we will allow it to be dominated by the bluish temperature that often dominates the shadow regions of a photographic image.

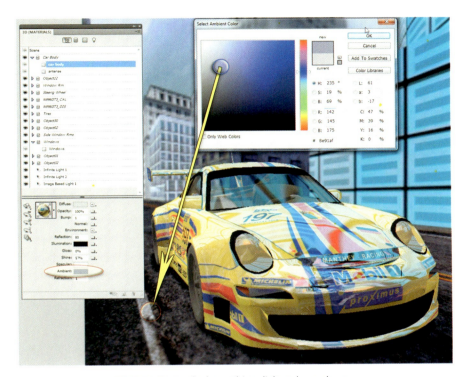

FIGURE 7.33 Apply the ambient light color to the car.

FIGURE 7.34 Select the ambient color for the city block.

ADDING LOCALIZED BUMP AND REFLECTIVE CHARACTERISTICS

We are going to finish up a few details on the cityscape behind the car. We will add localized bump and reflective details to the buildings, as well as the setting between the buildings.

1. Turn off the car layer temporarily to have less distraction and focus on the building to the right, as shown in Figure 7.35.

FIGURE 7.35 View of the building on the right with the car layer hidden.

2. Make sure that you have the 3D Materials panel open (Window > 3D). Find the surface attributes for the face of the building that you see in Figure 7.35. The material is titled "GraphicMaterial_32." Use "building reflect.jpg" from the Tutorials/ch 7 folder on the DVD to load in the Reflection properties. Rename it something easy to remember like "building texture," as shown in Figure 7.36.

This image is simply the black-and-white version of the original color image. The window regions were selected with the Polygonal selections tool and filled with white on a separate layer. The background layer was then filled with black, which ensures that only the windows will have reflective properties.

3. We will create the bump map in a similar way. Figure 7.37 is a black-and-white version of the color map. Just like the reflective map, the white areas will rise to display peaks, and the black areas will have no effect. Now, load "building bump.jpg" into the Bump properties of "building texture," as shown in Figure 7.37.

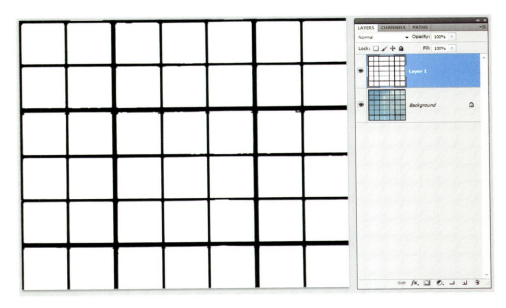

FIGURE 7.36 Load "building reflect.jpg" into the Reflection properties of the "GraphicMaterial_32" surface.

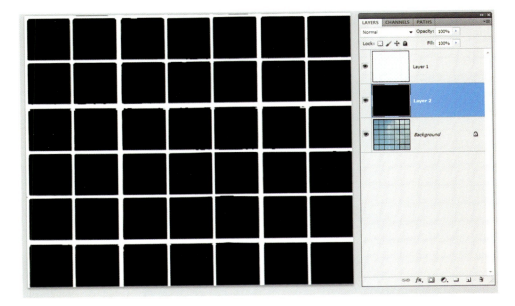

FIGURE 7.37 Load "building bump.jpg" into the Bump properties of the "building texture" surface.

4. In our 3D Scene Panel (Window > 3D), access the Quality drop-down menu and select "Ray Traced Final" to see the results (see Figure 7.38). You will initially see a square grid pattern moving across the image. This grid is simply making several passes to improve the final render by minimizing noise. You should only see the reflections from the surfaces of the neighboring building within the glass windows as a result of the reflection map. Also, the white-colored supports appear to rise forward, which are the white colors in that region of the bump map.

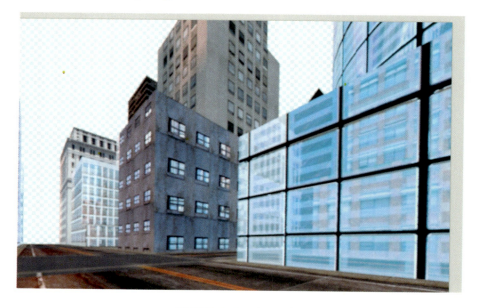

FIGURE 7.38 Render results.

ADDING DEPTH OF FIELD

We are about to do something really fun and add the splash that is caused by the speeding car. In addition, we will use the new DOF (Depth of Field) features in the Camera Zoom tool to limit the focus on the main character, which is the concept car.

1. Let's start with the car to apply the new DOF feature. Select the 3D Zoom Camera tool. On the Options Palette, there are two variables that we are interested in. One is the DOF Blur, which establishes the strength of the blur, and the other is Distance, which will set the plane of focus. In this example, the Distance is set so that the rear of the car begins to blur into the distance (see Figure 7.39).

FIGURE 7.39 Set the DOF Blur and Distance to blur the rear of the car.

2. Do the same thing for the city, but set the Distance so that the rear of the image is blurred and the foreground is more in focus (see Figure 7.40). Also apply some Gaussian Blur (Filter > Blur > Gaussian Blur) to the sunset to honor our chosen depth of focus.

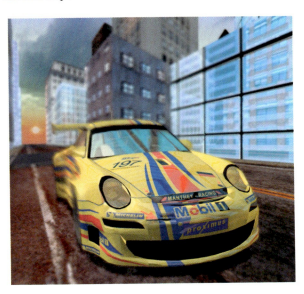

FIGURE 7.40 Set the DOF Blur and Distance to blur the city.

FINISHING TOUCHES

Now let's make the car stand out and add some motion to its surroundings to give it movement.

1. Duplicate the city layer and convert it to a Smart Object (right-click on Layer > Convert to Smart Object). Add some Motion Blur with the Angle set to -29 degrees (see Figure 7.41). Here, the Distance is set to 49, but you can experiment with it. This gives the car a sense of motion and up-and-down movement.

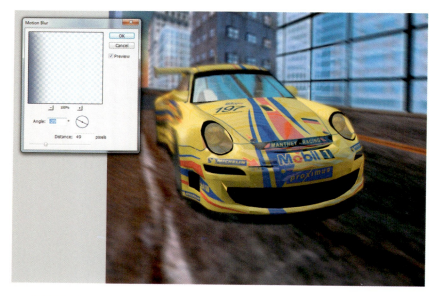

FIGURE 7.41 Apply Motion Blur to get a sense of movement through the streets.

2. Enhance the headlights by painting a white oval shape over the lenses in one layer. Then apply Lens Flare to a medium gray-filled layer. Change the Blend Mode to Hard Light to get rid of the gray and gain more intensified highlights. Position them over the headlights (see Figure 7.42).

3. Create a new layer above the Lens Flare that you created in Figure 7.42 and change the Blend Mode to Color Dodge. Now just paint with white on the ground below the headlights.

 To create a light spill onto the street, use a separate layer set to Overlay and paint with white on to the street. Finally, add a Curves Adjustment layer to darken the city and the sky. Figure 7.43 shows the final ray-traced render. We'll apply CS5 to a more artsy concept in Chapter 8.

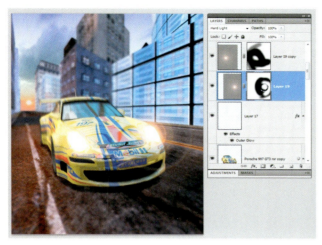

FIGURE 7.42 Add a light source to the headlights.

FIGURE 7.43 Completed ray-traced view of the scene.

WHAT YOU HAVE LEARNED

- You do not have to design 3D to use it in your workflow.
- You can use online 3D databases to use 3D in your work.
- 3DVIA is ideal due to its plug-in for Photoshop.
- 3D should be used as a means to illustrate an idea.
- Sometimes, it is more beneficial not to merge 3D layers into a single scene.
- It is better to create bump and reflection maps from the image in the color channel.

FINE ART APPLICATION WITH CS5

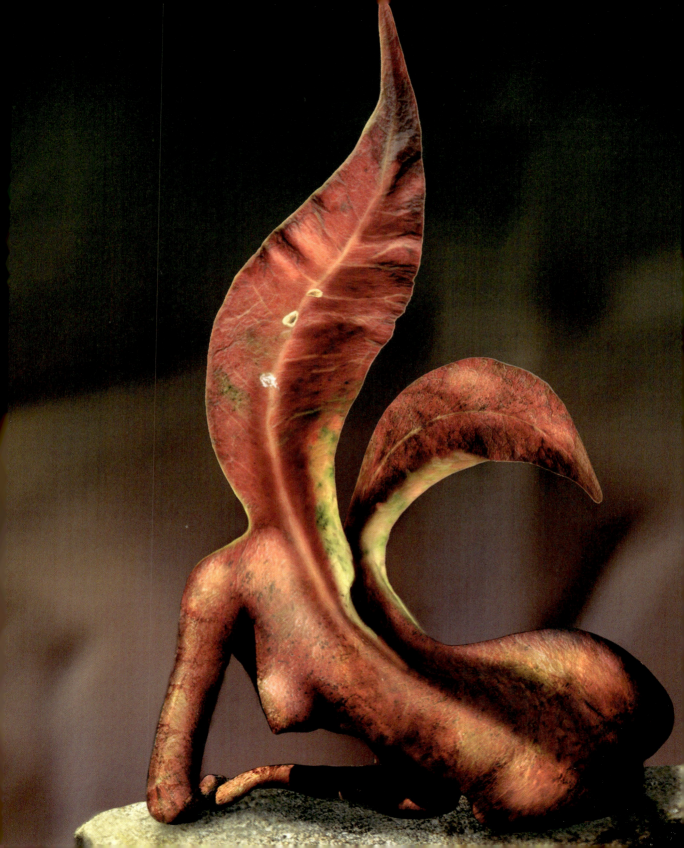

ALTERING THE RECLINING FIGURE

This chapter is an exercise in creativity. It should challenge you to create beyond the obvious and move toward a more expressive approach with digital tools. Keep in mind that simplicity is often the key to making interesting and effective imagery. Hopefully, this chapter will challenge you to understand that what you say with your tools is just as important as the technique used.

I will take a reclining figure and alter it to become something more sculptural and interesting.

1. In the Tutorials/ch 8 folder, open "reclining portrait.tif" and place it in the bottom portion of a 7.23 × 9-inch document with 150ppi resolution (see Figure 8.1). The portrait is a reclining woman on top of a flat-surfaced boulder. Human figures are ideal for blending with textures. Use the Quick Selection tool (W) to select the portrait.

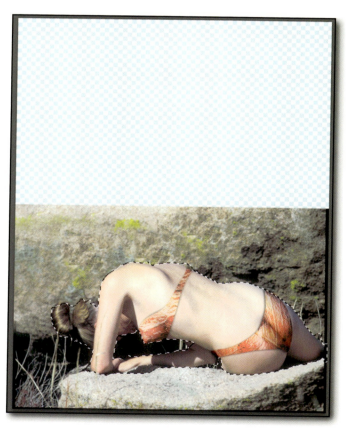

FIGURE 8.1 Open the portrait.

The technical goal at this point is to separate the portrait from the stone slab and place it and the slab into their own layers. This will give us some flexibility to create the various elements to complete the image.

2. Now that you have marching ants around your subject, activate Refine Mask (Select > Refine Mask). By default, you will see the result of the selection against a white background, as shown in Figure 8.2. Notice that the edges are not as clean as they should be. We will address that next.

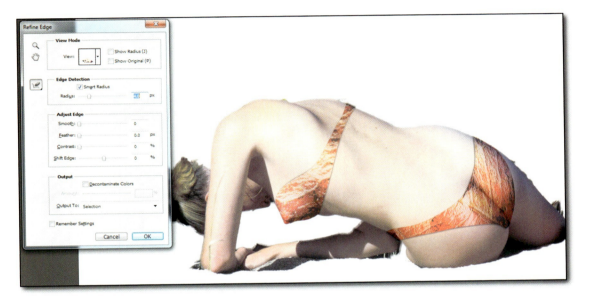

FIGURE 8.2 Activate Refine Mask.

3. Go to the Refine Edge command (Select > Refine Edge) and make adjustments to the Smooth, Feather, Contrast, and Adjust Edge sliders until you see something similar to Figure 8.3. To assist you better, you might want to view the result in background color in Refine Mask, as that will give you more contrast from the main subject (see Figure 8.4).

4. When complete, commit the result as a layer mask. Also, duplicate the original background and apply Refine Mask to the stone slab that the model is on (see Figure 8.5). In addition to your background, you should have one layer with a mask for the model and the other with a mask for the stone slab. The slab will not look perfect so we will modify it in the next step.

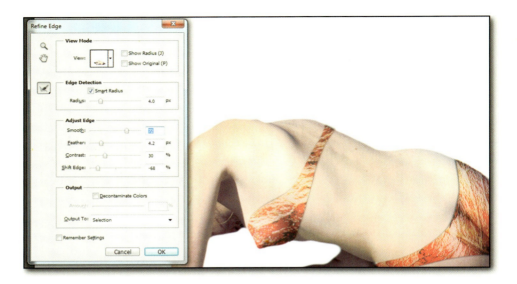

FIGURE 8.3 Refine the edge of your subject using Refine Mask.

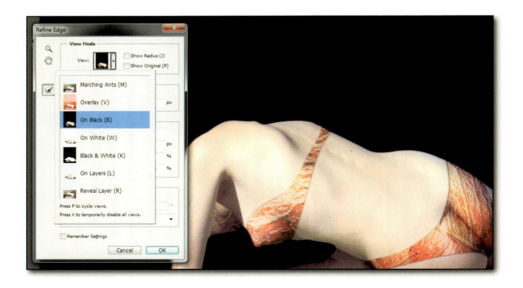

FIGURE 8.4 In Refine Mask, view the image with a black background.

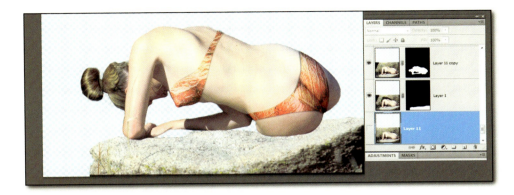

FIGURE 8.5 Also apply Refine Mask to the stone slab.

5. Use Figures 8.6 through 8.8 to create a brush that you will use to sculpt the stone slab a bit.

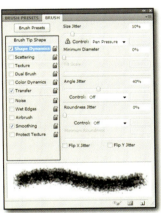

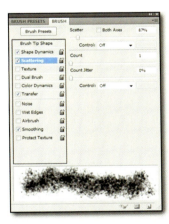

FIGURE 8.6 Choose the speckled brush from the Options palette.

FIGURE 8.7 Adjust the Shape Dynamics.

FIGURE 8.8 Adjust the Scattering.

6. Activate your Stamp tool (S) and select the layer with the stone slab. Use the Stamp tool to reshape the slab, as shown in Figure 8.9.

FIGURE 8.9 Use the Stamp tool to reshape the stone slab.

7. It is a good idea to keep the original masked layers, in the event that you need to go back later to make any modifications. Duplicate each layer and apply the mask (right-click on the layer mask > Apply Layer Mask) so that you just have the cut-out image on a blank layer. Looking at the Layers Palette in Figure 8.10, you can see the original image is on its own hidden layer, just in case you need an unaltered version later.

You should have one layer with a mask for the model, the other with a mask for the stone slab, and two layers without the mask.

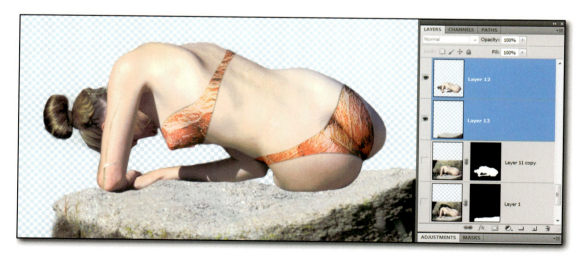

FIGURE 8.10 Apply layer masks to the image.

8. Now that you have each compositional element on its own layer, let's alter the portrait a bit. Apply Puppet Warp, which is new to CS5, and place an anchor at the base of the hip (see Figure 8.11).

FIGURE 8.11 Apply Puppet Warp.

9. Place another anchor at the base of the shoulder blade, as seen in Figure 8.12.

FIGURE 8.12 Place anchor at the base of the shoulder blade.

Deactivate Snap

Make sure to turn off Snap (View > Snap) so that you have complete control of how you want to alter the Puppet Warp mesh.

10. Select the point underneath the shoulder blade and hold down the Alt/Opt key. You will see a circle around the point, denoting that you can rotate the image that it is attached to. Rotate the image approximately 35 degrees clockwise (see Figure 8.13). Add more points around the figure so that you force the model's forearm to rest on top of the stone slab, similar to the original scene.

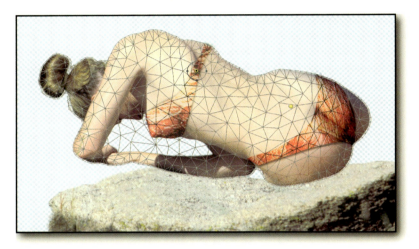

FIGURE 8.13 Rotate the upper portion of the image to the right.

Delete a Point

To delete a point in Puppet Warp, just hold down the Alt/Opt key and click on the point. Notice that you get a scissors symbol to denote cutting away the point.

11. Place a number of points around the perimeter of the portrait to reshape the body to be thinner and more shapely. Your results do not have to be exact, as you can see in Figure 8.14, but experiment to get something that you like.

FIGURE 8.14 Add more points to shape the model.

ADDING TEXTURE TO THE FIGURE

In this section, we will blend the texture of a reddish leaf into the skin. Blending the concept of the animate, which is represented by the portrait, and the inanimate, represented by the texture, will serve to produce some interesting results.

1. In the Tutorials/ch 8 folder, open "red leaf2.tif." The leaf will already be on a transparent layer. Place the leaf above the portrait and change its Blend Mode to Linear Burn (see Figure 8.15).

FIGURE 8.15 Apply Linear Burn to the leaf above the portrait.

2. Use the stem of the leaf and mold it to the shape of the model's spine. Use Puppet Warp to accomplish this, as shown in Figure 8.16.

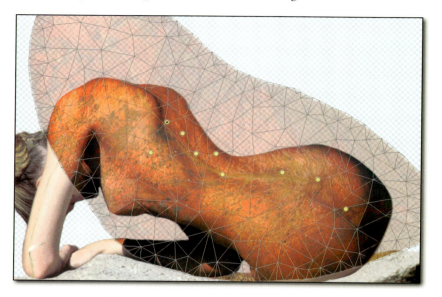

FIGURE 8.16 Use Puppet Warp to shape the leaf.

3. Apply the leaf as a clipping path to the portrait (see Figure 8.17).

FIGURE 8.17 Apply leaf clipping path.

4. Now that we have a clipping path, the leaf can only be seen within the shape of the model. So continue to mold it with Warp (Edit > Transform > Warp) to cover the rest of the lower body. Use Figures 8.18 and 8.19 as examples.

FIGURE 8.18 Select a portion of the leaf.

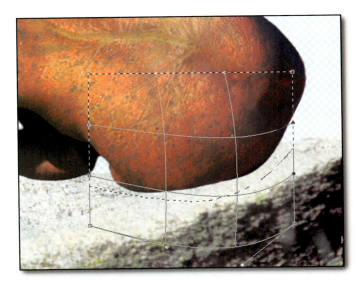

FIGURE 8.19 Use Warp to extend the texture.

5. Next, duplicate the leaf and apply the texture to the arms of the character (see Figure 8.20).

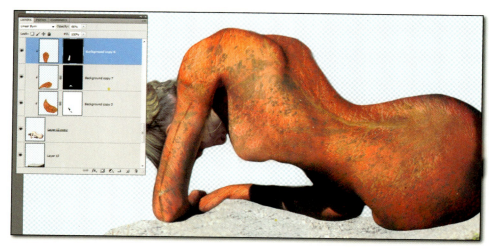

FIGURE 8.20 Apply the leaf to the arms.

6. Open "red leaf.tif" and use Puppet Warp to shape it to point upward, as you can see in Figure 8.21

FIGURE 8.21 Apply the red leaf to the model.

7. It is helpful to use your drawing tools to sketch out the shape that will connect the leaf to the shoulder blades of the character (see Figure 8.22). Also, use the Rotate command (R) to assist you in using the paint tools more effectively.

8. Apply a layer mask to the leaf to blend the leaf to the body, as you see in Figure 8.23.

FIGURE 8.22 Sketch out your form to apply Puppet Warp.

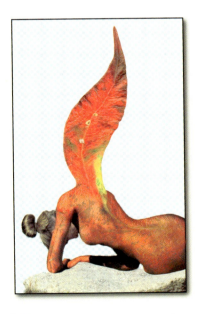

FIGURE 8.23 Blend the leaf with the character.

9. Open "moss.jpg" and change its Blend Mode to Hard Light and use layer mask to blend it with the character (see Figure 8.24).

10. Open "red leaf.tif" again and blend it until you transform it to what you see in Figures 8.25 and 8.26. Use the Warp tool to alter the initial shape and then apply Puppet Warp afterward.

FIGURE 8.24 Blend moss into the character.

FIGURE 8.25 Initially, alter the leaf with the Warp tool.

FIGURE 8.26 Then alter the leaf with the Puppet Warp tool.

11. The image could use a little more contrast so add a Curves Adjustment layer and increase the contrast slightly (see Figure 8.27).

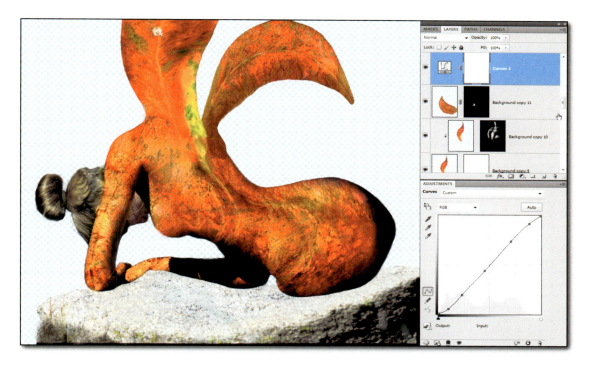

FIGURE 8.27 Apply Curves Adjustment layer to image.

12. Create a new layer and change the Blend Mode to Overlay. Apply this to the stone to warm it up a bit, as shown in Figure 8.28.
13. Open "texture 1.jpg" and apply it as the background to the scene. Alter it into a Smart Filter (Filter > Convert for Smart Filters). Now apply Motion Blur with a Distance of 118 and an Angle of 45 degrees. This will give you a background that will not compete with your point of focus, which is the character, and at the same time, it has some texture in it to provide some visual interest (see Figure 8.29).
14. Create a new layer and use your brush to paint in various shades of green and change the Blend Mode to Hard Light. Now, create a layer mask and apply a gradient to the mask so that the greenish hue is applied to the top portion of the image. If you want a more greenish color, then duplicate the layer and adjust its opacity accordingly, as shown in Figure 8.30.

FIGURE 8.28 Warm up the stone.

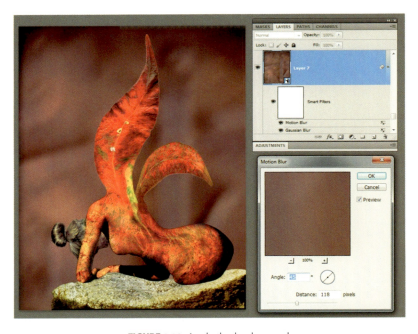

FIGURE 8.29 Apply the background.

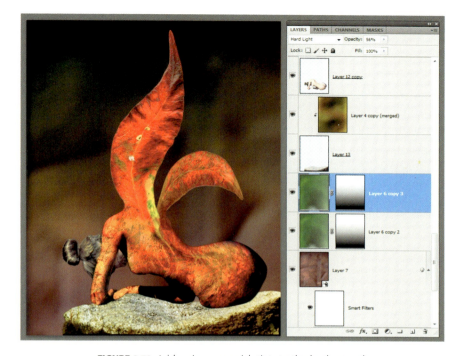

FIGURE 8.30 Add various greenish tints to the background.

15. Next, apply a drop shadow beneath the figure to give a connection to the stone platform (see Figure 8.31).

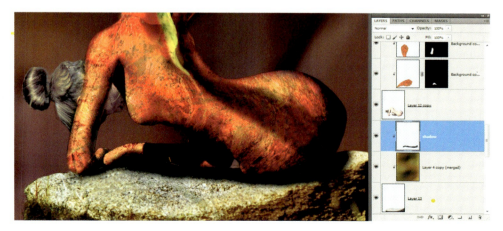

FIGURE 8.31 Create a drop shadow.

16. Figure 8.32 shows the results up to this point, but let's add a slight modification that will give this image more mystery.

17. The image has a strong sculptural appeal to it so why not portray this in a conceptual way. Let's allow the female form to serve as a suggestion of human integration into a sculptural idea. Remove the head using a layer mask attached to the character and now the image takes on a new life of its own (see Figure 8.33).

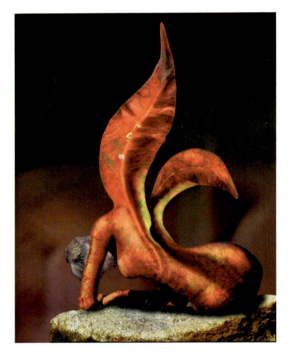

FIGURE 8.32 Results with the head.

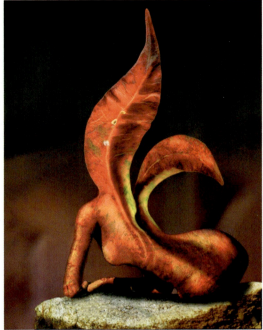

FIGURE 8.33 Results without the head.

18. Finally, add a new layer on top of all layers and change the Blend Mode to Multiply. Paint with black to add some shading to the character. Since the lighting is coming from the upper left, provide the shadows to the right side of any area that will accept it. Figure 8.34 shows the final image.

I hope that you enjoyed that one as well. In our final chapter, we will explore animating your 3D objects using the Animation command.

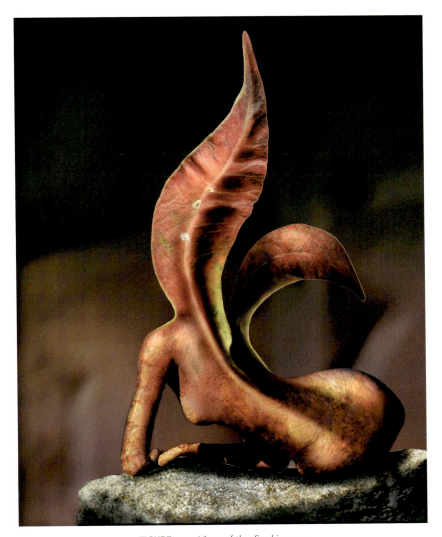

FIGURE 8.34 View of the final image.

WHAT YOU HAVE LEARNED

- To think differently can yield unusual results.
- Experiment with possibilities that go beyond the original photograph.
- You can rotate the points in Puppet Warp by holding down the Alt/Opt key on the keyboard.
- How to use a painterly approach to compositing.

ANIMATING YOUR 3D MODEL

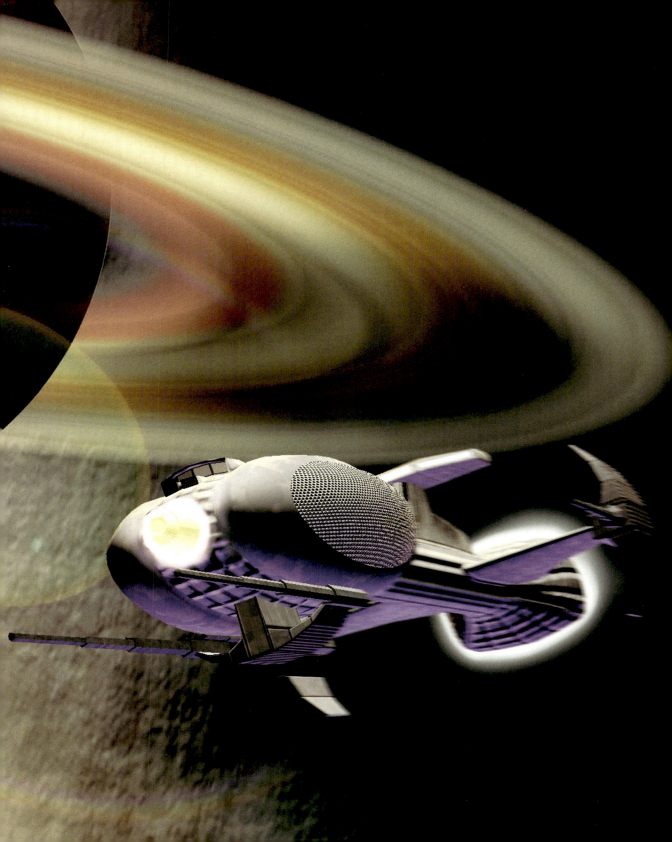

UNDERSTANDING THE ANIMATION TIMELINE

Now that you have a handle on how to texture and integrate 3D objects into your concept art, let's explore another aspect of CS5 Extended. After you have created your scene, what if you want to animate any or all layers in your scene? Photoshop CS5 Extended gives you that capability with the use of the Animation timeline for that purpose.

We are going to start with a finished 3D object image and explain the functionality of the Animation timeline. Keep in mind that the more layers you have open, the greater the amount of memory and processing power CS5 Extended will require. This is particularly true when you activate the Animation timeline. There are three things to keep in mind when applying animation features. First, it is important to realize that if you have high-resolution images that make up the surface textures of your 3D object, this will slow down the computer's resources. So for practice, you might want to consider reducing your textures so that the file size will be reduced to something more manageable. Second, consider reducing the overall size of the file itself. The animation features in Photoshop CS5 Extended are still elementary so be open-minded as to their capabilities and do some experimentation. Finally, make sure that the Rendering intent is set to Solid instead of Ray Tracing and that Draft is chosen for the Anti-Alias setting instead of Best (see Figure 9.1). If you don't choose these settings, CS5 Extended will consistently try to render a higher-quality output each time you apply a change to the timeline.

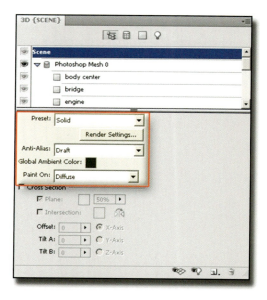

FIGURE 9.1 Change the Render setting to Solid and Anti-Alias to Draft.

To further conserve your resources, merge all of the layers that make up your background so that you have the 3D Object layers above it. For your convenience, you can use the 3D starship and the background located in the Tutorials/ch9 folder. Open the background and place the starship above it. Duplicate the ship twice so that you will have three starship layers. Place them according to what you like for the starting position and let's begin.

1. Open the Animation palette (Windows > Animation) and notice that every layer has been given its own timeline. The layer that you have selected in the Layers palette will be highlighted automatically on the timeline. In this example, you have the background image and three copies of the 3D starship (see Figure 9.2).

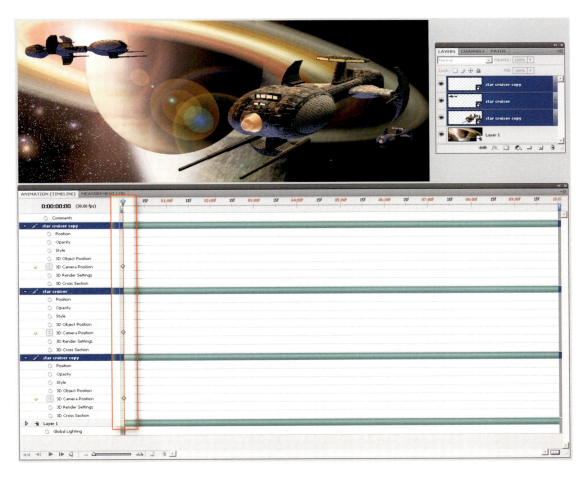

FIGURE 9.2 View of the background and the 3D objects.

2. Select all of the animation attributes for the star cruisers for all of the dupli-
cated 3D objects that you see on the timeline. You can open the animation
attributes by clicking the triangle located to the left of the object's title on the
timeline. You will see the variables to animate for 3D objects (see Figure
9.3). They consist of Position, Opacity, Style, 3D Object Position, 3D Camera,
3D Rendering Setting, and 3D Cross Section. With the playhead at frame "0,"
create a keyframe for the 3D Camera Position for each ship by clicking the
yellow diamond to the left of the timeline title.

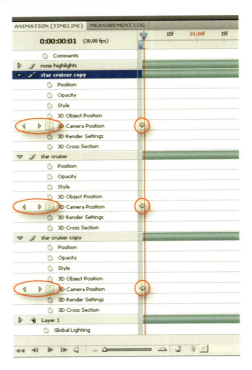

FIGURE 9.3 Create the keyframe at frame "0" for each layer.

3. Let's animate the 3D Camera Position to make the ship fly from the scene
and off the page (see Figure 9.4). Next, move the playhead to approximately
three seconds and move the 3D Camera for the larger ship in the foreground.
Move the ship so the star cruiser is positioned toward the bottom left and off
the canvas. In three seconds, the ship will move from its standing position
and off the page. Do this for all of the other ships by using varying time dis-
tances to portray different speeds for each ship. As you can see in Figure 9.4,
each ship after the larger one is animated later in time to give each one a unique
speed.

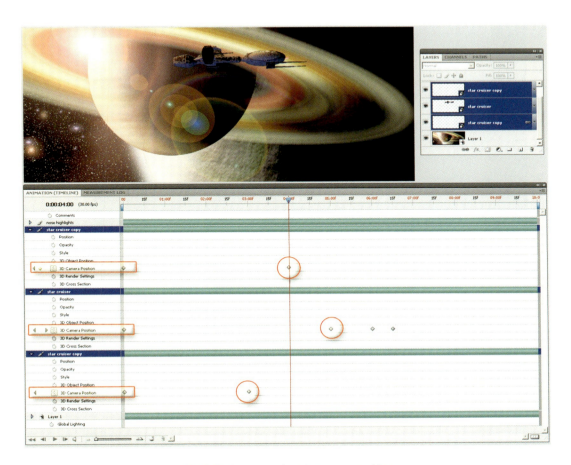

FIGURE 9.4 Animate the 3D Camera Position.

TAKE A CLOSER LOOK AT THE ANIMATION CAPABILITIES

As you can see, you can animate any and all of the 3D ships in any direction that you want, but let's simplify this process and take a closer look at the animation capabilities.

1. Go to your tutorial folder and open "star ship.psd." Use your 3D tools to place the ship in the upper-left portion of the composition. Now, establish a keyframe at frame "0." Use Figure 9.5 as a guide.
2. Place a keyframe at one second and rotate the ship so that it points toward the lower-right corner (see Figure 9.6). Scroll the playhead to see the animation results.

FIGURE 9.5 Open "star ship.psd" and set a keyframe at frame "0."

FIGURE 9.6 Set the keyframe at one second and rotate the ship.

3. Now, place a keyframe at four seconds and move the ship to the lower-right corner and rotate it (see Figure 9.7).
4. Add an additional layer above the star cruiser and with a soft-edged brush, paint a reddish flare that covers the diameter of the starship's engine (see Figure 9.8). Title this layer "flare." Notice that another timeline has automatically been created. Apply some Gaussian Blur to soften the edge. Next, give it a Blend Mode of Lighten. Position it in front of the engines to simulate an energy signature.
5. You will now use the timeline to animate the Opacity of the flare so that it will only become visible as a 1/2-second blast to launch the ship forward. At frame "0," set the flare's Opacity to "0" (see Figure 9.9). The ship will be at its starting position.

FIGURE 9.7 Move the ship to the lower-right corner.

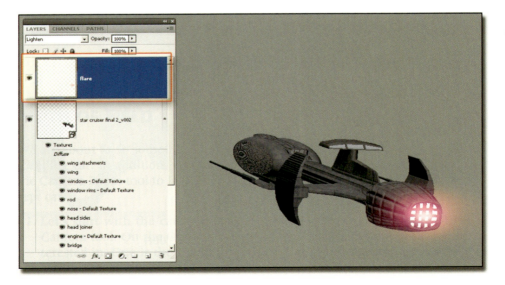

FIGURE 9.8 Create a flare on an additional layer.

FIGURE 9.9 Take the Opacity of the flare to "0."

6. At the "4 second and 15 frame" mark on the timeline, set the flare's Opacity to 100% (see Figure 9.10). In addition, place a keyframe at the same location for the Styles timeline, and we will animate that in the next step. You can animate your layer styles effects as well.

FIGURE 9.10 Take the opacity of the flare to 100%.

7. Double-click the right portion of the flare layer to open the Layer Styles palette. Add an inner shadow using a yellowish color. Also, add an outer glow using the same color and keyframe as the one you used at the five-second mark. Use Figures 9.11 and 9.12 as a guide. Figure 9.13 displays the styles attached to the flare.

FIGURE 9.11 Apply an Inner Shadow style.

FIGURE 9.12 Apply an Outer Glow style.

FIGURE 9.13 Layer styles attached to the flare.

8. Within the next 15 frames, you want simultaneously to move the ship to the upper-left corner and fade the flare effect to 0%. Select both keyframes by selecting one and using the Shift key to select the other. With that keyframe still selected, right-click it and use the Copy and Past Keyframes command to duplicate it into the "5 seconds and 15 frame" location (see Figure 9.14). When you paste it, make sure that the playhead is on the "5 seconds and 15 frame" mark (see Figure 9.15). Now, use your 3D Pan tool to move the ship to the top-left corner and then use the 3D Slide tool to place the ship further into the background (see Figure 9.16). This will simulate the ship moving quickly forward after the energy discharge from the engine. Then set the flare layer opacity to 0%.

FIGURE 9.14 Right-click and choose Copy Keyframes.

FIGURE 9.15 Right-click and choose Paste Keyframes.

FIGURE 9.16 Use 3D navigational tools to reposition the ship.

9. Create another keyframe at "5 seconds and 16 frames" for the ship and use it to make the ship 100% transparent; set its layer opacity to 0%.

You can place any background where you would like to add a story to the scene (see Figure 9.17). I provided a simple one for you called "planet.jpg." Play around with different ways to animate your objects and have fun with them.

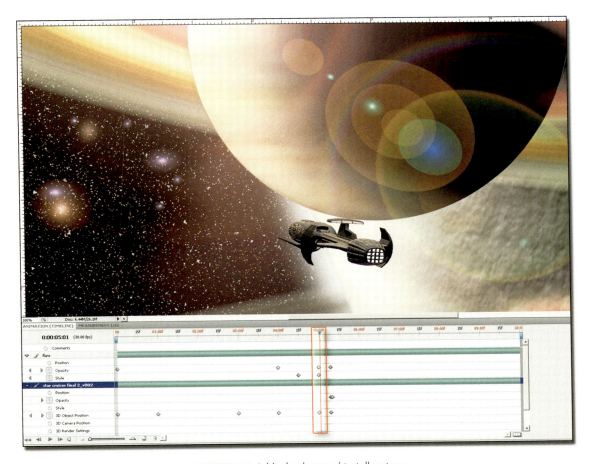

FIGURE 9.17 Add a background to tell a story.

ADDITIONAL NOTES ON ANIMATING EFFECTS

Also, keep in mind that you can animate every 3D feature in CS5 Extended, including color transformations, in the Layer Styles. Figures 9.18 through 9.21 display the color and width of the Stroke being animated over one second of time, as well as an Outer Glow and Color overlay being applied with an additional one second of time.

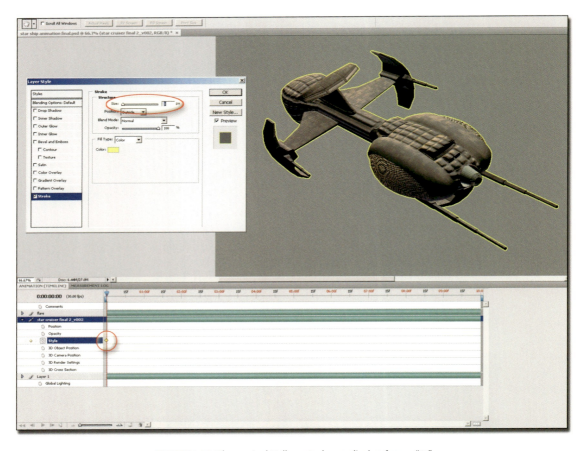

FIGURE 9.18 Three-pixel Yellow stroke applied at frame "0."

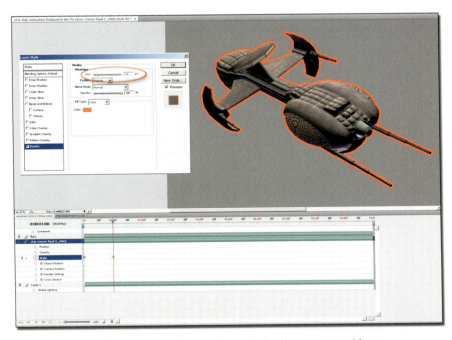

FIGURE 9.19 Ten-pixel Red stroke applied at the one-second frame.

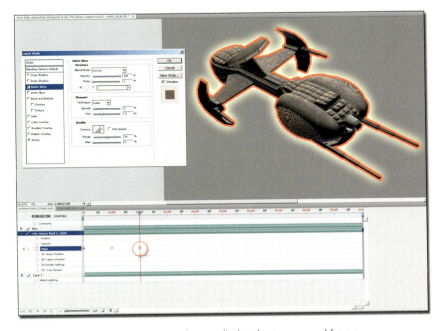

FIGURE 9.20 Outer glow applied at the two-second frame.

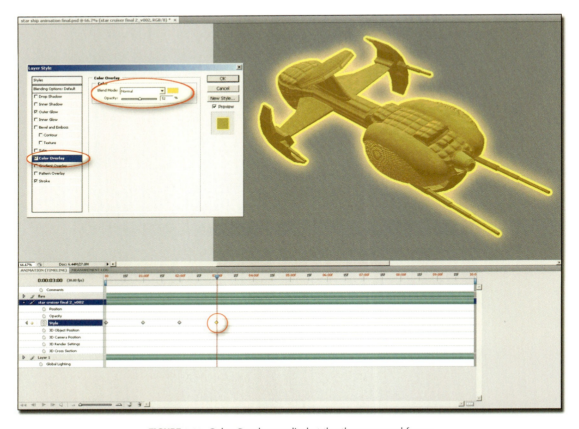

FIGURE 9.21 Color Overlay applied at the three-second frame.

Next, you can animate the Cross Section command. Notice in Figures 9.22 and 9.23 that the Layer Styles effect includes the cutting plane as well.

As a final note, if you want to duplicate a layer with all of the keyframes that you established, then select the timeline for that layer and access your submenu located on the top right-hand corner of your Animation palette and choose Split Layers, as shown in Figure 9.24. This will duplicate both the layer and its timeline so you can add additional objects like a fleet of ships moving in the same direction.

We're finally done. Please experiment as much as possible. Although it would be nice to animate features like Smart Filters, you already have much to work with. Try experimenting with animating your Adjustment layers and masks as well and see what you can come up with.

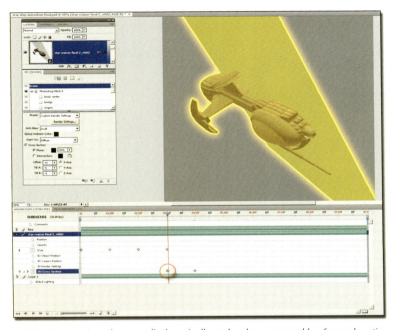

FIGURE 9.22 Cutting Plane applied vertically at the three-second keyframe location.

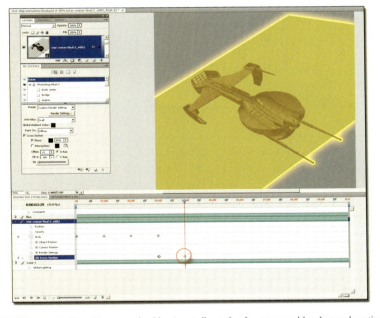

FIGURE 9.23 Cutting Plane applied horizontally at the four-second keyframe location.

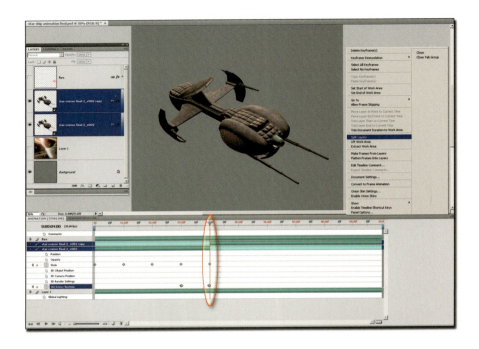

FIGURE 9.24 Use Split Layer to duplicate the timeline.

I hope that this book has given you some insight as to what you have to look forward to in Photoshop CS5 Extended. Experiment and have fun creating your masterpieces.

Enjoy,
Stephen Burns (www.chromeallusion.com)

WHAT YOU HAVE LEARNED

- You can animate any 3D object using its 3D navigational tools.
- All layers in your file are given an independent timeline with which to animate all objects in that layer.
- Once a timeline has been established, it can be duplicated, which will, in turn, duplicate the associated layer and all objects residing on it.
- You have the capability to animate a 3D objects Cross Section.

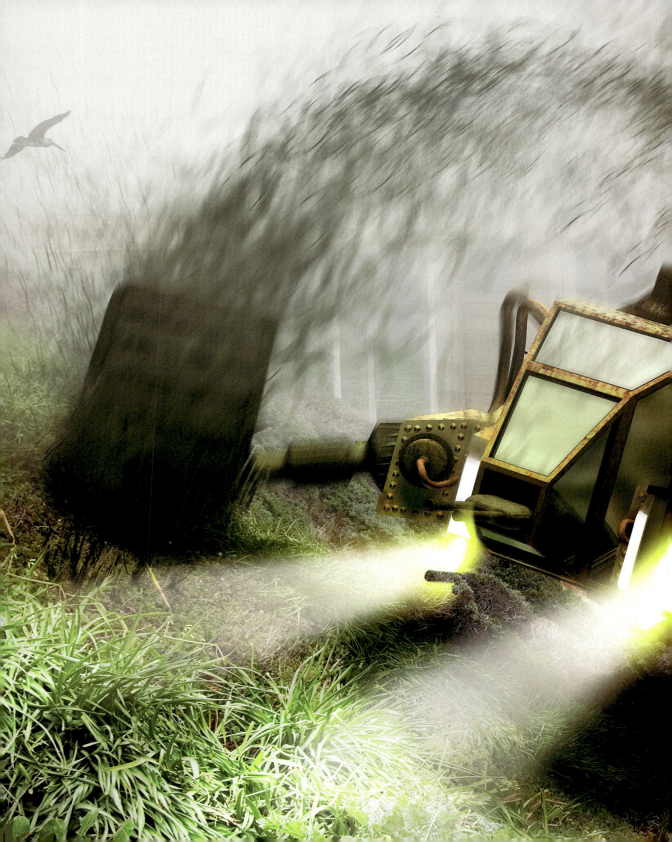

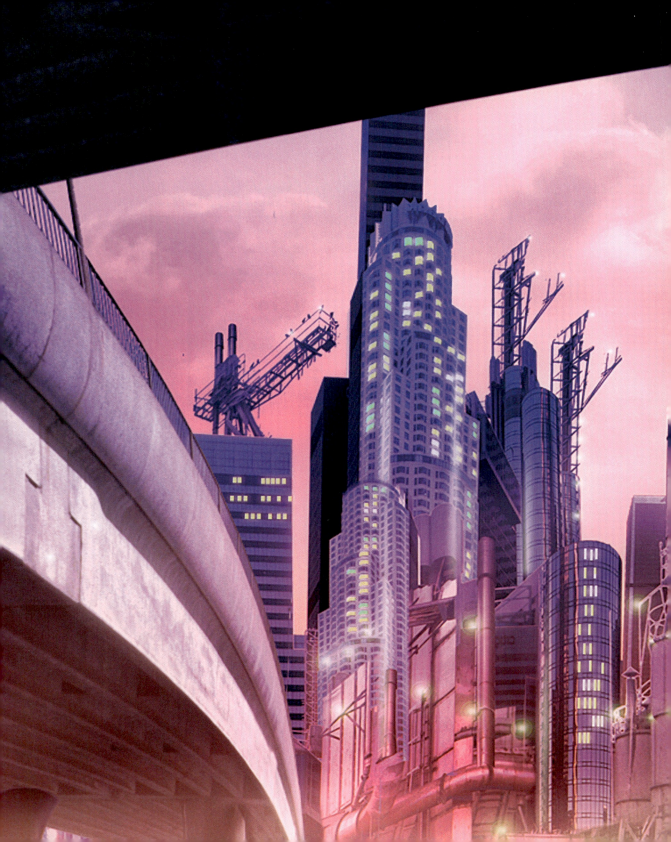

INDEX

Q–R

License Agreement/Notice of Limited Warranty

By opening the sealed disc container in this book, you agree to the following terms and conditions. If, upon reading the following license agreement and notice of limited warranty, you cannot agree to the terms and conditions set forth, return the unused book with unopened disc to the place where you purchased it for a refund.

License:

The enclosed software is copyrighted by the copyright holder(s) indicated on the software disc. You are licensed to copy the software onto a single computer for use by a single user and to a backup disc. You may not reproduce, make copies, or distribute copies or rent or lease the software in whole or in part, except with written permission of the copyright holder(s). You may transfer the enclosed disc only together with this license, and only if you destroy all other copies of the software and the transferee agrees to the terms of the license. You may not decompile, reverse assemble, or reverse engineer the software.

Notice of Limited Warranty:

The enclosed disc is warranted by Course Technology to be free of physical defects in materials and workmanship for a period of sixty (60) days from end user's purchase of the book/disc combination. During the sixty-day term of the limited warranty, Course Technology will provide a replacement disc upon the return of a defective disc.

Limited Liability:

THE SOLE REMEDY FOR BREACH OF THIS LIMITED WARRANTY SHALL CONSIST ENTIRELY OF REPLACEMENT OF THE DEFECTIVE DISC. IN NO EVENT SHALL COURSE TECHNOLOGY OR THE AUTHOR BE LIABLE FOR ANY OTHER DAMAGES, INCLUDING LOSS OR CORRUPTION OF DATA, CHANGES IN THE FUNCTIONAL CHARACTERISTICS OF THE HARDWARE OR OPERATING SYSTEM, DELETERIOUS INTERACTION WITH OTHER SOFTWARE, OR ANY OTHER SPECIAL, INCIDENTAL, OR CONSEQUENTIAL DAMAGES THAT MAY ARISE, EVEN IF COURSE TECHNOLOGY AND/OR THE AUTHOR HAS PREVIOUSLY BEEN NOTIFIED THAT THE POSSIBILITY OF SUCH DAMAGES EXISTS.

Disclaimer of Warranties:

COURSE TECHNOLOGY AND THE AUTHOR SPECIFICALLY DISCLAIM ANY AND ALL OTHER WARRANTIES, EITHER EXPRESS OR IMPLIED, INCLUDING WARRANTIES OF MERCHANTABIL-ITY, SUITABILITY TO A PARTICULAR TASK OR PURPOSE, OR FREEDOM FROM ERRORS. SOME STATES DO NOT ALLOW FOR EXCLUSION OF IMPLIED WARRANTIES OR LIMITATION OF INCIDENTAL OR CONSEQUENTIAL DAMAGES, SO THESE LIMITATIONS MIGHT NOT APPLY TO YOU.

Other:

This Agreement is governed by the laws of the State of Massachusetts without regard to choice of law principles. The United Convention of Contracts for the International Sale of Goods is specifically disclaimed. This Agreement constitutes the entire agreement between you and Course Technology regarding use of the software.